TERENCE LA NOUE

Best wishes,

[signature]

TERENCE LA NOUE

DORE ASHTON

HUDSON HILLS PRESS NEW YORK

FIRST EDITION

Text © 1992 by Dore Ashton
Illustrations © 1992 by Terence La Noue

Distributed in the United Kingdom and Eire by Shaunagh Heneage Distribution.
Distributed in Japan by Yohan (Western Publications Distribution Agency).

Editor and Publisher: Paul Anbinder

Copy Editor: Eve Sinaiko

Proofreader: Lydia Edwards

Indexer: Gisela S. Knight

Designer: Binns & Lubin/Betty Binns and David Skolkin

Composition: U.S. Lithograph, typographers

Manufactured in Hong Kong by South China Printing Co.

Library of Congress Cataloguing-in-Publication Data

Ashton, Dore.
 Terence La Noue / Dore Ashton. — 1st ed.
 p. cm.
 Includes bibliographical references and index.
 ISBN 1-55595-052-3 (alk. paper)
 1. La Noue, Terence—Criticism and interpretation. 2. Painting, Abstract
—United States. I. La Noue, Terence. II. Title.
ND237.L277A88 1992
759.13—dc20 91-58632
 CIP

CONTENTS

TERENCE LA NOUE: AN APPRECIATION

I T IS NOT EASY, ever, to locate the meaning of an artist's work. There are too many imponderables. Yet throughout the history of art, industrious respondents have sought to establish points of entry into the mysterious heart of artistic experience. Among them is the artist himself. Even he whose eyes, hands, and spirit have shaped a work is not always certain. If he were, there would be no need to go on. When Terence La Noue was asked what he thought his paintings were about, he answered:

> Well, one of the things that a painting does is present questions, but it doesn't always answer them. One of the most famous situations like this was when Stravinsky performed *The Firebird* for a particular audience. After he finished there was a question from the audience. The music was so revolutionary that they asked, "What's it all about?" So he turned to the orchestra and played it again.[1]

Throughout his oeuvre, La Noue has posed questions whose answers tend to be elusive, and in which the meanings, as he says, lie somewhere between the artist and the observer. Those who have responded to his elaborate, sometimes convoluted paintings are always aware that there is a great range of allusion; a personal culture that requires prolonged attention.

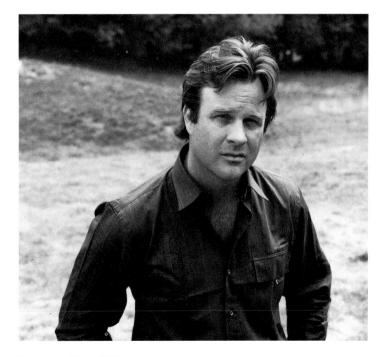

Terence La Noue, 1988.

Often, his allusions take in a broad geographical and cultural swath that reflects his many interests. These identifiable references—to the cultures of Africa, India, Mexico, Japan, for instance—have led to speculations concerning the essential nature of his work and sometimes to accusations of exoticism and eclecticism. Precisely there, La Noue challenges received ideas. Far from being a scavenger of non-Western cultures, he is an artist who has acknowledged a long-standing characteristic of Western art: that it was always acquisitive and open to imagery and styles from many points of the global compass.

La Noue is a Western artist in the best tradition. That tradition goes back and back, but for the sake of argument, one can start with Marco Polo, who returned to Italy from the realm of Kublai Khan in 1295, and whose widely read book, *Il Milione*, written in prison, was filled with allusions to the Arab world, Persia, Japan, Sumatra, and Zanzibar. No doubt the silk robes and copious caskets of jewelry he brought back were seen by artists, who could not have failed to be stimulated. In certain parts of Italy, responses by artists following its publication were unmistakable. Henri Focillon has cautiously proposed that in Siena, for instance, a certain sumptuousness "suggests links with places farther east than Byzantium":

> The Etruscans retained Asiatic forms within the imported Greek archaic style; the Latin basilicas and baths adopted Iranian techniques; and Byzantine Ravenna and Arab Sicily raised on the Italian skyline silhouettes which owe nothing to the West. Trading voyages established contacts between Asia and the great Mediterranean marts. Even if Siena had never sheltered a Chinese colony within its walls, it would still be necessary to acknowledge the fact of Tuscan Orientalism, and it would still be possible to explain it.[2]

Not only were artists always susceptible to visual stimuli from other parts of the world, but within the general history of culture in Europe there is a venerable tradition of looking elsewhere and assimilating as much as possible from as many sources as possible. What the best minds dreaded most of all was closure. Montaigne fought it, saying sarcastically: "Each man calls barbarism whatever is not his own practice; for indeed it seems we have no other test of truth and reason than the example and pattern of the opinions and customs of the country we live in." He made fun of his countrymen's awe at the miracles of printing and firearms, when "other men in another corner of the world enjoyed these a thousand years earlier," and said, "If we saw as much of the world as we do not see, we would perceive, it is likely,

a perpetual multiplication and vicissitude of forms."[3] Since *vicissitude* etymologically carries the suggestion of interaction and interchange, Montaigne's insight can stand for acknowledgment of a tradition consistent in European culture, and most obvious in its visual culture. It is this assimilative tradition in which Western art flourished, and which was animated with redoubled energy by the modernists of the early twentieth century. And it is this tradition within which we can locate the energies of Terence La Noue.

The basic drive within this tradition springs from an unspoken belief in the similarity rather than the difference between men of imagination (postmodernism notwithstanding). It always comes as a satisfaction to the questing artist to recognize another's imagery, or at least to respond to its originality. Artists are often endowed with great reserves of curiosity and great capacities to convert discovery into works. They constantly scan the world and travel—sometimes physically, sometimes in imagination—seeking correspondences between their own intuitions and what they see. Most artists would be happy to "see as much of the world as we do not see," although they are not always available to what they see. La Noue, however, is notably available, as were the early modernists. He extends one aspect of the early modern tradition when he reiterates, through his work, the passionate insistence on the value of abstraction, and its presence in works of many cultures. The chapter in modern art history opened by so many artists simultaneously during the first decade of the twentieth century is not yet closed. When, in 1908, Wilhelm Worringer, a twenty-six-year-old candidate for a Ph.D., published a thesis with the electrifying title *Abstraction and Empathy*, he struck a chord that is still reverberating. He had discovered his subject while visiting the ethnographic museum at the Palais du Trocadéro in Paris, where artifacts from many cultures languished until he and such artists as Henri Matisse, Pablo Picasso, and André Derain discovered their singular artistic value, all more or less around the same time. Worringer consciously attacked Eurocentrism (he may have been the first to formulate the notion) and declared, "The evolutionary history of art is as spherical as the universe, and no pole exists that does not have its counterpole." He believed that the slavish dependence of European culture on Aristotelian concepts had blinded it to "the true psychic values which are the point of departure and the goal of all artistic creation." He deplored the emphasis on "the beautiful," which usually meant European classicism, and declared that there is "a higher metaphysic which embraces art in the whole of its range and, pointing beyond all materialistic interpretation,

finds its documentation in everything created, whether in the wood-carvings of the Maori or in any random Assyrian relief." All artistic creation, Worringer believed, is "a continual registration of the great process of disputation, in which man and the outer world have been engaged, and will be engaged, from the dawn of creation till the end of time."[4]

Worringer's emphasis on psychic values was echoed by Wassily Kandinsky, whose own thesis concerning the role of abstraction in universal culture was being shaped at around the same time. Kandinsky's views, which he gathered into a book published in 1912, *On the Spiritual in Art*, were similar to Worringer's but more directly reflected his encounters with works of art from all over the world. After carefully studying them, he concluded that there could be "a similarity of 'inner mood' between one period and another.... This may account partially for our sympathy with and our comprehension of the work of primitives. Like ourselves, these pure artists sought to express only inner and essential feelings in their works; in this process they ignored as a matter of course the fortuitous."[5] When, in 1912, he and Franz Marc published their remarkable *Blaue Reiter Almanach*, their avowed purpose was to juxtapose art from all epochs and all geographical sectors in order to find comparable "inner sounds," as Kandinsky called the formal affinities among works from Borneo, China, New Caledonia, the Pacific Northwest, Bavaria, Russia, northern and southern Africa, Paris, and Malaysia. In their preface to the first edition of the *Almanach*, Kandinsky and Marc concluded that the principle of internationalism "is the only one possible" and that,

> as with a personality, the national element is automatically
> reflected in each great work. But in the last resort, this national
> coloration is merely incidental. The whole work, called art,
> knows no borders or nations, only humanity.[6]

There is a current in the torrential stream of modern attitudes toward works of art that flows steadily into the present, bearing the conviction that somewhere beneath all outer phenomena there are common sources. The artists who instinctively share what might be called this humanistic view often come to it through their own experience. Their preoccupation with an unspoken and perhaps inexpressible insight concerning commonality draws them into a perpetual search for a *Weltanschauung* that supports or confirms their initial experiences. Many modern artists, La Noue among them, have been drawn to the beliefs of Carl Jung, whose idea of a collective unconscious seems to support their investigations. Jung's well-argued structure

of belief helped many artists after the Second World War to ground their work. It offered a broad field for speculation and implicit permission to believe in their own discoveries. La Noue, whose independence as an aesthetic thinker is notable, has never renounced Jung's general view of the vicissitudes of symbols, but has understood that while "we have the same fears, loves, strong passions...we don't have the same kinds of rituals."[7] His awareness of this basic difference among seemingly identical symbols found in vastly different cultures has spurred him to explore not only a world filled with sights and sounds and extending beyond his immediate environs, but also the hidden founts of his own temperament. In the course of his wanderings, both physical and spiritual, La Noue has synthesized with precision the many kinds of experience he has accumulated. The works in which his knowledge is embedded are not, then, mere repositories of symbols but, rather, evidence of his curious journey. They are to be read, as Kandinsky said all modern art would be read, as a new harmony in which "the inner plane of a picture should remain one, though the canvas may be divided into many planes and filled with outer discords."[8]

THERE ARE OVERLAPS AND RETRIEVALS in La Noue's history as an artist— threads picked up, dropped, picked up again, sometimes unconsciously. These threads run consistently throughout his oeuvre and can sometimes, although not always, be followed back to specific experiences. His work is better discussed in terms of considerations rather than influences. What did he stop to consider?

When, after graduating from Ohio Wesleyan University and winning a Fulbright grant, La Noue made his way to Europe in 1964, he brought with him certain not-very-well-formulated problems. The shock of living in his first big city, Berlin, brought them into clear focus. At issue above all was his attitude toward the religious and ethical motifs that had accompanied him throughout his childhood in Indiana. The son of a Catholic father and Protestant mother, La Noue was accustomed to the strong interest in moral issues shared by his family. His father was a labor-union organizer who had courageously fought for the racial integration of his plant, and who made sure that La Noue learned the value of hard work by setting him, during summer vacations, to cleaning out huge vats of rancid vegetable oil used in making soap. Then there were the two grandfathers: one ran a hardware and farm-implement store and was, as La Noue recalls, "a

country sage; a moral and religious man interested in what we can do here on earth."[9] A great conversationalist, this grandfather could talk with tobacco-chewing farmers and his college-educated children with equal ease. He was, as La Noue fondly recalls, "comfortable with his life." The other grandfather, who apparently impressed La Noue deeply, was a custodian for a large Catholic parish who, La Noue says, knew how to use tools and could make anything. He was a wood-carver and La Noue cherishes the memory of his skills. Jesuit priests who were "smart and smoked cigars" were among La Noue's early influences, and exposed him to the Catholic ritual, with its intense theatricality, as well as to the long tradition of Jesuit scholarship. With a well-furnished mind, La Noue went off to college in 1960. Even though his midwestern college was somewhat insulated from the great world, news of disquieting events reached the campus. 1960 was a year of world-wide agitation: there were student riots in Turkey, Japan, and South Korea; marches against nuclear weapons in England; and the stirrings of the civil-rights movement in the United States. Paul Goodman published *Growing Up Absurd*, showing Americans that they had shortchanged their children, and winning vast numbers of radical adherents among those children. The arts, during La Noue's four years in college, were in a great state of up-heaval, the visual arts in particular. Calvin Tompkins called 1962 the *annus mirabilis* for Pop art, when almost all of its practitioners had their first exhibitions in New York and effectively countered the influence of the Abstract Expressionists.

La Noue, taking courses in both sciences and fine arts, found his way slowly. Although his mother had been an amateur painter, he did not consider painting as a profession until his final year, when he excelled in the fine-arts program. Visits to Chicago to the Art Institute, the Field Museum of Natural History, and the Museum of Science and Industry broadened his culture, but it took him time to assimilate the paintings of the Abstract Expressionist generation. When he saw the Art Institute's Clyfford Still painting—a looming, huge, heavily impastoed work—he thought at first that it could not be art. Soon after, he began to think about Jean Dubuffet, whose cult of the ugly served as a goad to La Noue's consideration of artistic values. Partly through Dubuffet, he began to feel that he was missing a great deal by "always looking for the pleasurable aspects of painting," as, for instance, in the splendid Post-Impressionist works in the Art Institute. Casting about for precedents congenial to his burgeoning artistic bent, La Noue found the German Expressionists, above all Max Beckmann.

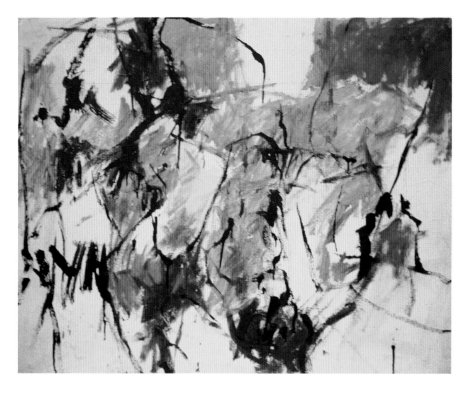

UNTITLED, 1963
OIL ON CANVAS
CA. 36 × 48 INCHES
COLLECTION THE ARTIST

Beckmann was to be an important figure in La Noue's artistic life, considered and reconsidered at every stage of his development. What drew him to Beckmann at first was undoubtedly the older artist's consistent interest in ethical and religious issues: the "psychic drama" to which La Noue felt he wanted to get close in his own art. At that age—twenty to twenty-two—La Noue was deeply interested in "concepts of religion and ideas of responsibility." What attracted him during the period in which he first considered Beckmann was the use of religious iconography "in a primitive and ritualistic way." La Noue's direct knowledge of Beckmann's major works derived from a trip to New York, where he saw both the early painting *Descent from the Cross* (1917) and *Departure* (1932–33). *Descent from the Cross* suggests several Northern Renaissance precedents—artists whom Beckmann called "manly mysticists"—particularly Matthias Grünewald; yet Beckmann's harsh diagonal Christ and the intricate composition of body parts, ladder, and sun were entirely original. The renowned triptych *Departure* also made a crucial impact on La Noue, setting out an aesthetic problem that he has carried with him to this day. It was the almost cinematic character of the triptych that lingered in his memory and, above all, the idea that "it was at once quite beautiful and quite ugly." The arcane symbolism, the disturbing cruelties depicted in the side panels, and the dreamlike, harmonious cen-

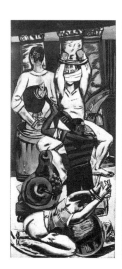

Max Beckmann, *Departure*, 1932–33, oil on canvas, 84¾ × 123⅞ inches, Collection the Museum of Modern Art, New York.

tral image combine in a way that suggests a ritualistic source without ever being explicit. The fusion of great ugliness with lyrical beauty, which La Noue sees in Paul Klee also, became, almost unconsciously for him, an aesthetic ideal to which he has cleaved faithfully ever since. The implicit question, What is ugly and what can be seen as beautiful? is central to his oeuvre. Later, he saw Grünewald's Isenheim altarpiece in Colmar for himself and confirmed Beckmann's insight.

Fortunately, La Noue had a professor at Ohio Wesleyan, Richard Wengenroth, who had a deep interest in German Expressionist art and who stimulated his own curiosity. When he considered what to do after he received his bachelor of fine arts degree, it was natural enough for him to apply for a Fulbright fellowship for research in Germany, where his teacher had studied a decade earlier. In preparation for the voyage, La Noue read everything he could about twentieth-century German art history and especially about Karl Schmidt-Rottluff, who, at eighty, was still a professor at the Hochschule für Bildende Kunste, where he had been appointed in 1947. Schmidt-Rottluff's work from the Brücke period had differed considerably from that of his fellow members. He was far more concerned with the planar simplicities he had found in a close study of African sculpture. His colors also reflected the intensity associated with African artifacts with audacious sweeps of brilliant reds, yellows, and blues. La Noue's inner *Bildungsroman* was nearing a climax that would come once he arrived in Berlin, ready to encounter a grand old man of a period to which he was so deeply drawn.

2 LA NOUE'S FIRST EXPOSURE to old Europe was fortunately buffered by an idyllic period of language study in the small city of Lüneberg in northern Germany. He was as enraptured with the town's majestic Gothic churches as was the fifteen-year-old Johann Sebastian Bach, who had his first glimpse of an important city in Lüneberg in 1700. La Noue's experience in the town, "a fairy-tale German city built on canals," was important to his aesthetic formation, for it was there that he discovered his innate love of music. A number of his fellow Fulbright scholars were training to be musicians and opera singers and brought him almost nightly to concerts, often in one or another of the city's sixteen celebrated churches. The magnificent organ in St. Michael's Church, and the great sense of

Lüneberg tradition it conveyed, remain among La Noue's cherished memories. Music henceforth was more than an entertainment—it became a need.

From Lüneberg, with its traditions and its physical tranquillity almost intact, to Berlin was a wrenching transition. Berlin in 1964 was a shattered, divided city struggling to define itself despite its unnatural condition (West Berlin in those days was an island, cut off from the rest of Germany and still occupied by the Allied powers). The young painter, keenly alert and observant, threw himself into the new experience fervently. He explored the city, was moved by the scabrous Wall that had been erected only three years before, and made sorties to East Berlin, where he met artists and smuggled Western art journals into their studios. The feverish ambiance of West Berlin suited his temperament, for he had arrived at a moment in his own life when the issues vividly current in the artistic life of the city were pertinent to his own inner struggle.

From his background reading, La Noue certainly understood that Berlin had always been a special case in German art history. For nearly a century its artists had contended with what Goethe in 1800 had called the "prosaische Zeitgeist" of Berliners. When the rest of Germany looked at the art of Berlin during the nineteenth century, it judged it wanting in imagination. Berliner art was realist art at its most prosaic. This background had plagued Berlin artists and in part accounted for the vehemence with which they broke with the past during the first decade of the twentieth century. Before the First World War, Berlin had seized the attention of Europe with its aesthetic radicalism, which culminated in the postwar Dada manifestations. And after the Second World War, a dazed and wounded Berlin dug out of the spiritual ruins by turning resolutely away from an aesthetic literalism that, in 1945, was associated with the hateful realism sponsored by the Nazis. La Noue's principal teacher in Berlin, Hann Trier, who was forty-nine years old when La Noue arrived, had been one of the postwar rebels who had turned to abstraction at the furthest remove from Berliner realism. Trier's linear and colorful paintings, with their freely wandering configurations, and those of his colleague and friend Fred Thieler (with whom La Noue's teacher in Ohio had studied), were thought of as declarations of absolute freedom comparable to that found in the work of the American Abstract Expressionists, which had been seen in Germany during the 1958–59 tour of an exceptionally important exhibition, "The New American Painting," organized by New York's Museum of Modern Art. La Noue found in Trier an extremely congenial and understanding teacher who never imposed his own views on his students. In fact, by 1964

most of those students had turned away from abstract painting and were busy developing a local idiom that was even then being called "Critical Realism."

A respected local critic, Heinz Ohf, later remarked:

> It is therefore remarkable that out of the painting classes taught by Trier and Thieler no new Triers or Thielers come, but the majority of young realists do. It is not their style, but their basic attitude toward art, namely, art as continuous experimenting with personal and social liberation, that they pass on to the next generation.[10]

La Noue's principal experience was with this "next generation" that was vigorously debating every conceivable aspect of modern painting and sculpture. He understood that they were in the throes of far deeper problems, many of them stemming from the black hole of suppressed history. "They seemed," he said, "to accept everything in their effort to get rid of their own past." He himself was attuned to struggle, since he was in the process of settling his own conflict with organized religion. The young artists in Berlin were quick to see that the past would have to be dealt with, and were more alert than Germans in the West to signals in the present of past vices. The symbolism of the Wall was always with them, as was the presence, just a few blocks away, of artists who were consciously retrieving the Expressionist past in an effort to exorcise the Nazi past.

Several important events had prepared the ground for the Critical Realists and during La Noue's sojourn there were more. The "New American Painting" show had been exhibited, in the fall of 1958, in the very Hochschule für Bildende Kunste in which La Noue worked six years later. It was received with tremendous enthusiasm and the most powerful of all German art critics, Will Grohmann, writing in *Der Tagesspiegel*, September 7, 1958, remarked that for the first time in the history of art personalities were emerging that were not influenced by Europe but, on the contrary, were influencing Europe. "Here, there is no comfort," he said, "but a struggle with the elements, with society, with fate." Grohmann concluded that these young Americans "stand beyond heritage and psychology, nearly beyond good and evil." This interpretation of the audacities of Abstract Expressionist painters was the prevalent attitude, even among the young, who were impatient to earn their own condition of personal freedom and to grapple more directly with society and their own fate.

This first exposure to American art was followed soon enough by exposure to the next generation of Americans, who had set a course that

SOUL DEATH OR BIRTH OF HUMANITY, 1964
MIXED MEDIA ON MASONITE
72 × 48 INCHES
COLLECTION THE ARTIST

diverged considerably from the Abstract Expressionist view. There were Americans whose works had moved away from conventional painting on canvas, and whose attitudes were iconoclastic. They found an ally in Germany, Joseph Beuys, who, since 1961, had been installed as a professor at the Düsseldorf academy. Beuys made contact with Allan Kaprow, one of the originators of Happenings, and with the international Fluxus group (an amorphous entity that included rebels of a neo-Dada cast from both Europe and America), and by 1963 Kaprow had performed in Berlin. By 1964, when La Noue installed himself there, Beuys had had his first public scandal: he was attacked by right-wing students inflamed by his ironic proposal to raise the Berlin Wall five centimeters. Beuys's attack on the "mental wall" that existed all over Germany drew many exasperated students to his side, and when, in December 1964, he gave a nine-hour performance in Berlin, they became his enthusiastic acolytes. That year, La Noue saw Beuys's installation, a room covered with lead and copper, in the "Dokumenta" show in Kassel. At the same time, the most recent developments in American art were promptly brought to Berlin. Above all, a Pop-art show came to the academy in 1964 that included several important Robert Rauschenberg Combine paintings. This was quickly followed by an exhibition of Rauschenberg's drawings at Amerika Haus in January 1965, including the entire suite of illustrations for Dante's *Inferno*. Another exceptionally important exhibition in 1965 took place in Hamburg, and many Berliners went to see it: a large exhibition of the work of Francis Bacon. Not only art exhibitions were brought to Berlin; La Noue also had the opportunity to see the Living Theater in a daring production of Jean Genet's *The Maids*. From these sources, and from their own past, La Noue's fellow students in Germany were inspired to create an art that could reflect the vexing political, social, and economic realities they had to confront—an art that could be both imaginative and realistic.

In retrospect, the work of the Critical Realists exhibited in 1964 seems a feverish pastiche of American Pop art, French New Realism, and earlier Dada sources. These young artists, many of them still students at the Hochschule along with La Noue, were caught up in an agony of self-doubt and self-assertion. They exhibited in cooperative galleries such as the Grossgörschen Gallery, founded in 1964, and established a communal image (critics spoke, for instance, of "the Grossgörschen group"), which La Noue characterizes as focused on "grotesque and angst-ridden figures." They had their own hellish associations—with the Holocaust; with the reappearance in Germany of business exploiters straight out of George Grosz,

brought about by the *Wirtschaftswunder*, the country's remarkable economic recovery; with the symbolism of the Wall. La Noue's associations were also hellish and to some degree were certainly inspired by his participation in the political activities increasingly preoccupying Berlin's intelligentsia. But his fundamental need was to express his personal crisis, which seemed to stem from the loss of God.

Still young enough to search for an appropriate personal means, La Noue was as impressed as his German peers by the works of Rauschenberg exhibited both in the Pop-art show and in the extensive drawings exhibition at Amerika Haus. As a student in Ohio he had encountered reproductions of Rauschenberg's work, as had his colleagues in Germany. Berliners, like all islanders, reached out for all the information they could get from the great world. But encountering the originals is always a totally different experience. La Noue was profoundly affected by this encounter, above all by the thirty-four drawings in Rauschenberg's unique project, the illustration of Dante's *Inferno*. These drawings, known as Combine drawings, were rendered in an unorthodox technique using chalk, pencil, ink, and transferred newspaper photographs. In them Rauschenberg, who used to say "I have a special kind of focus—I tend to see everything in sight," gathered many images and signs drawn from contemporary life and scattered them in imaginative configurations on the page. His bold analogy with Dante's own interest in quotidian life, with the imagined spaces of the Inferno so graphically described by Dante but so totally unlogical, and with the vulgar vocabulary deliberately invoked by Dante struck his young admirers with immense force. In these drawings Rauschenberg transformed Dante's hellfire and brimstone into rockets; his Florentine merchant politicos into hatted, bespectacled men in neatly creased trousers; his warriors and men of action into Olympic athletes, and his squads of demons into racing cars. The spaces Dante described—caves, circles, ledges, ascents, and drops—were rendered in various perspectives, with some pages reading downward, some upward, some both downward and upward. These fragmented spaces were traversed, in Rauschenberg's vocabulary, by footsteps moving from the top down, or by arrows skidding around the page, or by dotted lines that hinted at connections among disparate images. Ambiguities abounded, and Rauschenberg made full use of erasures, veils, truncated allegories as he worked.

La Noue, galvanized by this direct experience with infernal imagery, began to work out his own spiritual destiny in a group of drawings and paintings that he thought of as a Purgatory series. His Jesuit encounter had

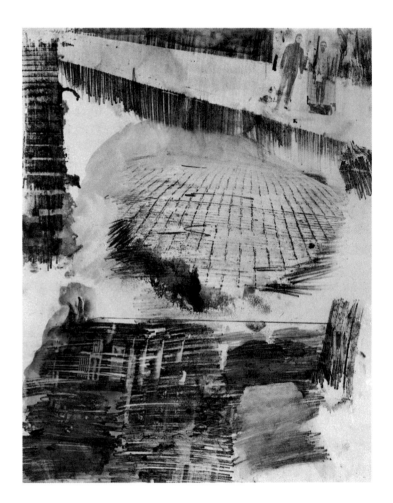

Robert Rauschenberg, *Canto XXVI: Circle Eight, Bolgia 8, The Evil Counselors*, from the series Thirty-four Illustrations for Dante's *Inferno*, 1959–60, transfer drawing, watercolor, wash, and pencil, 14⅜ × 11½ inches, collection the Museum of Modern Art, New York.

amply provided him with the emotional qualifications. His imagery in the drawings of 1964–65 often suggests the passing of souls through several layers of Purgatory and a sense of falling. These drawings are episodic, spasmodic. They borrow devices such as the stitched lines and arrows from Rauschenberg, but they are far more turbulent than Rauschenberg's relatively indifferent (as Marcel Duchamp said an artist must be) images of suffering. In 1964 he drew *Christmas Ghosts*, in which rigid, faceless bodies seem to be aligned at various levels of Purgatory, their predicament emphasized by the use of watercolor heightening in blood red and flesh tones. A few months later, in a pencil drawing, *Race for Grace*, matters become more complicated, and instead of a steady progression of forms sliding down a vertical page, there are elements flying in several directions, with the racing figures sometimes all but obliterated by erasures, sometimes symbolized by curving arrows. Rauschenberg's trick of vignetting certain crucial images is adopted, but the vignettes in La Noue's drawing are almost unreadable. They carry in their curvilinear suggestions a hint of dismemberment, of flesh decayed to the bone; but they are essentially mysterious. He had not forgotten Beckmann. Another drawing of 1965, *The Souls Perform the Necessary Tasks and Are Admitted*, heightened in bright watercolor, is a prototype for compositions La Noue later created in his abstract paintings, for it has a dynamic whirling fulcrum and clusters of images that move off the page. Here, La Noue's other tendency at the time, a preoccupation with erotic imagery, is notable.

By the summer of 1965 La Noue was exhibiting in one of Berlin's most prestigious galleries, Galerie Springer. His work was sufficiently distinctive to draw enthusiastic reviews, including one by Will Grohmann, who noticed La Noue's interest in Beckmann. "To be sure," Grohmann commented, "he has translated the nocturnal fantasies of the German into the realm of Pop Art with violent gestures, skin-close references to drastic, predominantly erotic occurrences, unobtrusive gayness of colors."[11] But, Grohmann added, these were "normal and sound paintings without aggressive ornamentation." Eberhard Roters, also a distinguished critic, wrote the catalogue note, calling the twenty-four-year-old painter both individualistic and intelligent in the way he organized "conglomerations of the contents of consciousness which have flowed half-way between chaos and organization."[12] The critic of the important newspaper *Die Welt* thought that the work "could well have grown on Berlin soil, and could well have originated in the Galerie Grossgörschen,"[13] while Heinz Ohf, writing in *Der Tagesspiegel*, noticed an affinity with such artists as Rauschenberg,

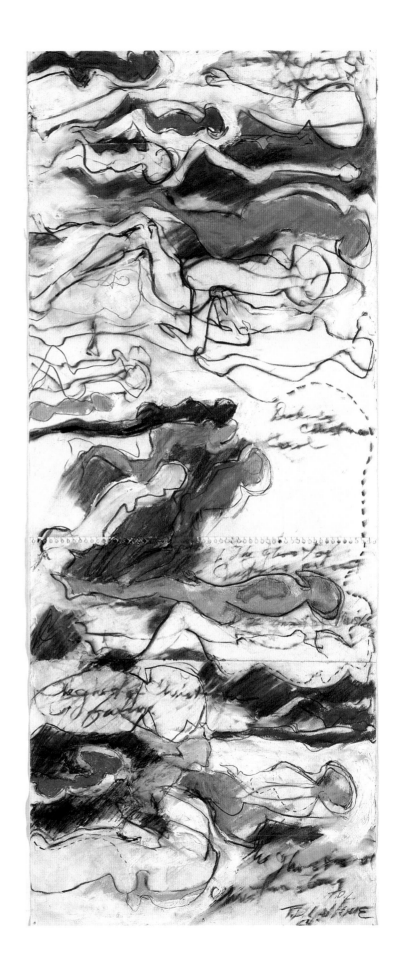

CHRISTMAS GHOSTS, 1964
WATERCOLOR ON PAPER
28 × 11½ INCHES
COLLECTION RUDOLF SPRINGER, BERLIN

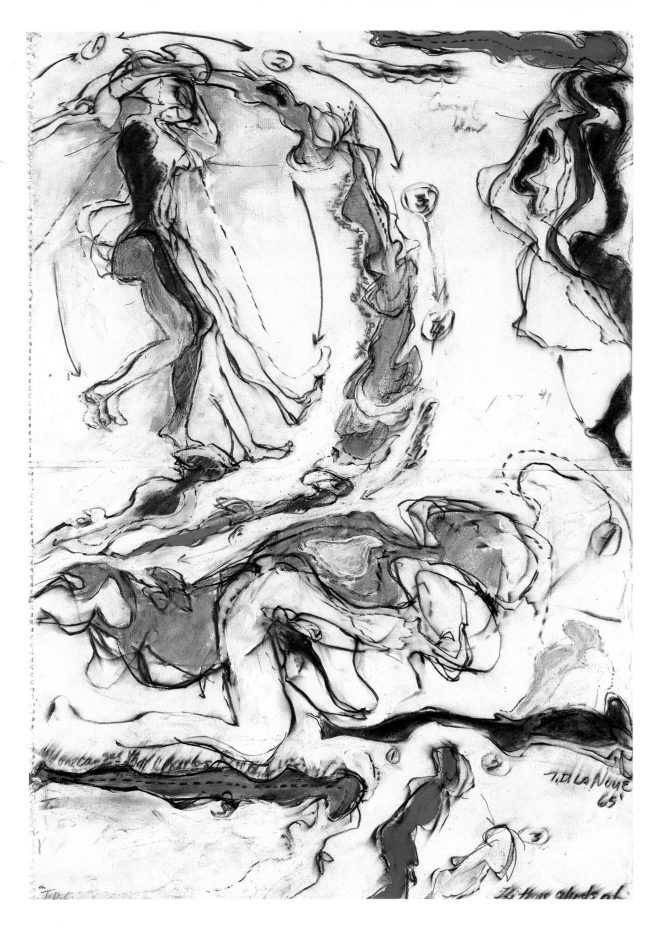

THE SOULS PERFORM THE NECESSARY TASKS AND ARE ADMITTED, 1965
WATERCOLOR ON PAPER
23 × 17 INCHES
COLLECTION RUDOLF SPRINGER, BERLIN

Jasper Johns, R. B. Kitaj, and Alan Davie. Ohf detected a note of irony in La Noue's drawings and a peculiarly muffled colorfulness, and he concluded his review with the flattering sentence: "He is, even now, an important painter."[14] Interestingly enough, Ohf chose to reproduce one of La Noue's most specifically Critical Realist works of the period, a work called *Candid View of an Inquisition*, inspired by El Greco, but with a mixture of academic drawing (not completely successful, especially in the hand) and abstract vignetted commentary. This one allusion to El Greco hints at La Noue's preoccupation with religious imagery and also with the compositional intricacies that later emerged in his abstract paintings.

Underlying the Berlin works of both La Noue and his peers was a general acknowledgment of a previously posited aesthetic represented by one Berlin resident of the earlier generation, Hannah Höch, who was being rediscovered at the time. The theory of photomontage that had emerged during the First World War was still evident in her work. The influence of the Dadaists, who had been well publicized in the United States during the 1950s, had filtered into the work of many of these younger artists. In 1961 the Museum of Modern Art mounted a significant exhibition, "Assemblage," which traced the history of the art of putting together both Cubist collage and Dadaist montage. La Noue, like others of his generation, was alert to the implications of the "Assemblage" exhibition. Fragmentation and additive approaches were widely practiced by the 1960s. La Noue's gradual development, culminating in the works in which his process is literally additive—the elaborate process of casting shapes in a mold and then painting over them—began in Berlin with these works that so apparently adopt the synoptic approach of the montagist.

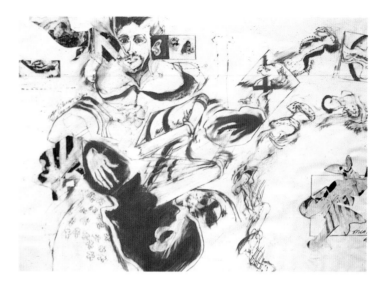

CANDID VIEW OF AN INQUISITION, 1964
MIXED MEDIA ON PAPER
22 × 33 INCHES
PRIVATE COLLECTION, GERMANY

3 LA NOUE RETURNED TO the United States in 1965, spending the next two years at Cornell University, where he took a master's degree. Although the semipastoral surroundings of Cornell may have been a relief from the urban turmoil of Berlin, America was edging its way into the abyss of the Vietnam war and no one in the American intellectual community could remain untouched by its ravages. The issues that had absorbed La Noue in his own life and work in Berlin were still pressing. In graduate school he turned to sculpture, resuming his meditation on the artistic issues he had first discerned in the paintings of Beckmann. He sought, through

reading and looking, "a completion of my ideas." The necessity of producing a written thesis for his degree was not unwelcome. Although working primarily in three-dimensional, monochrome forms, he chose to write about two painters, Beckmann and Francis Bacon, who had addressed the problem of expressing both the terror and the beauty, the tragedy and the sensuous delights of existence. Like most artists, La Noue was at once seeking support for his own temperamental proclivities and a philosophic framework in the attentive scrutiny of two artists whose work had deeply touched him. What he found, as he wound his way through the life and works of these two who had probed the darker side of life, were points of view that would sustain him and nurture his work for years to come.

Beckmann, who could paint an exquisite still life juxtaposed with a scene of torture, and whose allegorizing was so often mythic in tone but not specific in motif, challenged the young artist with his paradoxes. In his longest public statement, a lecture given in London in 1938, Beckmann had said: "Paradoxical as it may sound, it is reality that constitutes the true mystery of existence."[15] Yet the irreal seemed to dominate his paintings. Moreover, his remarkably tight and controlled compositions and the shapes he invented were, he said, often the result of chance. "My figures come and go as good or ill fortune dictates; they develop in what seems to be an accidental way, but it is my task to give them permanent shape." Perhaps La Noue's steadfast idea that the permanent shape of his own works must somehow embrace both discordant and concordant elements was instilled by Beckmann, who spoke in his lecture of "dreams of double meaning" that ran through his head:

> Samothrace, Piccadilly or Wall Street, Eros and the death wish,
> all these besiege my brain like crime and virtue, black and white.
> Yes, black and white are the two elements I had to do with. For
> good or evil, I cannot see everything in white: if I could it would
> be simpler and less ambiguous, but it would also be unreal.
> Many people, I know, would like to see everything white, that is
> objectively beautiful or black, that is negative and ugly; but I can
> only express myself in both together.

Beckmann also tried to define the purpose of art. He said that its purpose is knowledge, "not diversion, pastime or transfiguration," and that, finally, it is a quest for our own identity.

Bacon, whose paintings seem so distant from the subtleties of Beckmann, nonetheless worked from similar assumptions. He, too, pondered the accidental events in the painting process. In a 1962 interview

with David Sylvester for the BBC he said that all painting is an accident. "I foresee it and yet hardly ever carry it out as I foresee it. It transforms itself by the actual paint."[16] Bacon spoke then about what he called "illustrational painting," which he tried to avoid, suggesting that paint in itself has a life of its own:

> Can you analyse the difference, in fact, between paint which
> conveys directly, and paint which conveys through illustration?
> It's a very close and difficult thing to know why some paint
> comes across directly on to the nervous system and other paint
> tells you the story in a long diatribe through the rain.

Four years later, in another interview with Sylvester for the BBC, he was asked to describe the difference between an illustrative and a nonillustrative form. Bacon replied:

> Well, I think that the difference is that an illustrative form tells
> you through the intelligence immediately what the form is
> about, whereas a non-illustrative form works first upon sensation
> and then slowly leaks back into the fact.[17]

Given the way La Noue's work has developed in recent years, given his own emphasis on the material, nonillustrational aspects of his work while retaining an imagery moored in real experience (Beckmann's "true mystery of the world"), it is apparent that this scholarly concentration on the philosophies of two major artists during his years at graduate school was exceptionally important to his further explorations.

He was clearly casting about for a means to express often contradictory feelings. During that period, he says, his work was "open-ended," and he was able to move from welded-steel sculptures to fiber glass in a very short time. A photograph of a group of welded sculptures in his Cornell studio shows that even then La Noue was wary of convention and eager to introduce an element of arbitrariness into the standard vocabulary of welded metal. Wildly looping linear shapes erupt from irregularly contoured volumes in these early pieces, and the profusion of forms expresses a quality of richness and whimsy that flew in the face of prevailing Minimalist sculptural idioms.

La Noue was experiencing the same restlessness as others who had dismissed conventional approaches to sculpture and were at work further dismantling static ways of beholding. The late 1960s were notable for unbridled experimentation, not only with synthetic materials, but with the very notion of spatial configuration. Artists began to move into spaces that

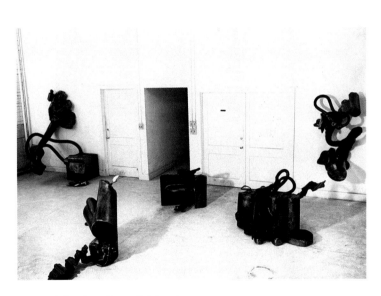

La Noue's Studio at Cornell University,
Ithaca, New York, 1965–66

had hitherto been regarded as merely accessory to the work of sculpture. The floor, for instance, took on new functions as many young sculptors assimilated its horizontality into the conception of their works. There were many discussions of the psychology of perception, and certain artists became spokesmen for a new view (or at least a newly revived view) of spatial integrity, which they saw as "anti-Gestalt." One of the important artists of the period, Robert Morris, had shifted from hard to soft materials—felt, above all—in order to express his insights concerning the possibilities of nonformal composition. The long preoccupation with the notion of the informal in the immediate postwar years had, until this time, largely been confined to painting. Morris and others now came forward with a challenge to the gestalt theory of perception in works in three dimensions that displayed what he called a purposeful detachment from holistic readings in terms of Gestalt-bound forms.

In La Noue's last few months as a graduate student at Cornell, he, too, sought to undermine the powerful formal tendencies that had prevailed in American sculpture. He began to make large sculptures that required the fabrication of huge rubber molds, into which he poured raw synthetic resin. A characteristic work, *Barrier Blue Horizon*, spills in softly draped shapes from a central fulcrum. It clings to the floor tenaciously and seems to spread in almost liquid forms. Yet, a certain rhythm in its stepped sequences suggests that La Noue was never willing to relinquish formal

RUBBER PIECE WITH LASH, 1967
NETTING AND RUBBER
CA. 108 × 72 INCHES
DESTROYED

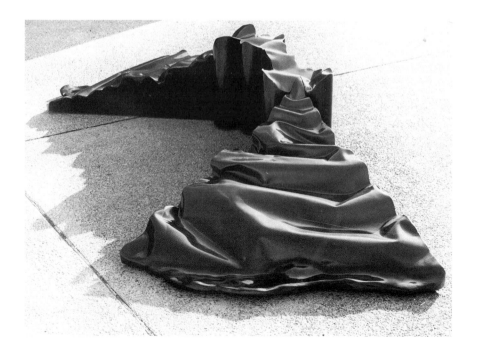

BARRIER BLUE HORIZON, 1967
FIBERGLASS
39 × 162 × 18 INCHES

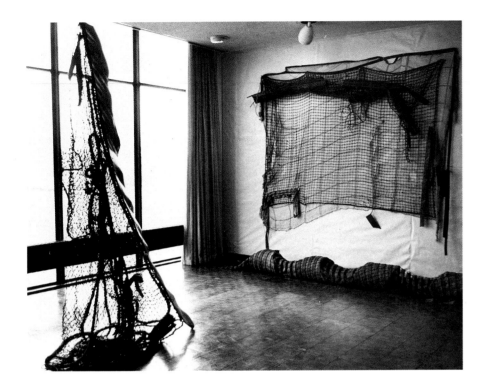

Installation, Trinity College,
Hartford, Connecticut, 1967–68

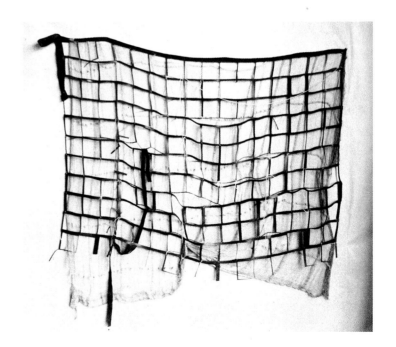

NETTING AND RUBBER, 1968
NETTING AND RUBBER
CA. 48 × 63 INCHES
DESTROYED

associations. These terraced shapes, no matter how much they simulate clothlike, rather than earthlike, tactile characteristics, nonetheless hint at La Noue's growing fascination with the contours of land as seen from great heights, an interest that has grown stronger over the years.

After graduate school, things moved swiftly. Having explored the flexible and unpredictable properties of synthetic materials, La Noue was swept up in a fever of experimentation. He took a post as teacher at Trinity College in Hartford, Connecticut, in the fall of 1967; this brought him closer to New York and to the growing number of young artists there interested in using unorthodox materials. Working concertedly, La Noue was able to mount a one-man exhibition at Trinity in 1968, in which certain enduring characteristics of his work first emerged. An installation photograph shows two transitional works: a hanging piece composed of tensile, ropy lines and billowing, transparent netting that is three-dimensional; and a wall hanging, partly two-dimensional, in which layers of irregularly hung netting form a roughly rectangular shape, which is contravened by strips that move out from the general shape and point to a serpentine, coiled form encased in netting on the floor. This latter work signals a move from a primarily sculptural to a pictorial mode, a shift that further strengthened La Noue's determination to get past traditional obstacles. In his Thesean

search for an appropriate mode, La Noue probed the possibilities of drawing, suggested in the sculptures by the superimposed netting, and of painting, which the use of colored latex enhanced, while taking advantage of the range of veils and transparencies available in his materials.

In 1969 La Noue took a cold-water loft in Manhattan, where he was able to take part in the burgeoning movement toward what was called "Process art," a term whose meaning was not very clear, but pointed toward an attitude of experimentation with new materials and new ways of conceiving visual objects. In Manhattan there were still meeting places for artists intimate enough for desultory conversation and the sharing of discoveries.

After working in his loft La Noue would stop in at Max's Kansas City, a congenial bar with jazz performances, where many artists of his generation gathered. No doubt he heard much about Process art at the bar, and it was there that he first heard about Eva Hesse, the artist whose work had the clearest affinities with his own. Other Process artists were more truculently interested in revealing their ways of working. For instance, Keith Sonnier was making works that dripped off the walls into the viewer's space, leaving all the traces of their passage in rubber, latex, and other industrial materials. But Hesse was far less explicit about her means. What seemed to interest her most was the possibility inherent in such materials as latex and fiber glass, with their potential for both transparent and opaque light effects, and the possibility of suggesting volume without ponderous materials such as plaster or bronze. Hesse also seemed to be further probing the issues raised by the older generation of Abstract Expressionists—issues of ambiguity, partial disclosure, and nonconfined spaces.

La Noue, who in his student days had discovered Willem de Kooning's painting *Excavation* at the Art Institute of Chicago, was keenly interested in the possibility of proposing a space that, like de Kooning's, was at once packed with detail and seemingly infinitely extensive. As his pictorial technique evolved, his forms were cast in such a way as to suggest many layers and many hidden distinctions. Working toward his first one-man exhibition in a professional American gallery, Paley and Lowe, in 1971, La Noue sought a resolution of his personal aesthetic. More and more, the works of primitive cultures that had so impressed him at the Dahlem Museum in Berlin seemed to hold the key to his own deepest feelings:

> Primitive art was something that I wanted to somehow assimilate
> for my own. It's very difficult to simulate the iconography from
> primitive art because one makes a painting in our culture for
> quite different reasons than a work of art is made in the Senafu

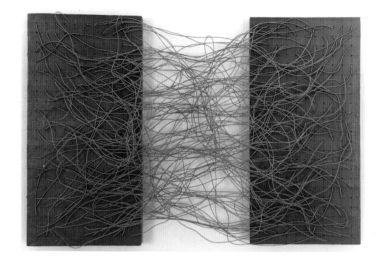

Eva Hesse, *Metronomic Irregularity,* painted wood, sculpmetal, cotton-covered wire, 12 × 18 × 1 inches. Robert Miller Gallery, New York.

KAWICH RANGE, 1970
LATEX, WOOD, AND RUBBER
126 × 153 INCHES
PRIVATE COLLECTION, WASHINGTON, D.C.

or Bambara cultures in Africa. But there is strength in the spirit of those images that calls up a similar emotional state that we as human beings continue to re-enact and deal with in our inadequate rituals today.[18]

In his effort to capture the spirit of primitive imagery, La Noue concentrated more and more on the elimination of traditional means, such as the closure offered by the rectangular picture plane. One of his last hanging works still alluding to a sculptural space is *Kawich Range*, of 1970; despite its vertical extrusions of wood, rubber hose, and rope, some of which touch the floor, the work suggests a Native American painting on deer hide rather than a bas-relief. La Noue's complicated technique of casting a synthetic

material base on an inlaid-wood floor produced a basket-weave pattern in the heart of the composition, while the fluted edges, created by metal molds, suggest a feathering effect. The edges of this piece, which is delicately colored in earth tones, curl or fray as would an organic animal hide, making a strong reference to the arts of other cultures.

4 IN FACT, AROUND THIS TIME La Noue was intensely studying the arts of other cultures, and had even begun to collect objects from African and South Seas cultures to have around him as he worked. These, in effect, were his "thoughts" about the direction his work would take, and have always remained so. In their presence La Noue was inspired to move away from his earlier attitudes—to both technique and content—to explore a totally fresh idea. In 1972 he abandoned the roughly rectilinear format of his wall pieces, together with the extrusions that moved into the real space of the viewer, touching the ground. Instead, he conceived of a series of works that explored the spatial and psychological issues implicit in the circular format. This was an important move for him, spurred by his perception that when his works were exhibited in large gallery spaces, their scale was altered. The circle, he discovered, resisted. With his background in the history of the arts of many cultures, La Noue began to ponder, through his new works, the issues of centrality—its symbolic and virtual meaning—that arise in so many phases of art history.

Centric composition, as Rudolf Arnheim has pointed out, occurs in nature when a system is free to spread its energy in space by sending vectors ("a force sent out like an arrow from a center of energy in a particular direction")[19] evenly in all directions, like rays emanating from a source of light. The perfect embodiment of the sunburst pattern is in the spherical shapes of planets and stars. Arnheim quotes Goethe, who, in his aphorisms on geology, said: "Anything that embodies itself with some freedom seeks round shape." We are dominated by the force of gravity, Arnheim argues, and the geometric center of the earth is its dynamic center as well. "Overcoming the resistance of weight is a fundamental experience of human freedom." The ideal form of resistance is pure roundness that "spurns any relation to the eccentric co-ordinates of terrestrial space. Even though in and by itself it points in no one direction, it encourages mobility: it belongs everywhere and nowhere." No doubt Arnheim had in mind Pascal's myste-

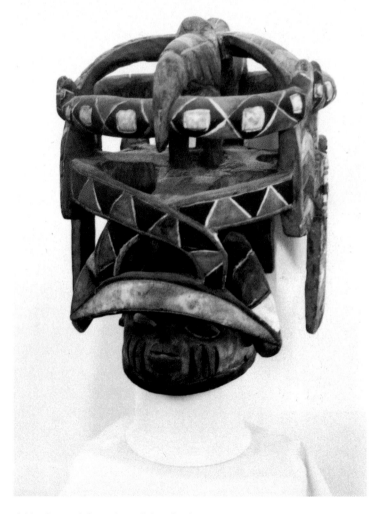

A Yoruba mask from the artist's collection.

rious dictum about nature: "It is an infinite sphere, the center of which is everywhere, the circumference nowhere." With this arcane vision of roundness and its self-contained mobility, artists have often explored its countless implications, as have their commentators. The tondo shape, as Arnheim says, transports us from the limitations of earthly gravitational space to the "more fundamental model of cosmic concentricity."

Cosmic concentricity is implicit in the works of many cultures called "primitive." The circle shape frequently has symbolic overtones, and in some instances clearly stands for a specific theogony. In studying objects he found in museums and books, and some he eventually acquired for his own delectation, La Noue inevitably came up against the awkward problem of the Western artist who feels himself to be closed out of the primary experience of cult objects, and yet is moved by them. As a thoughtful artist, he was bound to examine the difficult problem of cultural difference, and yet he had to acknowledge that somehow the artist in New Guinea or Africa had found a universal that went beyond the particular rituals of the tribe. No doubt he was aware that there is, even in the most ritualistic societies, almost always a level on which a cult object is appreciated for its aesthetic value, as it would be in Western society. Leopold Senghor has written that in most African languages there is no way of saying *beautiful* or *beauty*, yet there are words to praise a work of art.[20] The Wolof tribesman, for example, uses the adjectives *dyeka*, *yem*, and *mat*, which are translated as "what is suitable, agreeable," "what is the measure of," and "what is perfect." The beautiful mask, Senghor writes, or the beautiful poem, "is that which produces on its audience the effect intended: sadness, joy, hilarity, or terror." These criteria obviously exist also in Western art and provide the Western artist with some entry into the works of other cultures. As La Noue was avowedly seeking in his own work an equivalent of the spirit of primitive art, with its capacity to move even strangers to its mythic world, it was apparent that the cult objects he collected would work their way, in spirit, into the new circular compositions.

His interest, at the time, was in the arts of New Guinea and the wooden masks of the Songye tribe of Zaire, called *Kifwebe*. These distinctive masks were considered by Leo Frobenius, who visited southeastern Zaire in 1906–7, to be used in the prevention and curing of illness and the expulsion of the spirits of the dead. They are, accordingly, powerful but not gracious, grotesque rather than elegant, and embody La Noue's feelings about the potency of the melange of the ugly and the beautiful. The peculiar characteristics of these wooden masks are the powerfully coursing

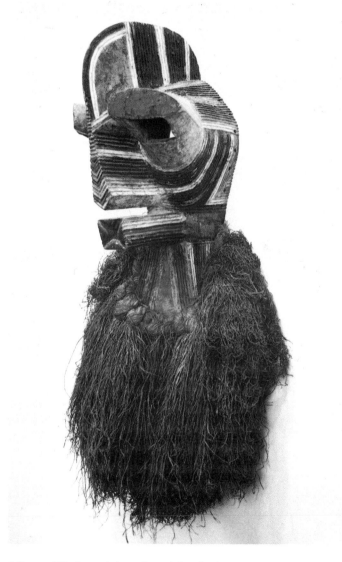

A Songye *Kifwebe* mask from the artist's collection.

incised lines that frequently describe circular or semicircular patterns. When painted, usually in earth colors and whites, they are even more visibly keyed to circular patterning. Certainly La Noue was drawn not only to the strong patterning of these masks, but to the source of the power of masks in general. A mask in its essence represents an other; a double of a personality, a means of existence outside of everyday contingency—a function that is similar to the function of a work of art. The mime in which the mask participates always alludes, no matter how remotely, to the drama of the cosmos. This is true of Songye masks and also of the masks carved by the artists of New Guinea. While the techniques and materials of the South Pacific are radically different, these works are still fashioned to produce drama. La Noue had studied photographs of New Guinea ritual celebrations in which great, shieldlike headdresses imitate the circularity of the cosmos, and had seen photographs of houses in the South Sea islands in which gables are decorated with solar discs. The memory of such glimpses of other cultures is implicit in the large circular compositions of 1972–73. These were still conceived as reliefs, constructed of latex and fabric, and worked up from a basic mold. In *Terre Haute*, for example, La Noue posed for himself problems of centricity and eccentricity by using the relief patterns of floorboards, all rectilinear, horizontal bands, and weighting the bottom of his circle with squared shapes, conserving, as he said, the "feeling of openness and spaciousness in regard to the heaven-and-earth theory." Although the round panel was ragged at the edge, La Noue worked slender rubber tubes through it that circumscribe his composition. In places he still alluded to the viewer's space, allowing a strand of rubber rope to dangle from an edge (reminiscent of certain Native American shields, with fragments of feathers dangling from their circumferences), but the circle is emphatically announced by the linear outline. In his early, large, circular compositions, La Noue limited the color of his latex and acrylic-paint details to close and almost neutral tones, emphasizing the unity of the round object and his determination to escape from the architectural reference that inhabits infinite scale.

Soon after, La Noue made the decision to reduce the size of his circular paintings. By now, the elements of painted surface, design, and containment made his works far more like paintings than sculptured reliefs. This smaller scale infused them with the power of primitive masks. Almost immediately, the ancient motif of the maze appeared, as La Noue fashioned concentric elements clearly emanating from the center, but not at all clear in their ambiguous trajectories. In these works, about thirty

TERRE HAUTE, 1972
LATEX ON TOBACCO CLOTH
92 INCHES DIAMETER
COLLECTION WHITNEY MUSEUM OF AMERICAN ART, NEW YORK

THELA, 1973
LATEX ON TOBACCO CLOTH
36 INCHES DIAMETER
PRIVATE COLLECTION, NEW YORK

THOTH, 1973
LATEX ON TOBACCO CLOTH
36 INCHES DIAMETER
COLLECTION THE ARTIST

inches in diameter, he was able to concentrate the plastic power of the circle not only in the slight ridges that describe circle within circle, but in colors that seep over the edges and establish subtle countercurrents. At times La Noue designed vectors that suggest a geometric distinction within the circular form—wedge and pyramid shapes, for instance—but these are contained, always, by a clearly delineated circular edge. Gradually, color took on a more emotional function, sometimes darkening to purples and browns with flecks of scarlet, but sometimes resplendently brilliant, as in a piece with a clear central hub from which wedges of deep terra-cotta, brown, warm gray, and pale ocher radiate, much as in a South Sea solar disc.

As the series of smaller circular forms progresses, one feels that La Noue's preoccupation with primitive art lends the works substance. There are inflections of darkness and primitive terror, in some aspects comparable to the Western infernal themes that had preoccupied him as a student; and there are also aspects that are formal, beautiful, and visually pleasurable —elements that had also been important to him in the past.

The circle shape aided La Noue in his struggle to avoid the illusionism of the conventional rectangular painting format, and confirmed the substantial, the *object* nature of his work. Yet it also limited his imagination. It wasn't long before he cut his circle in half, radically changing the assumptions with which he worked. The instant the half circle appeared, it brought with it the association of the groundline, the horizon, and, inevitably, our condition of being subject to gravity. It also initiated a host of other associations. The arch, as Giorgio de Chirico always maintained, is implicitly mysterious. Referring to metaphysical painting, he quoted Otto Weininger: "In the arc there is still something incomplete, that needs to be and can be completed—*this makes for a presentiment*."[21] In other commentaries, de Chirico extolled the arch as the most open geometric form there is. Certainly the element of "presentiment" is something La Noue has courted in all his work. The demand to be completed is implicit in the half circle. The shape—like a proscenium arch—offered La Noue many possibilities to enact various fantasies, which he had recently stimulated through extensive travel. But it also circled back to earlier impressions of the arched naves and altarpiece settings he had seen in his student years in Germany. Certainly a trip to Morocco in 1969 had prompted new images with arched settings, as did trips to important Mesoamerican sites in Mexico, Guatemala, and Honduras.

Photographs by the artist of land contours in the Dra Valley, Morocco.

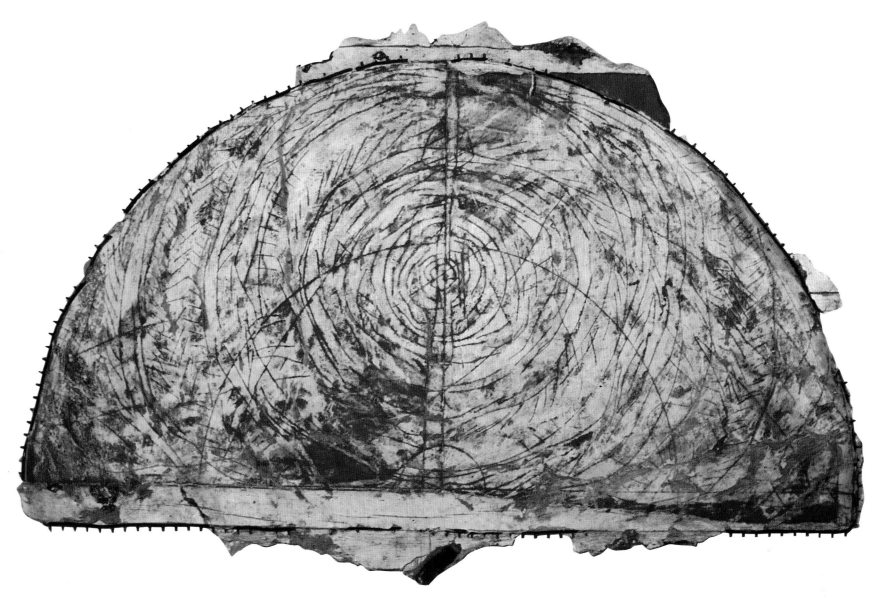

The half-circle compositions are highly varied. A piece from 1972, for instance, *Aurora*, alludes to La Noue's long-standing interest in cartography and his earliest childhood ambition to re-create the dioramas he had seen in the Field Museum in Chicago. This delicately tonal work, with a vertical axis and a small hublike shape near its lower edge, is inscribed with circular whorls that suggest an aerial view of the earth or a topographical rendering of layered landscape. La Noue has expanded the composition beyond the boundaries of the half-circle format, suggesting the existence of further horizons and stressing the unfinished or perhaps behind-the-scenes visions he harbors. The strong feeling of looking down from an aerial viewpoint is characteristic of many of La Noue's paintings, and at times he has traced it back to his earliest experiences. In a 1977 catalogue note he wrote:

AURORA, 1972
LATEX AND RUBBER
62½ × 96½ INCHES
DESTROYED

TERENCE LA NOUE

When I was growing up "back home" in Indiana, the entire world as I knew it, was flat. My only concept of space was either linear or aerial. My first airplane ride left an indelible impression on me . . . because of the incredible pattern and design one could see, as the fields butted up against each other forming intricate compositions and textural interplay. I thought then and continue to believe, that if you had the right tools and/or vision, you could rip up this superficial collage and uncover hidden patterns that have no relation to what was visibly apparent on the surface. . . . I still think and experience the universe as the inverted bowl just like the midnight-blue-stars-and-planets-hand-painted-plaster ceiling of the Paramount Theater on Hohman Avenue in Hammond, Indiana.[22]

MONUMENTS FOR QUETZALCOATL, 1975–76
WATERCOLOR AND CHARCOAL ON PAPER
29 × 41 INCHES
PRIVATE COLLECTION

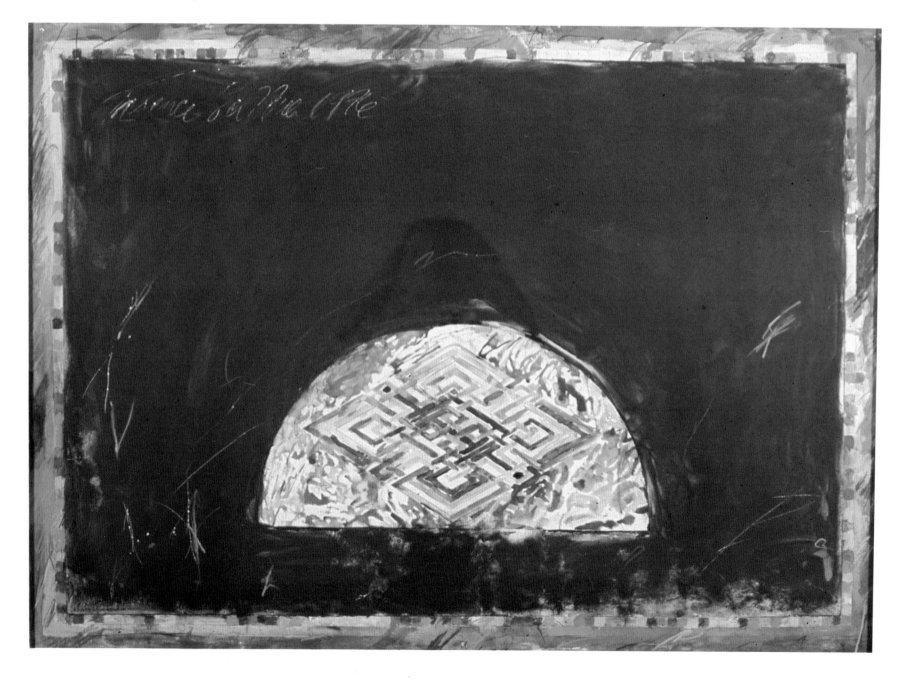

The lunette shape—the lunar association—was to remain with La Noue for many years. Quite often it conjured, for him, memories of Mesoamerica, as in the 1975–76 drawing *Monuments for Quetzalcoatl*, where a colorful geometric, mazelike pattern is contained in a lunette, which in turn is ensconced in a nocturnal, highly suggestive sky in a rectangular format. Certainly the experience of Mesoamerican monuments had a profound effect and released a host of associations. La Noue's allusion to the magnificent god Quetzalcoatl in his 1977 statement is a remarkably succinct commentary on his work:

> Quetzalcoatl, the feathered serpent, represents a captivating dichotomy, . . . a beautiful poisoned symbiosis. The tension between opposites is what my work and life are about.[23]

BY TEMPERAMENT LA NOUE is a dreamer of places. Long before he was able to travel, he had begun inventing places, imagining places, perusing books on geology, geography, architecture, and archaeology. These perpetual imaginings, sometimes incited by the presence of an object in Berlin, or at the Brooklyn Museum, or the Field Museum, or the Museum of Primitive Art in New York, or in shop windows, deposited stores of imagery in his memory. Actual, physical travel to their sources sometimes merely confirmed his earlier presentiments. As one who at moments has thought of his work as a stage, with its proscenium arch, within which his forms become characters "which I sometimes pick up and move around on the stage," the dramas of certain monumental sites were of great interest. His attraction to the congealed mythology embodied in Quetzalcoatl was one of many such attractions based on a deep desire to know for himself —though he well knew it was ultimately impossible—the founts of such spectacular creations. Exoticism as such, with its concern with superficial differences and quaintness, held little interest for him. What concerned him was the tension between opposites, the "poisoned symbiosis." This was the same concern he had found implicit in the attitudes of Beckmann and Bacon. Strangeness, writes Octavio Paz, begins with surprise and ends with questioning:

> The sculptures and monuments of the ancient Mexicans are works that are at once marvelous and horrible. By that I mean

works that are impregnated with the vague and sublime sense of
the sacred. A sense that wells from beliefs and images issuing
from very ancient and radically *other* psychic depths. In spite of
their strangeness, in an obscure and almost never rational way,
we recognize ourselves in them. Or, more exactly, we glimpse
through their complicated forms a buried part of our own being.
In such strange objects—sculptures, paintings, reliefs, sanc-
tuaries—we contemplate the unfathomable depths of the cos-
mos, and we peer into our own abyss.[24]

Unquestionably La Noue, contemplating his early acquisitions of primitive
art, desired to know, as far as possible, what Paz calls "the buried part of
our own being" through direct exposure to distant cultures. In 1972 he
won a grant that enabled him to spend seven months in Africa, where he
encountered the "marvelous and horrible" and sensed, to some degree, the
kind of life from which the continent's extraordinary works issued. For
him travel in Africa was not just a matter of observing and registering
various artistic styles among tribes; he was able to participate in the activi-
ties of tribal life at a level that would have shocked him to contemplate
before his departure from New York. For instance, on a trip with members
of the Masai tribe, the artist first watched as the men made a small slit in
the neck of a cow, drank the spurting blood, and then covered the wound
with mud—a most efficient and economical way of nourishing oneself on a
prolonged journey. He, too, then learned by doing to nourish himself with
blood and in the learning no doubt temporarily freed himself from deep
resistance to the strange. Of course there were many instances in which the
watcher remained the watcher, and many in which the aesthetic dimension
was the most important. La Noue's interest in the varied landscapes of
Africa—from the savannahs to the jungles—was amply rewarded and en-
tered his repertory of spaces. He was privileged to watch while men painted
their bodies, and perceived the results largely aesthetically, as would an
outsider. In his wanderings through Senegal, Liberia, Ghana, and the Ivory
Coast in the west; and Kenya, Ethiopia, and Tanzania in the east, La Noue
registered many impressions, including the images of scarification—a some-
what horrible West African practice that, though profoundly foreign to a
Westerner, nonetheless reflects innate aesthetic impulses not entirely re-
mote from the Western notion of body ornamentation.

All of these experiences entered La Noue's inner life, depositing
feelings and visions that lay dormant until needed as he worked. The pal-
impsests of his visual life acquired even greater reality as he traveled and

recognized what had earlier been mere intimations. After his wanderings in southern Africa, for instance, he made another trip to North Africa and Morocco. This time La Noue undertook an arduous excursion through the Atlas mountains and the desert, reaching a remote area, Zagora, where caravans had once gathered. His photographs of the vast, contoured rises in the desert show how attuned he was to the drama of the earth as it touches the sky, and how deeply impressed he was by its rhythmic, sculptural quality as it is shaped by the winds. Not long after, he returned to the treasures of the Western hemisphere, where again the role of nature as it invested specific sites with its slow labors of transformation captured his imagination. In the partially cleared jungle sites of Yucatan he found marvelous ruins, alive with nature's incursions—ruined pyramids overgrown

ZAGORA, 1977
RHOPLEX, ACRYLIC, METALLIC POWDER, AND TOBACCO CLOTH
64 × 116 INCHES
COLLECTION MUSÉE D'ART ET ARCHÉOLOGIE, TOULON

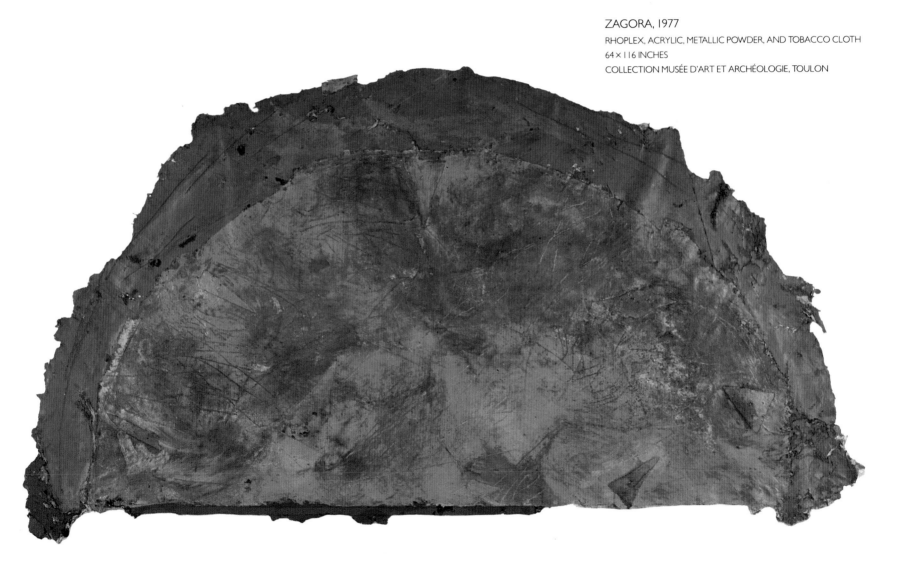

with trees, rubble walls invested with leaves and flowers, and sculptured details that were vegetal fantasies of immense grandeur. In the volutes and serpentine reliefs, the sculptured architecture, the ridges, whorls, meanders, and labyrinths of these ancient cultures La Noue found motifs that he had already instinctively broached in his own works, encouraging his belief in the hidden universals of human experience.

His curiosity about other cultures during the 1970s brought him to consider certain arts of the East, most particularly the art of Tantric Buddhism. Even before he traveled in India and Nepal in 1976–77, La Noue had been interested in Tantric art, not, as he has stressed, as an initiate, but for formal reasons. Still, Tantrism, with its openness to sensuality, its deep erotic meditations, and its tendency to embody both evil and good in a single deity or human soul, was not uncongenial to him. Eventually he began to collect tankas and mandalas in which mineral colors, red, yellow, gold, blue, and white, were distributed in nearly—but never totally —symmetrical patterns. The square within the circle of the hanging mandala and the central image of the tanka, surrounded at the four corners by other images, offered La Noue new compositional ideas that found their way into his work in the late 1970s. He discovered that the tanka is an object to be used in meditation, and that its creation was a ritual act. Perhaps he knew that the artist polished his silk or cotton surfaces with chalk and glue to a mirrorlike surface, from which he conjured his imagery, and that the final image was called in Tibetan *me-long*, which means "mirror." La Noue had his own ritual, which ordained that he incise his basic drawing in a mold so that the painting would reveal itself in reverse; he could thus find at least a small piece of common ground with the lamas who painted in the remote Himalayas.

La Noue's crucial voyage occurred in 1979, when he undertook an extended visit to India and Nepal. It was in India that he passed over almost entirely into the realm of the painter. Color is a painter's single most compelling issue, and La Noue had confronted it for several years as he moved away from sculptural preoccupations. In India he suddenly discovered, as he says, that he was "a thoroughly conventional person, even a conservative person." He had always fought his innate conservatism, and had known the fear of slipping blindly into convention; his elaborate painting technique, with its generous attitude toward the unpredictable, had been developed partly to avoid falling into convention. The unparalleled experience of India was a watershed experience.

It was not only the great monuments, such as the Taj Mahal, that excited him, but his casual experience of the exceptionally vibrant atmosphere in India: "In my day-to-day encounters with color," he recalls, "I changed my entire attitude to color." These included glimpses of clothing, signs for movies, popular images hawked in the streets, and abundant objects of folk art. Above all there were the markets, where La Noue saw piles of pure pigment, such as the scarlet powders used to anoint household shrines. Fruits, vegetables, dry goods—everything ebulliently displayed wherever he traveled—filled him with delight. Always seeking reminders—the works he keeps around him in his studio and home—La Noue acquired living memories in Indian miniatures, Rajput paintings, and, in Nepal, tankas. Visits to shrines where colors were rampant left him with indelible memories. And always there were the spectacular landscapes, rivers, mountains, and implacable vegetation to inspire him and to broaden his vocabulary of natural wonders. The good traveler, feasting his eyes, added layer upon layer of impressions that, after 1979, were refined and distilled in a whole new phase of his work. The way Asian artists suggest a world view in their art—the tankas, for instance, in which, as he says, "microcosms spring up either repeating or reflecting"—completed observations that he had begun in Africa and Central America, and confirmed La Noue in his purpose. Henceforth he would be interested in the way to project somehow what he calls "the decipherable levels of complication" that he had first remarked in the works of Beckmann and later observed in the arts of so many non-Western cultures.

6 AFTER THE EXTENSIVE TRAVELS of the 1970s, La Noue set to work with renewed confidence in his own view of the nature of painting. His lexicon of symbols had been greatly expanded. With his characteristic psychology of abundance, he was eager to explore his inner world in the confines of his studio. It was not a matter of systematic exposition; at no particular moment did images arise. Rather, for a dreamer, a browser, they were there, deposited in the psyche, available for retrieval when needed. Now in his late thirties, La Noue could summon disparate images and impressions—the scents and atmosphere of various places and concomitant emotions—from a rich cache of memories. Refreshed by so many novel impressions, he sought the freedom invested in the Western tradition: he

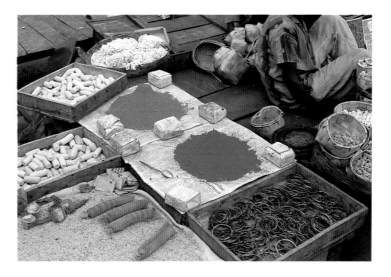

Photographs taken by the artist in Bhubaneswar, India.

returned to the painter's format, abandoning the arched object in favor of the infinite possibilities offered within the traditional format of the rectangle and square. The necessity of painted illusion became obvious to him as he embarked on paintings that could no longer be seen first as a series of objects. Each painting, now, had its own savor.

La Noue's approach to the problems of painting remained singular. His highly personal technique was itself metamorphic. Everything is in a state of change as he works, applying his colors in shifting layers and manipulating various textures. The state of mind of the excavator, always on the threshold of discovery, was sustained. Although in the works of the late 1970s and 1980s there was still the element of carving, as he incised his basic drawings in a mold, and still the fitting of shapes and collaging of final elements, and still the relief effects of ridges and hollows, these were simply methods of expanding the possibilities that painting embraces. What La Noue sought, as he worked in various perspectives—from above, from below, within discrete areas—was to establish a mood with specificity. Perhaps as a result of seeing temple hangings, he now began to mount his works on canvas that could be affixed to a length of wood at top and suspended on a wall. As if to emphasize the properties of these works as hanging paintings rather than affixed objects, he began to paint borders at their upper and lower rims, although he still emphasized gravity by allowing lower edges to be unevenly shaped, as though everything in the composition above had literally *expressed* them. Three works of 1979 allude directly to his Indian experiences in their titles and, although exactly the same size, demonstrate La Noue's ability to alter the emotional climate. Incorporating pairs of half-moon shapes into a roughly rectangular painting, La Noue arranged one above the other and set them in a series of boundaries that suggest the framing of tankas and Indian miniatures or the existence of pictures within pictures—a conceit so often found in Eastern art. Yet little in these works draws directly upon any specific tradition. La Noue has freely invented these places. *Kashmir*, for instance, with its bone whites and ivories, pale, washed grounds and square black insert (the gate in a mandala?), is traversed by freely drawn lines that set up counterrhythms to the contained half-moon shapes and insistently confirm the work as a painting, in which line and color share the burden of proposing varied spaces. *Jaipur* subsists in a warmer climate, with ambiguous painterly areas, and *Lahore* is warmer still, with its key tonality of red, altered, dimmed, or heightened as the painter moves across his surface. A strong blue is threaded subtly through to the lower border, picked up beneath the richly varied textures.

KASHMIR, 1979
ACRYLIC, RHOPLEX, METALLIC POWDER,
AND TOBACCO CLOTH ON CANVAS
93 × 71 INCHES
COLLECTION ALBRIGHT-KNOX ART GALLERY, BUFFALO

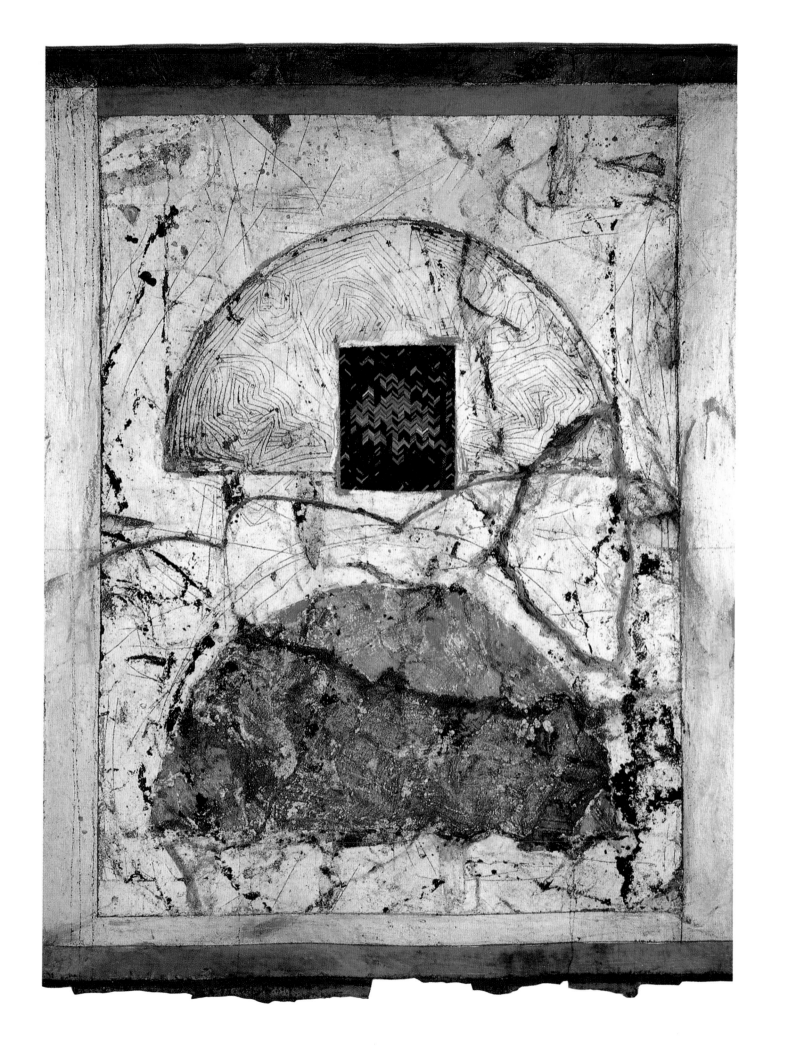

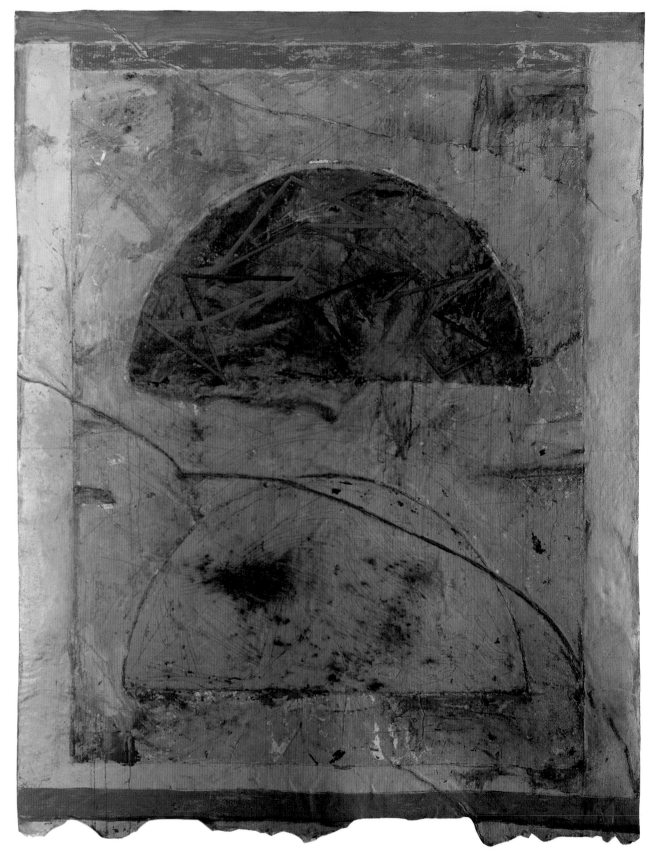

JAIPUR, 1979
ACRYLIC, RHOPLEX, METALLIC POWDER,
AND TOBACCO CLOTH ON CANVAS
93 × 71 INCHES
PRIVATE COLLECTION, FLORIDA

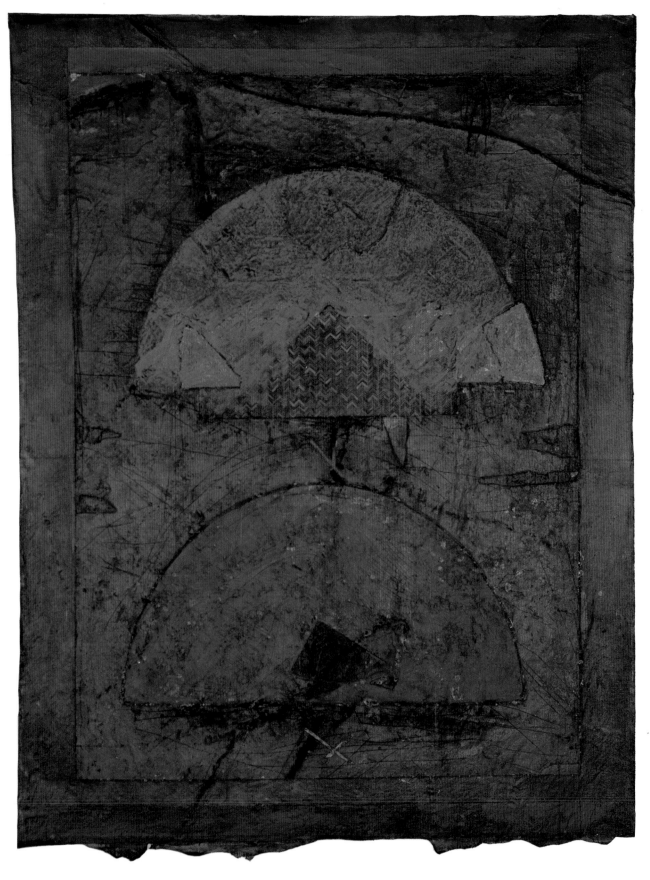

LAHORE, 1979

ACRYLIC, RHOPLEX, METALLIC POWDER,
AND TOBACCO CLOTH ON CANVAS

93 × 71 INCHES

COLLECTION PRUDENTIAL LIFE INSURANCE,
NEWARK

The question of texture, always important in La Noue's works, became more urgent around this time. In another 1979 work with allusions to India, *Benares*, texture is given a key role. Here, in an expressive abstraction, the half-circle shape is halved yet again and the two shapes are placed on end, forming a symmetrical couple, like two mythical mountains, surrounded by barely visible red circles such as one might find in a mandala. The rich purple and red tones in an elaborately textured surface, reminiscent of painted cave walls, are host to small, emphatic red triangles that establish many levels in space, many different scales, and a suggestion of an entire cosmos. This ravishing painting is not indebted solely to La Noue's memories of India. As always, various experiences are compared, perhaps intuitively. In an article published in 1979, La Noue mentioned a visit to Copan, in Honduras, the previous year, as he discussed his new palette, in which he had departed from habitual earth colors:

> I have recently begun to work with colors not associated with the earth, such as violet, bright red and yellow. In 1977 I had visited Copan for the first time. I didn't notice then the residual color on the sculpture. When I returned there in February, 1978, I was already preoccupied by the densities and contrasts of stronger colors. I noticed the residual paint, that had been visibly decayed by the mushrooms and lichen that fiercely pushed themselves through, around, and beside the red sandstone of the sculpture. It was a strange combination of artificial color, real color, and growing color. In a way it seemed to me the visual symbol of excavation.[25]

La Noue's attraction to the process of the archaeologist is expressed again and again in the titles and images of his paintings. The ideas of digging, uncovering, revealing, and above all the element of surprise inspire him and goad him into constant experimentation in his work.

Around 1980 La Noue added to his repertory of hues by using the rich possibilities inherent in graphite powder. The dusky undertones of a painting such as *Bight of Benin*, 1981, were laid in and built up in barely discernible layers. Interruptions of the surface occur with inlays like bits of intarsia. Jagged lines suggest stormy events taking place at a distance. The regularity of the straight-edged border may have been suggested by La Noue's visits to the sites of ancient Mayan ball courts, but the general feeling, or mood, of this painting is of the hidden passions resident in all

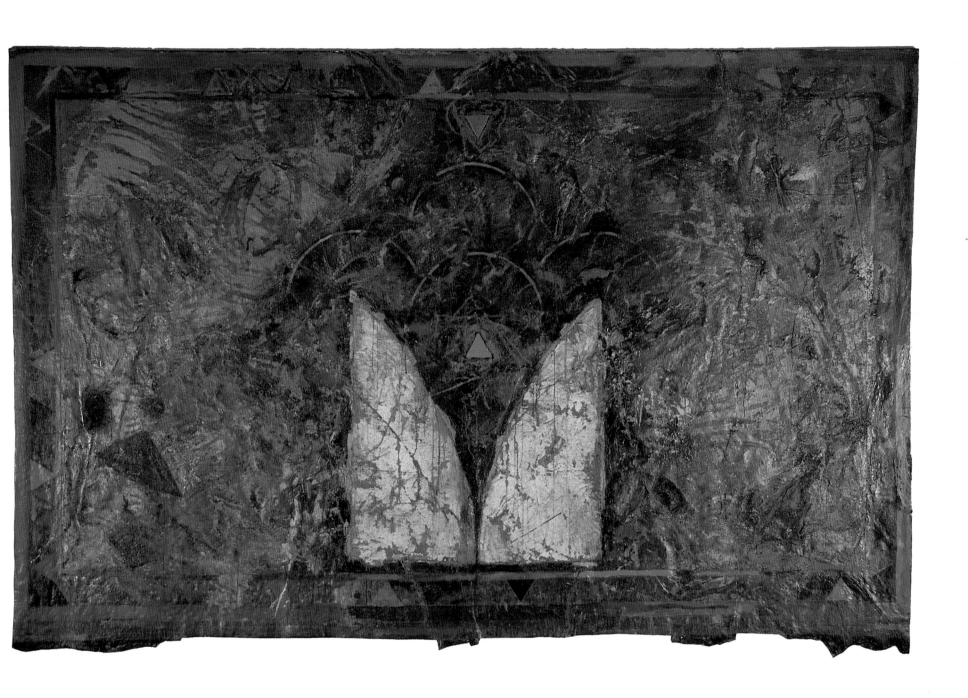

BENARES, 1979
ACRYLIC, RHOPLEX, METALLIC POWDER, AND TOBACCO CLOTH ON CANVAS
77 × 117½ INCHES
COLLECTION THE ARTIST

TERENCE LA NOUE

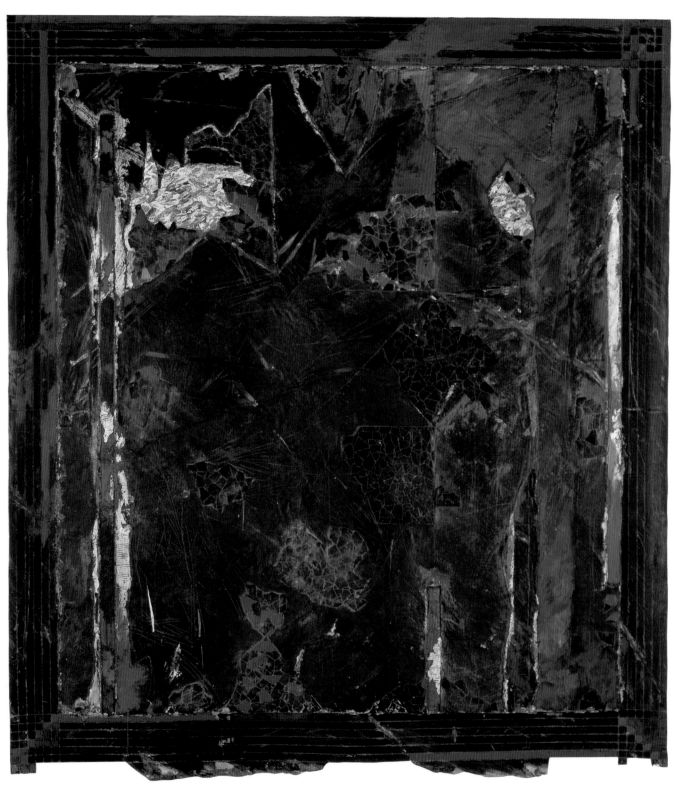

BIGHT OF BENIN, 1981
ACRYLIC, RHOPLEX, METALLIC POWDER,
AND TOBACCO CLOTH ON CANVAS
90½ × 83½ INCHES
COLLECTION SHELDON MEMORIAL
ART GALLERY, UNIVERSITY OF NEBRASKA, LINCOLN

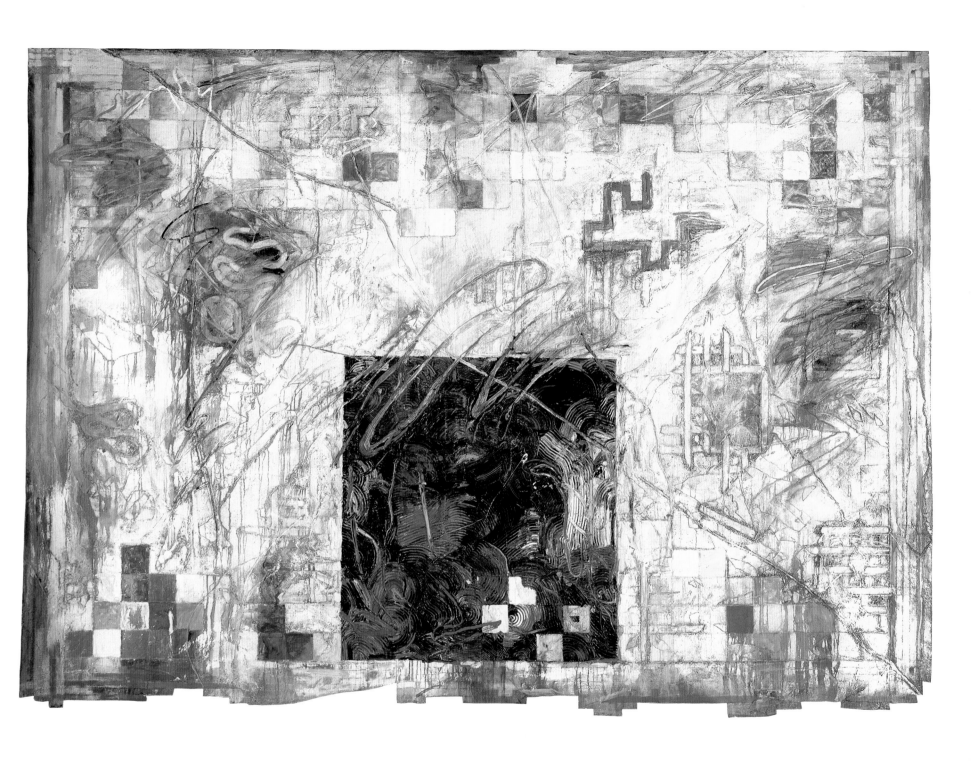

A JOURNEY TO COPAN, 1981–83
MIXED MEDIA ON CANVAS
93¼ × 131⅝ INCHES
DESTROYED

The artist in Copan, Honduras, in 1976.

mankind. La Noue's abiding interest in the character of landscape and the experience of traversing it, either on foot or from the air, grew more insistent in the early 1980s. He had always envisioned a painting from many viewpoints, and the suggestion of ground plans, diagrams, maps had often underlain his compositions. But in a work such as *A Journey to Copan* the viewer is obliged to take the same journey in several dimensions. At first glance, the grid patterns, like those La Noue had seen painted on houses of the Dogon in Africa, and in India and Nepal, appear in irregular sequences throughout this painting, often seeming to be a key to a mysterious map. Overlays of scribbled lines and fragmentary labyrinths suggest specific incidents or places and a dark square at lower center is rich in suggestions of mysterious depths. The archaeological metaphor is sustained throughout the large surface, whose elements go in and out of focus as La Noue mutes or brings up his levels of color. This painting admirably represents the nature of his seeing as he embarks on his own imaginary archaeological digs. His comments on real digs are illuminating:

> One thing that fascinated me was that if you wanted to go out looking for a place to dig, or even if you were at one of the major sites where they were excavating a hill that wasn't touched before, it was covered with organic growth—vines all over the place. Without some previous knowledge, it might be rather difficult to actually know that this might be a temple of some sort. The digging progresses; they begin to tear off materials and a highly complex structure underneath is revealed. The issue that fascinated me was the idea that underneath this portion of the landscape could be this man-made structure and design.[26]

Photographs by the artist of ruins at Copan, Honduras.

Disclosing such man-made structures and designs became an important goal for La Noue. The critic Carter Ratcliff, viewing his new work, saw that his new geometries offered endless readings. The geometries of *A Journey to Copan*, he wrote,

> which verge here and there on the labyrinthine, tangle with a
> complex pattern of curves. In this painting, the topographical
> opens simultaneously onto the architectural and the organic.
> Havens here take the form of passages that belong clearly
> neither to the right-angled nor to the curvilinear impulses of the
> images.... However one experiences these paintings, one of
> course does it by looking; yet not all looking is the same.
> Sometimes it is a lot like exploring on foot.[27]

La Noue's shifts in mood and the emphasis on the singularity of each painting can be seen in a painting completed around the same time, 1982, titled *Winterkill: Sunset*. This patently Expressionist vision is filled with nongeometric ambiguities and bursts of light that expand both within the depths of the painting and on its surface. There are many small incidents here, drawing the eye from corner to corner and up and down, but the overwhelming volatility of mood is the primary experience. This is a landscape, obviously, but with a curious perspective that forces the eye to adjust to a vertical picture plane on the left and to a horizontal plane on the right, bound by coursing serpentine lines that overcome its limits. Here La Noue has intensified the great burden of complications that so attracts him. The viewer is detained, delayed, forced to consider surfaces and textures minutely. An element of time is successfully enacted. From now on, La Noue commands a vocabulary of spatial inversions and extrapolations that definitely establishes his fundamentally stratified, archaeological point of view. Reviewing an exhibition of these works in 1983, the critic Noel Frackman sensitively summarized La Noue's special talent for multiple suggestion when he said that his work always conveyed a feeling of the veiled image,

> of the kinetic potential of a final veil that may suddenly drop
> away, somehow revealing a naked, primal truth.... The excite-
> ment of the electric potential for uncovering, the metaphorical
> and physical possibility of revealing an underlying substance of
> significant content, exists in all of La Noue's paintings. As such,
> his work parallels the depth and complexity of the human
> psyche which includes, in our present society, the separation of
> man from nature.[28]

Photographs by the artist of a building in Kathmandu, Nepal, and a Dogon house in Mali.

WINTERKILL: SUNSET, 1982
MIXED MEDIA ON CANVAS
94½ × 85⅞ INCHES
PRIVATE COLLECTION

Detail of WINTERKILL: SUNSET

7 UNMOORED FOR MANY YEARS from conventional pictorial practice, La Noue has been moving freely across all kinds of boundaries for the past decade. In the privacy of his imagination, he is a teller of tales that eventually, through hints and cues, emerge—but only dimly—in his works. Despite the generally congested appearance of some of his paintings, an underlying motif is always perceptible, giving the final unity that all painting demands. In his desire to express specific emotions (as he says, "Emotions that are aesthetic are almost a religious experience") La Noue has drawn not only upon visual experiences as he wandered through the world, but on specific adventures. These have sometimes provided materials that both incite his invention of imagery and provide "structures that in the end are right and whole." Certain procedures in his usual studio practice have enhanced this need for the right and whole. The tobacco-cloth mesh that he had begun to incorporate into his paintings years before remains a highly responsive medium for La Noue, who can use its elasticity and fundamental grid pattern to deposit an internal wholeness that often rides just beneath the final surface and sometimes appears, shadowy but consistent, even on the surface. The harmony La Noue achieves by means of juxtapositions and dissonances is quite consistent with the vision of painting suggested by Kandinsky early in the century, when he wrote: "The new harmony demands that the inner plane of a picture should remain one, though the canvas may be divided into many planes and filled with outer discords."[29]

Although many of his motifs during the past decade have still been derived from exotic sources, La Noue is firmly engaged with Western traditions. His thoughts have moved toward the questions posed by the early-twentieth-century abstract artists, who in turn had drawn upon the traditions of the nineteenth-century avant garde. Cultural foraging was characteristic of artists in the nineteenth century, when painters such as Eugène Delacroix drew inspiration from the light and color of North Africa and the Orient. Although these ventures into other climates have frequently been derided as picturesque, superficial exoticism, in reality they were the authentic actions of artists who sensed the necessity for enlarging their vision. Delacroix's paintings gained through his immersion in the movement and color of North Africa. La Noue has studied Delacroix with attention, as did Cézanne and Matisse; in his opinion, "there is a bias against anything that doesn't spring directly from the Western tradition" that has led to misunderstandings for almost two centuries. Delacroix's entry into a life that differed

greatly from that of his own upbringing was more than a sortie into the picturesque: it was a way of confirming certain fundamental insights. La Noue, when he speaks of his own exotic experiences, always stresses the necessity of comparative experience. Observing Delacroix's intense scrutiny of light, of color, of landscape and animal life outside of his native abode, he speaks of the familiar, the "things that are part of our soul." Recognition of repeated motifs and psychological intonations in widely differing cultures is essential. La Noue points to the art of ancient Irish monks, such as the *Book of Kells*, remarking: "It looks like it was made in Tibet." Such observations are the stuff of his daily ruminations, and make their way into his paintings.

A look at the paintings of the year 1984 reveals the wide range of La Noue's imagination, and the way both the lived and the imagined mingle in his work. Although he had never been to Japan, La Noue's museum experience suddenly appeared in a painting called *Bushido*. The almost chiseled central form, with its axe-blade shapes and its fully saturated contrasts of red and black, recalls the angular costumes of the Kabuki and the art forms of the samurai. This emphatically Japanese shape sits astride a wayward map of some faraway place traversed by paths that lead the eye far afield, always to return to the central form. The strong emphasis on the edges must have suggested the title, and even the feeling that dominates the work. Bushido, the way of the warrior, is a stern ethic, an unbending philosophy that gained great currency in Japan during the medieval period. Daisetsu Suzuki links it with Zen:

> The soldierly quality, with its mysticism and aloofness from
> wordly affairs, appeals to the willpower. Zen in this respect walks
> hand in hand with the spirit of Bushido.... The fundamental
> intuition the Zen masters gain through their discipline seems to
> stir up their artistic instincts if they are at all susceptible to art.
> The intuition that impels the masters to create beautiful things,
> that is, to express the sense of perfection through things ugly
> and imperfect, is apparently related closely to the feeling for
> art.[30]

La Noue was obviously pondering the issue of the ugly and imperfect, and perhaps the conundrums of Zen, in 1984. His way of freely associating, through shape and color rather than a literary idea, brought the Bushido spirit into yet another group of works, these based on living experience. Several paintings and drawings, under the general title *Varieties of Coral*, cluster around a terrifying experience La Noue had while scuba div-

ing in a coral reef, in which he nearly touched catastrophe. His memory of the crustaceous skeleton of this compound creature called coral holds both menace and beauty. The sapphire blue lights within the waters flicker toward darkness as danger approaches. The deceptive, swaying, treelike structure is at once appealing and disturbing. To this group of works La Noue appended subtitles alluding to his emotional state while in the throes of a specific experience of a coral reef; one of these is *Varieties of Coral: Zen Deliverance*. Recalling his experience, La Noue told Ellen Lee Klein:

> The actual forms that at one level and one time had been quite beautiful and exotic became quite dangerous and life-threatening. In some respects, the coral, which is a living organism but has no land-based relationship to anything, became almost a protagonist in the story.[31]

This protagonist, so gorgeously colored and so treacherous, is juxtaposed, in *Varieties of Coral: Zen Deliverance*, with the firm and equally menacing shape he had devised in *Bushido*, in a crossover typical of La Noue's imagination.

The somber realities of an underwater exploration, with all its mythic overtones, are conjured in another painting from the series, *Varieties of Coral: Transfiguration*. Here, the qualifying subtitle suggests a Western iconography, but the spirit of Bushido lingers in a dark subordinate form enclosed in a sheath of coral mesh. Although coral was part of a lived experience, La Noue's interest in biology has often led him to explore natural forms. But his curiosity doesn't stop there. After he had painted his nightmare of coral, the creature remained in him, and his curiosity about it grew. Seeing a Renaissance painting containing the image of a stalk of coral, he asked his friend Catherine Hoover its meaning; he cherishes the note she sent him, providing the mythical background of coral, and its iconography:

> According to Ovid, coral was a kind of petrified seaweed formed at the instant Perseus laid down the Gorgon's head, after rescuing Andromeda from the sea-monster. The Mediterranean red coral . . . was believed by Romans and [in] the Middle Ages to have healing properties and the power of averting the attentions of the "evil eye." It was often hung around children's necks as a protection. It is seen in this sense usually as a string of beads, in pictures of the Virgin and Child. A necklace of coral is an attribute of Africa personified, one of the four parts of the world.[32]

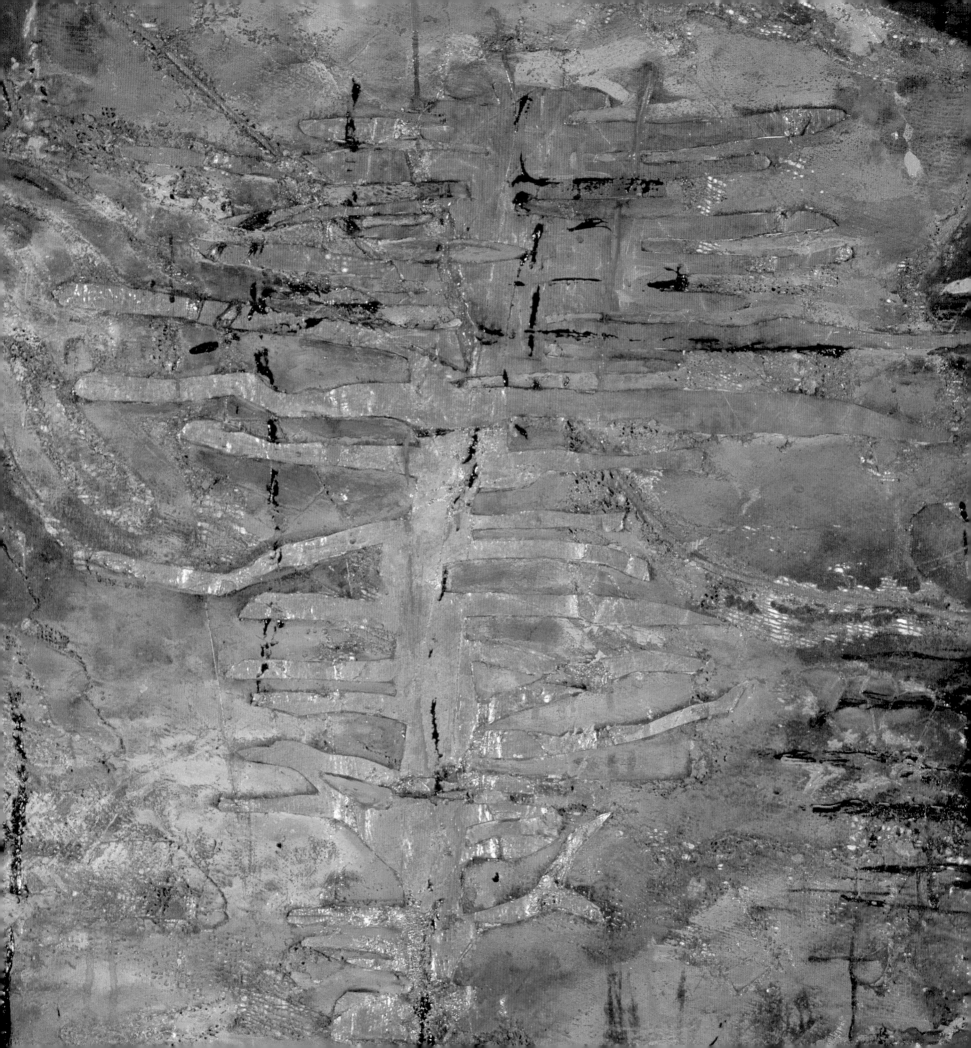

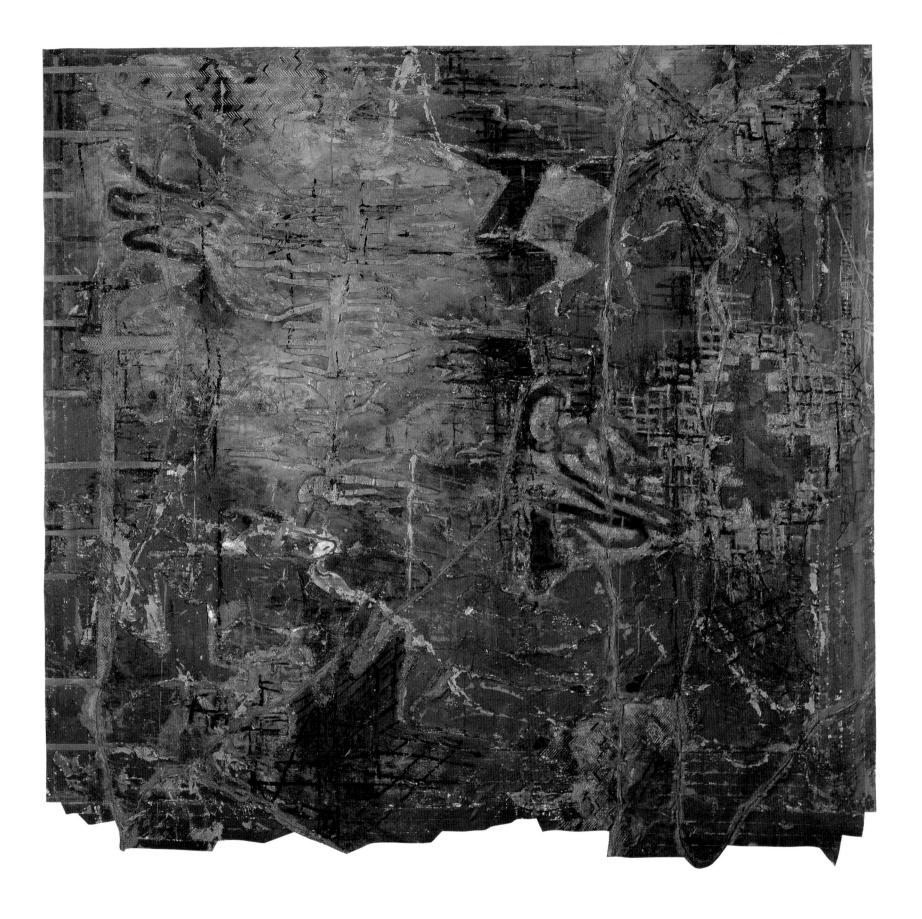

VARIETIES OF CORAL: TRANSFIGURATION, 1984
ACRYLIC, METALLIC POWDER, AND OTHER MATERIALS ON CANVAS
70¼ × 73½ INCHES
PRIVATE COLLECTION

Detail of VARIETIES OF CORAL: TRANSFIGURATION

Two other paintings based on personal thoughts, and holding implicit stories beneath their abstract surfaces, are called *Problems of Government: The Palace* and *Problems of Government: The Desert*. They refer to La Noue's thoughts about the Third World, and specifically about India. Once the hint is given, it is not difficult for the viewer to associate the vivid images in the painting subtitled *The Palace* with the splendors of the Indian capital and the dark underside of contemporary Indian life, which, as he says, has all the equipment of the modern era and yet is ruled by beliefs rooted in the tenth century. How is such a place governed? His questions are posed in the painting's small incidents, in its dusky ground, and in the unmistakable palatial ambiance, recalling inlaid floors and decorative detail.

Not all the tales told in the paintings of 1984 are so directly derived from personal experiences. Sometimes, as in the case of *Prophecy of Gordius: The Solution*, the story emerges after it is told, or at least becomes specific. In the course of composing this painting, investing the lightly scored, adobelike ground with his habitual symbols, La Noue found that the labyrinth he had constructed suddenly seemed to have no exit and to resemble a knot. This sent him directly to the story told of Alexander the Great, who "solved" the problem of the Gordian knot with his sword. From this painting on, both the sword (which of course can also be associated with Bushido) and the knot have remained in La Noue's vocabulary, to be used with still other associations. The titles of these works of 1984 may be seen as key signatures in music, rather than as iconographic indices: they augment the spirit of the work, but do not entirely define it.

8 I regard my paintings as being very much physical expressions; they're very physical paintings. I have tremendous interest in tactile qualities and they continue to be, in my mind, very much objects, not simply painted surfaces with illusions on them.[33]

While La Noue continued, in 1985, to think of his paintings as "very much objects," his works were moving ever closer to painterly illusion. The topographical aspect of earlier work was now subverted by an increasing interest in suggesting depth by means of illusion. Taking back a primary lesson

VARIETIES OF CORAL: ZEN DELIVERANCE, 1984
ACRYLIC, METALLIC POWDER, AND OTHER MATERIALS ON CANVAS
89 × 91¼ INCHES
COLLECTION THE ARTIST

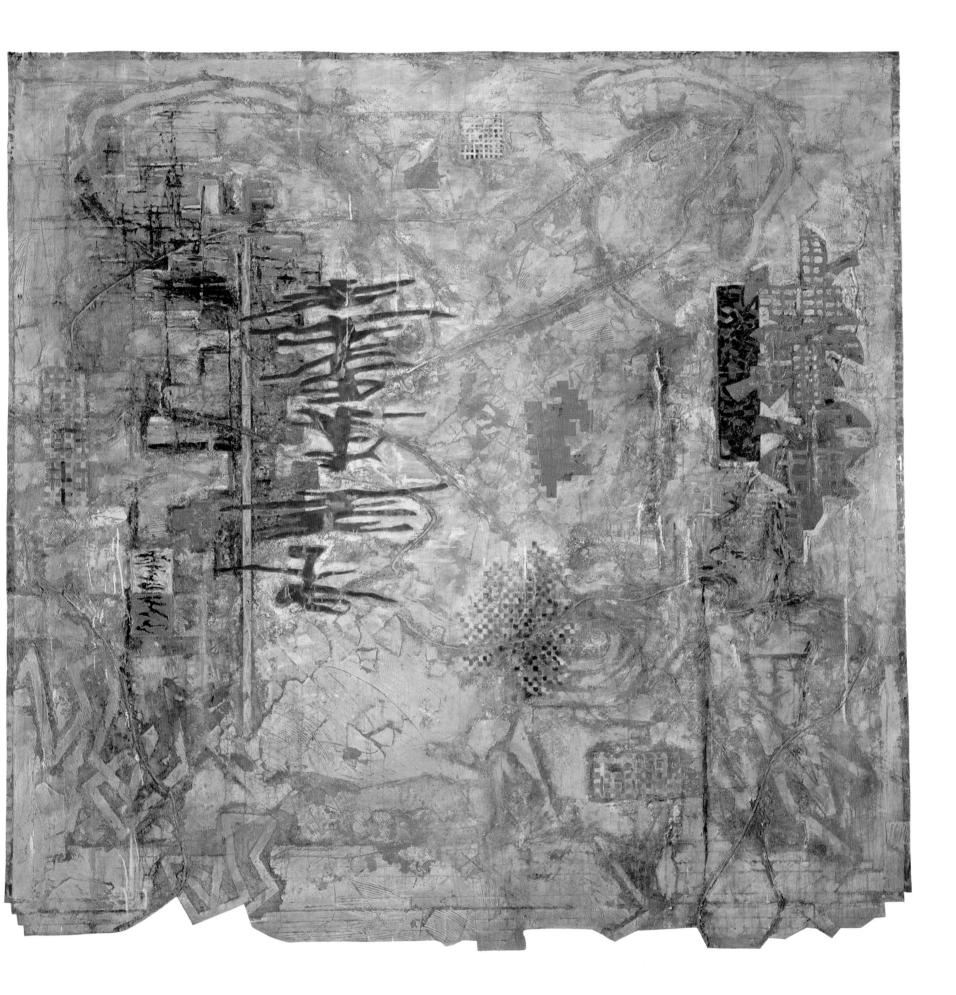

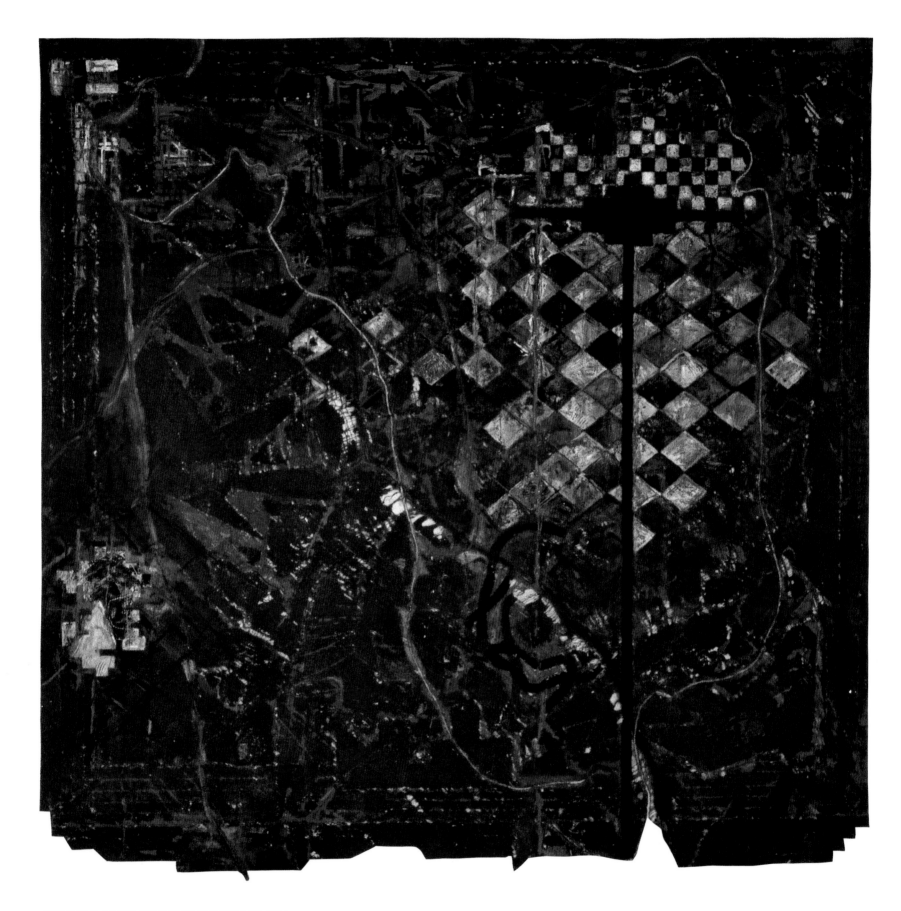

PROBLEMS OF GOVERNMENT: THE PALACE, 1984
METALLIC POWDER AND MIXED MEDIA ON CANVAS
72 × 73½ INCHES
COLLECTION SOLOMON R. GUGGENHEIM MUSEUM, NEW YORK

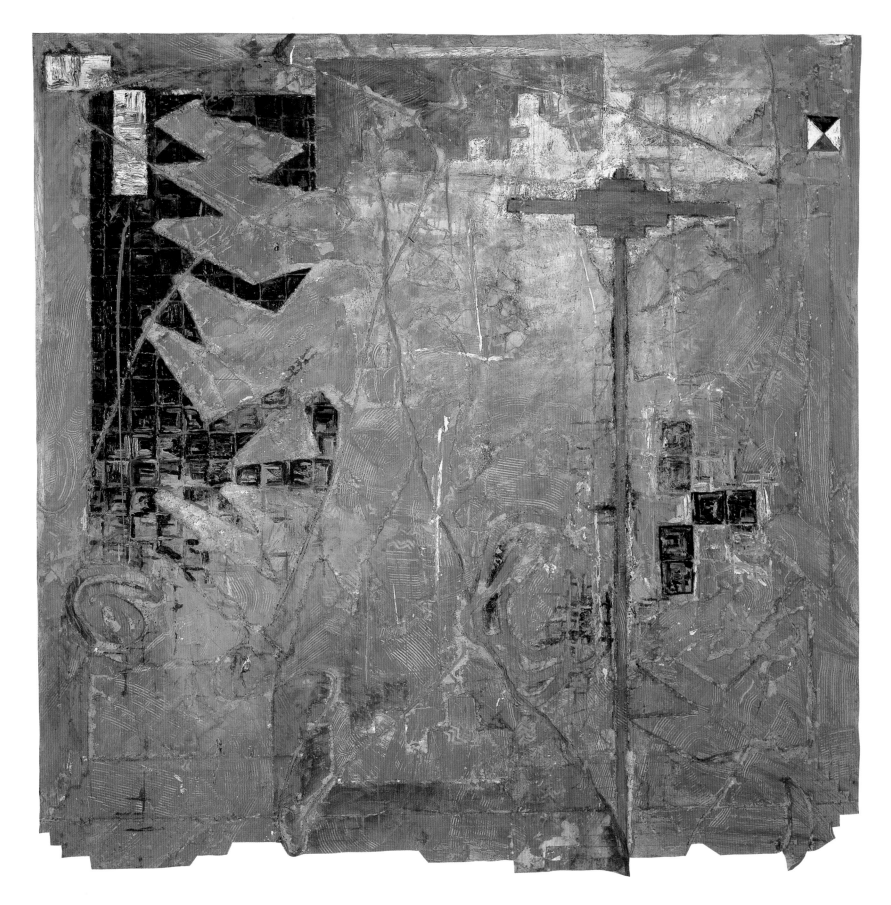

PROBLEMS OF GOVERNMENT: THE DESERT, 1984
ACRYLIC, METALLIC POWDER, AND OTHER MATERIALS ON CANVAS
72¾ × 73⅝ INCHES
PRIVATE COLLECTION

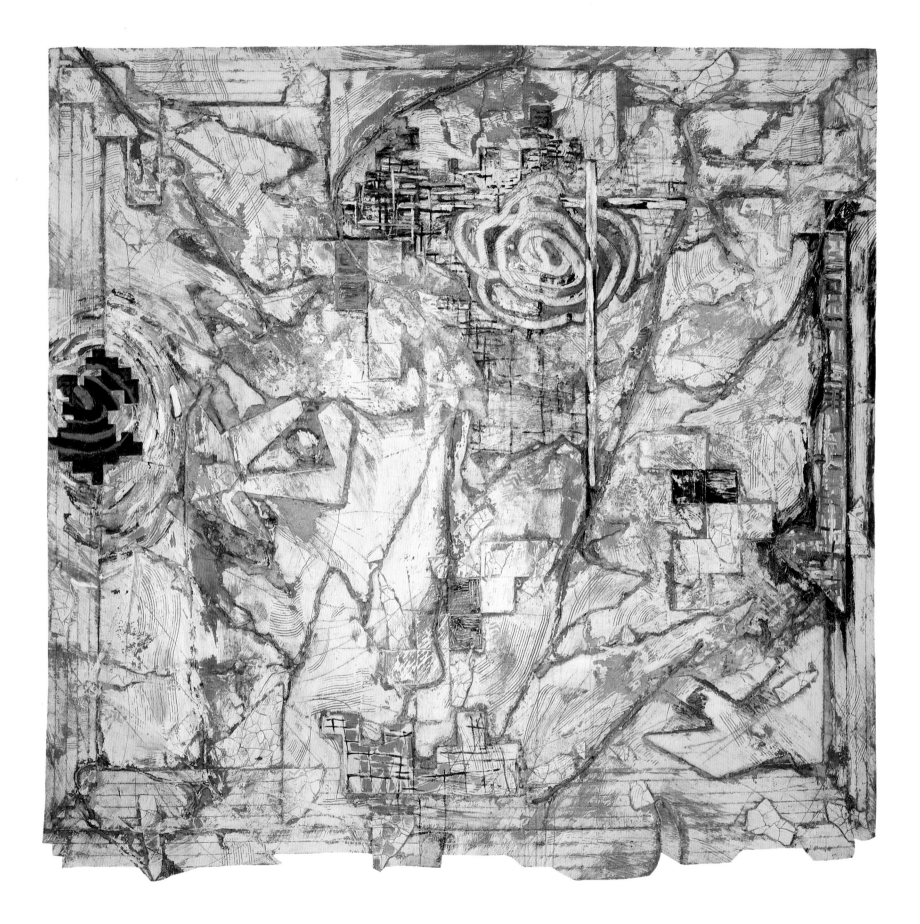

of Western painting—that line and color can suggest, rather than transcribe, tangible spaces—La Noue began to draw mystifying objects in perspective. He did not leave behind his already reflexive symbols, such as the labyrinth, the circle, the pyramid, and the triangle. He merely delegated to them a secondary function. His intention remained the same: to ensure that the viewer scan his surfaces inch by inch, moving from mood to mood and texture to texture, in frequently disrupted sequences, toward an image that becomes syncretic only in time. It should be stressed that La Noue had not departed from his early convictions. He, like Bacon, intended that the physical effects, the "paint which conveys directly," as Bacon put it, be of prime importance and work first upon sensation. Painting should be perceived first in its own terms. La Noue has no interest in the postmodern, intellectualizing concept of art that insists that a painting is a text and must be "read." The affective properties of painting cannot be coded. By retrieving perspective of a Western kind, in which forms seem to diminish as they recede from the plane, La Noue gave way to a desire to invest his works with still more; to encompass an even broader range of experience.

In works of the next few years there are notable allusions to certain Western motifs, as well as dark indications of troubling thoughts. In 1986 La Noue painted *River Styx*, a Dantesque schema with glints of fire, sharp disruptions, and direct references to classical Western preoccupations in the primitive rendering of Ionic capitals and columns. The seething activities of colors and shapes remind us of the feared netherworlds that haunted the artists of other cultures La Noue had previously studied, but here have Western sources. Hell, said Origen, is the lack of cohesion.

The hellish aspect of modern existence is stressed, as well, in a painting of 1989–90, *Gemstone: Strange Fruit*. La Noue had studied the structure of gemstones for several months in 1989, drawing their faceted likenesses until they metamorphosed into shapes like skulls. This painting is full of portentous events, even in the shards and mosaics in its depths, and expresses La Noue's preoccupation with existential tragedy. It was inspired by the haunting song, delivered by Billie Holiday, called "Strange Fruit," which had set La Noue on a trail of associations, from thoughts of the economically depressed areas from which such songs emerge to images of the mineral called coal and its dark interior, to the terrible resemblance to a skull he had arrived at in his freehand studies of the properties and structure of the gemstone. From a literal mineral to a symbol—this is a route that in La Noue's working life is very direct.

OPPOSITE:

PROPHECY OF GORDIUS: THE SOLUTION, 1984
ACRYLIC, METALLIC POWDER, AND OTHER MATERIALS ON CANVAS
71¾ × 73¾ INCHES
PRIVATE COLLECTION

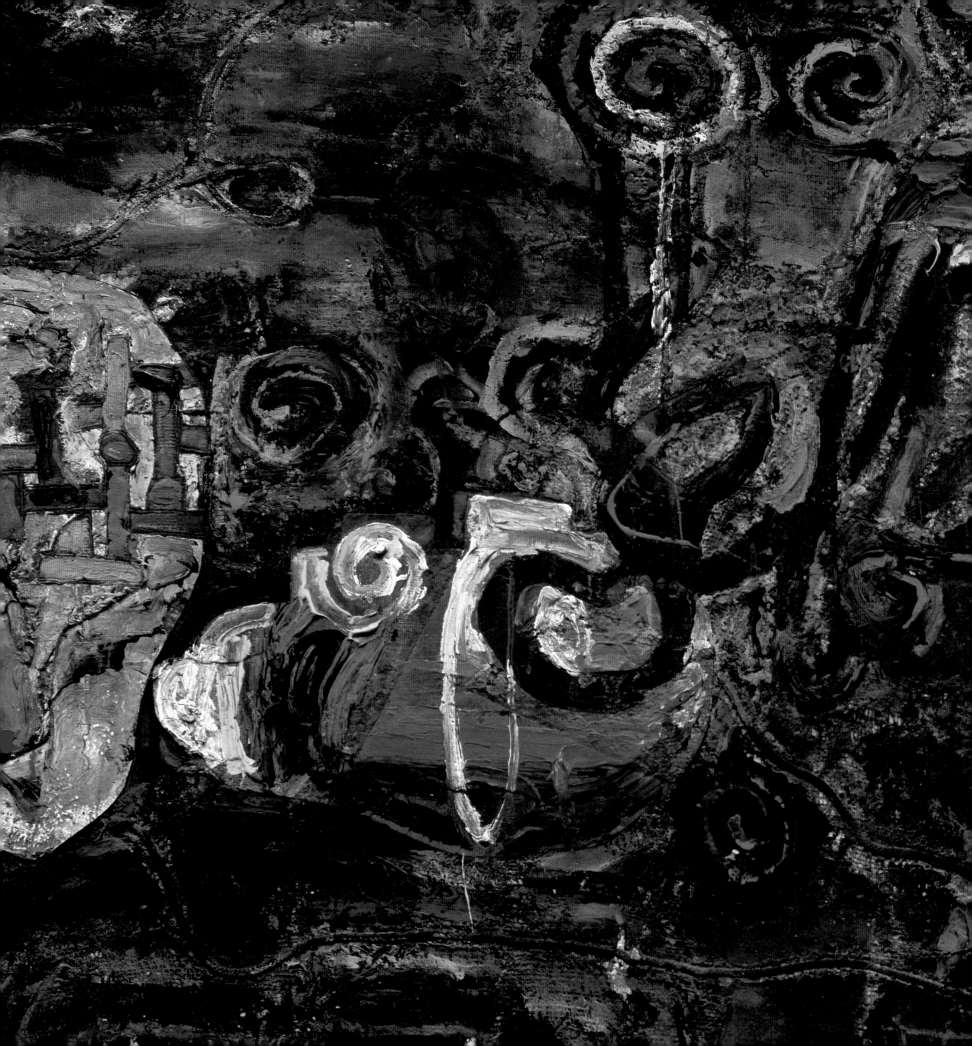

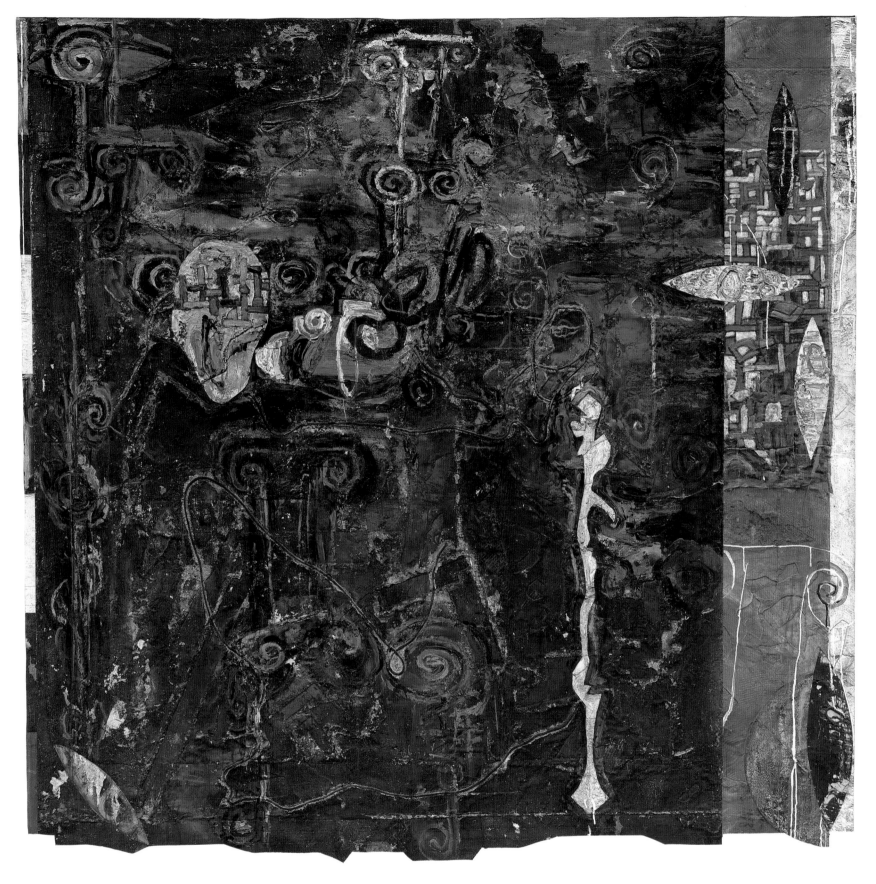

Detail of RIVER STYX

RIVER STYX, 1986
ACRYLIC ON CANVAS
77 × 80¼ INCHES
COLLECTION THE ARTIST

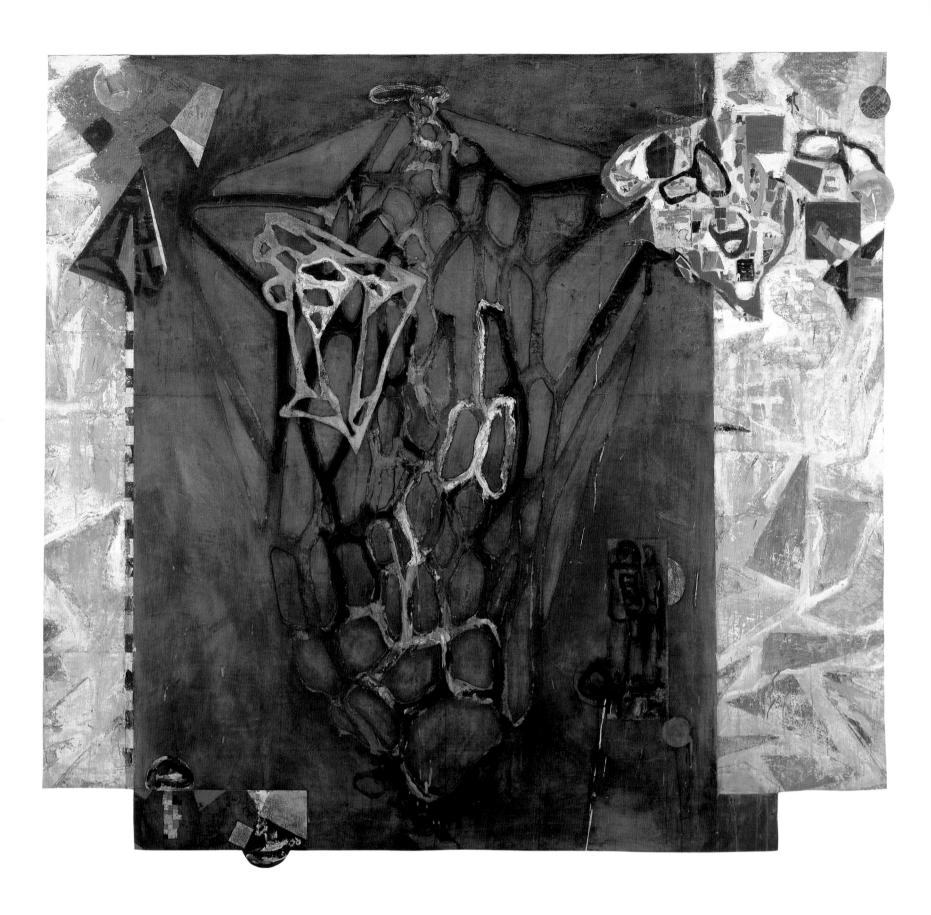

GEMSTONE: STRANGE FRUIT, 1989–90
MIXED MEDIA ON CANVAS
86¼ × 92½ INCHES
COLLECTION THE ARTIST

Lack of cohesion became a formal virtue in two extremely large paintings La Noue undertook in 1988–90. That is, fundamental structure was designed in a polyptych format in such a way that discrete sections were emphasized. The larger of the two, *Extraordinary Possibilities: Harrowing Complications*, is more than sixteen feet long and cannot be taken in by a viewer all at once. Its four panels each have self-contained dramas that are ultimately assimilated as a single painting. Perhaps La Noue's early impressions of multipaneled German altarpieces suggested the scheme. Certainly another German impression—one that had very broad formal consequences in subsequent works—contributes substantially to the power of this work: that of spiraling stone stairways in a small medieval castle in southern Germany. These marvelous spiral staircases, hewn by hand from unyielding stone, not only inspire awe, but bring into play countless associations. The spiral is one of the fundamental symbols of mankind, used by ancient artists and moderns as well. Its implications are legion. It winds through the psyche, calling up natural forms, such as the chambered nautilus (which La Noue had also begun to consider around this time), with its splendid, arcane geometries and symbolic associations. Most of all, it shapes a way of creating, for as a stairway is ascended or descended, the viewpoint always changes. Such broad associations are endlessly stimulating. Authors such as James Joyce and T. S. Eliot have drawn upon the spiral in the winding-stair motif, with its many levels of potential meaning. For La Noue, the discovery of the endless transformations implicit in the very shape was the means by which he reincorporated perspective into his work. In the right panel of *Extraordinary Possibilities* the shape of the stair fans out in several arresting variations, billowing here, sliding there, moving into curvilinear, rounded forms seen from above and below. The motif is repeated in the largest panel, this time in a clatter of red, white, and yellow forms splayed like a deck of cards. Throughout this painting there is an alternation from chaos to wholeness, as the title suggests. It is of incidental interest that in it La Noue was responding to the tremendous upheaval and change in Eastern Europe between 1988 and 1990.

The sensation of painted, rather than molded, three-dimensional forms is even stronger in the other major work of 1988–90, *Castle of the Winds: Atlantis*. A resplendent work with powerful motifs, this tripartite painting has a strong rhythm that, while syncopated and even broken, finally achieves consonance. A certain rigor is invoked in the clean lines of all the panels' edges, interrupted only by a single circular shape extending out of the lower boundary of the central panel. Containment, as painters have

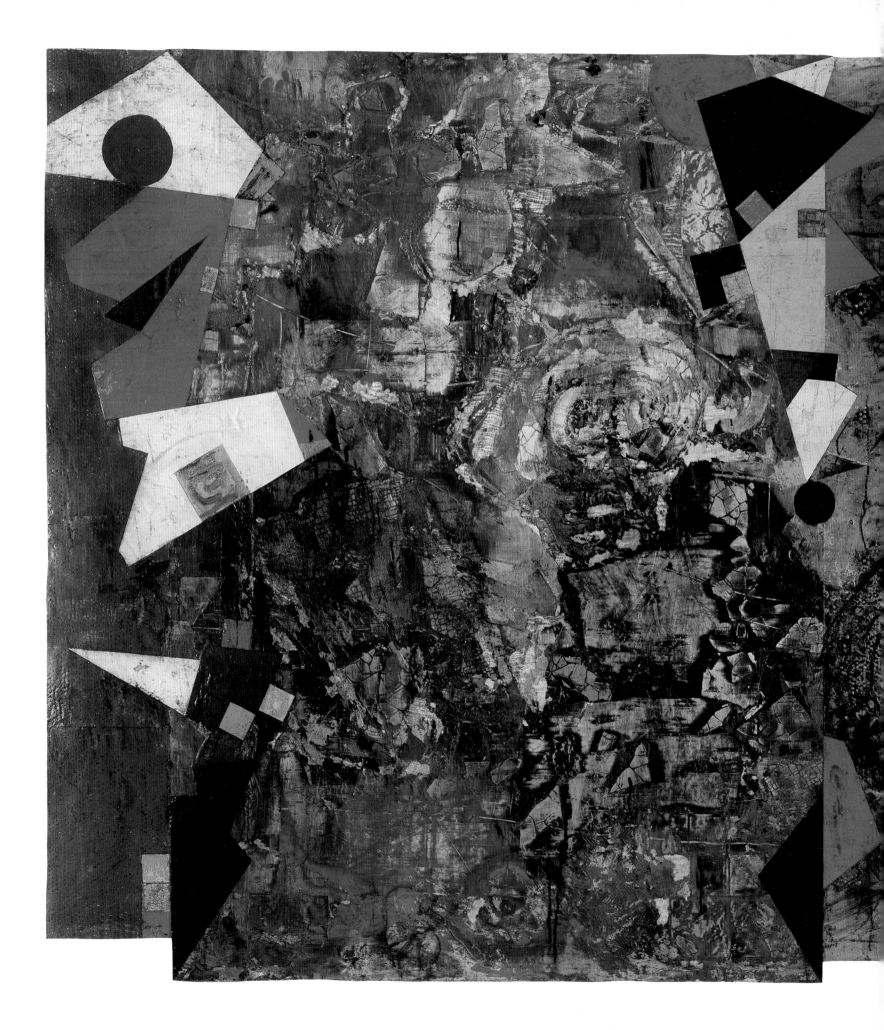

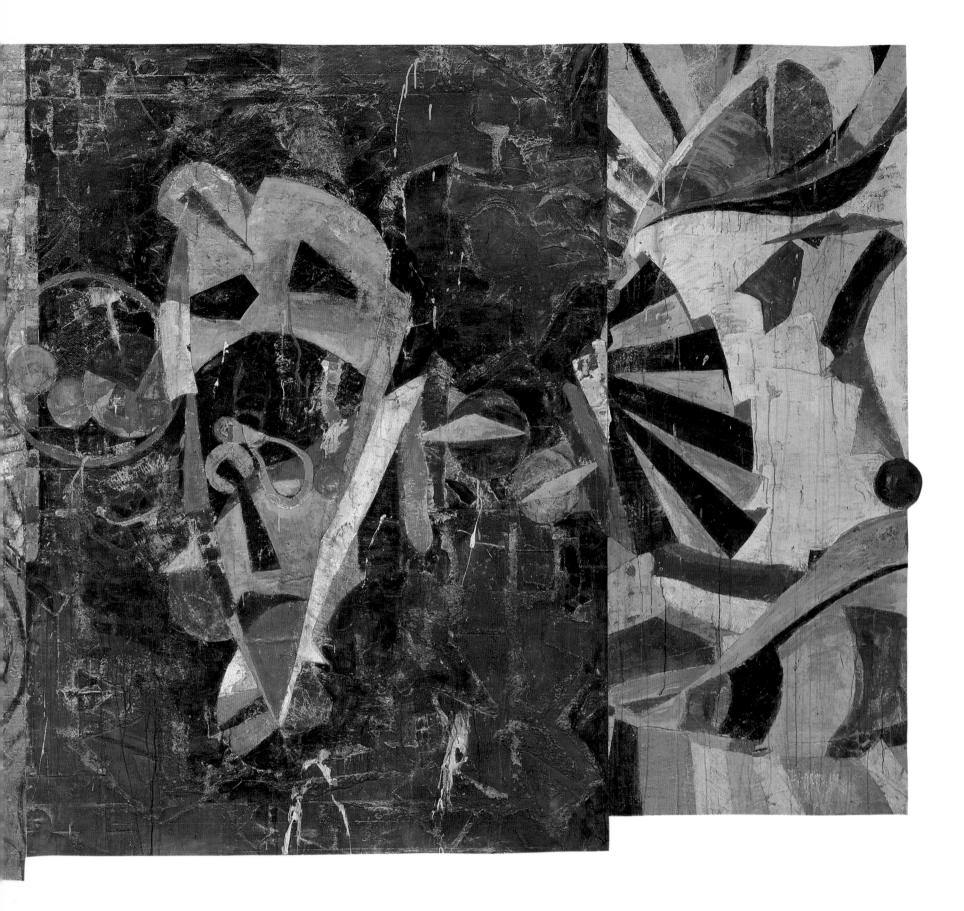

EXTRAORDINARY POSSIBILITIES: HARROWING COMPLICATIONS, 1988–90
MIXED MEDIA ON CANVAS
89½ × 198 INCHES
AHMANSON COLLECTION, AHMANSON COMMERCIAL DEVELOPMENT, OAKLAND, CALIFORNIA

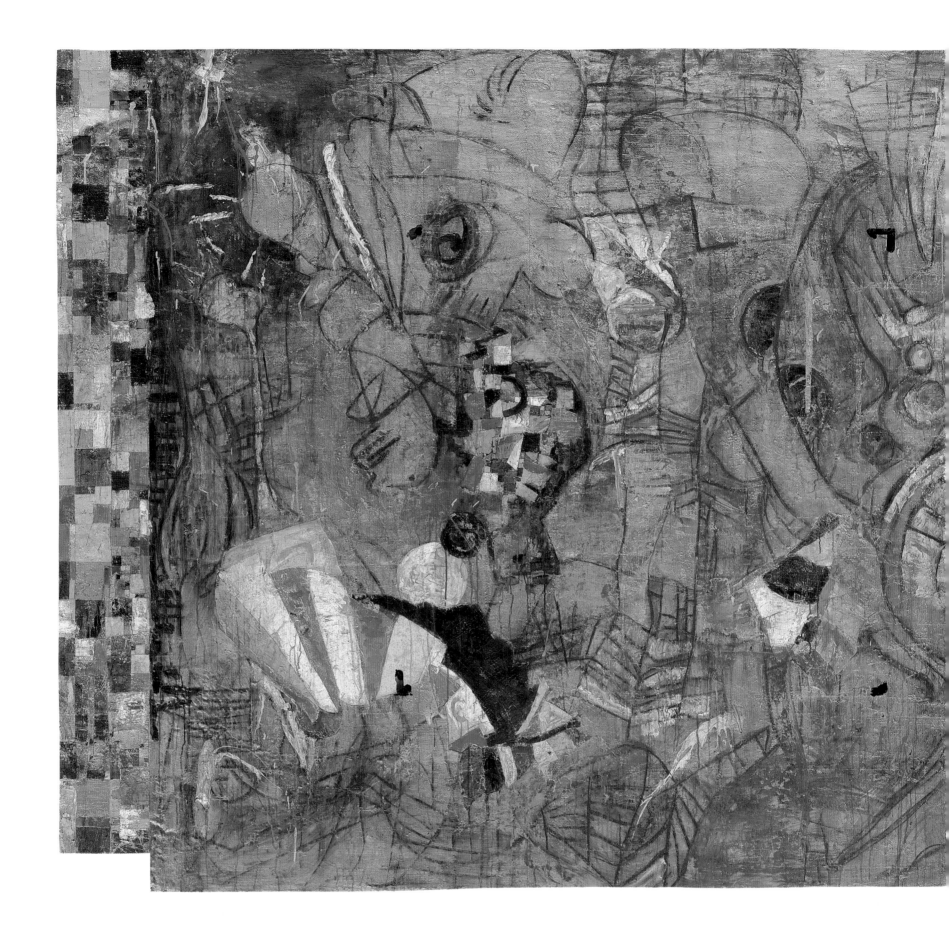

Detail of EXTRAORDINARY POSSIBILITIES: HARROWING COMPLICATIONS

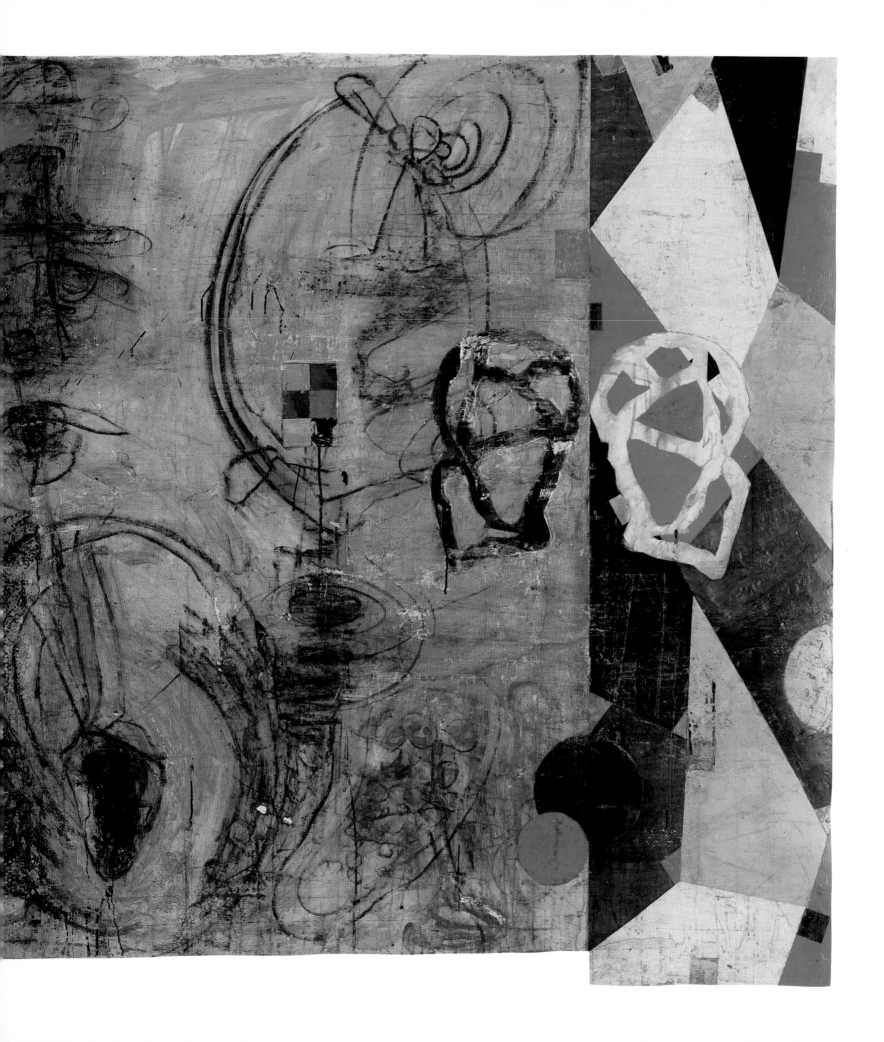

often argued, lends power to internal forms: in this work La Noue decisively insists on the importance of the painted image when he aligns his borders and repeats geometrical shapes along their edges. Even here, however, it is not a single tradition that he invokes. At the time when he was working on these large compositions, he was reconsidering the art of the East, specifically the art of Japan:

> Sliding screens offer [an] inherent potential for secrecy. To function properly they cannot be completely opened to reveal the full potential of the room, so some aspects have to be imagined so as to complete our understanding of the entirety. Recently I've tried to use panels (screens) in the paintings to suggest this kinetic potential for concealment. But it is possible to *imagine* an event or action that has been obscured by the screen for the sake of privacy or for other reasons of non-disclosure.[34]

The character of *Castle of the Winds: Atlantis* enforces this screening process. The sharp vertical divisions between each of the panels suggest that each rides behind the others. Moreover, the strong forms derived from the spiral metamorphose into striped spindle-shapes that at once project into space, thanks to their modeled, rounded flanks, and retreat into a mazelike ground. Color functions much as it does in the great Japanese screen paintings of the Muromachi period: La Noue uses gold-hued powder to heighten certain areas, just as the Japanese used gold both to keep forms close to the picture plane and to diffuse interior light. An increased feeling for the burnished surface—La Noue has almost returned to the Renaissance glaze here—gives the painting luster and the effect of a patina, lending it the prestige of time. Perhaps Zen memory is at work as well in the linear traces—all the secret "paths" that the initiate must traverse to reach satori, enlightenment. Without abandoning any of his most cherished signals—the gemstone, the grid, the spiral, the circle, intarsia, ridged reliefs—La Noue has charged this painting with new pictorial energies that unite in the mind's eye with unforgettable intensity.

Between 1988 and 1990 La Noue produced a wealth of paintings in this mode—richly colored, tactile, and large-scale. Some were multipaneled, others divided into sections in various ways. A number were works he had developed over several years, from as early as 1986. They are distinguished not only by their brilliance of tone, but also by their titles, evoking the fairy tale, the myth, the epic.

The incorporation of many perspectives in the works of this time was modified by La Noue's extensive experimentation in both drawings

OPPOSITE:

CREATING ANCESTORS: LACK OF COMMUNICATION, 1988
MIXED MEDIA ON CANVAS
66¼ × 123 INCHES
PRIVATE COLLECTION

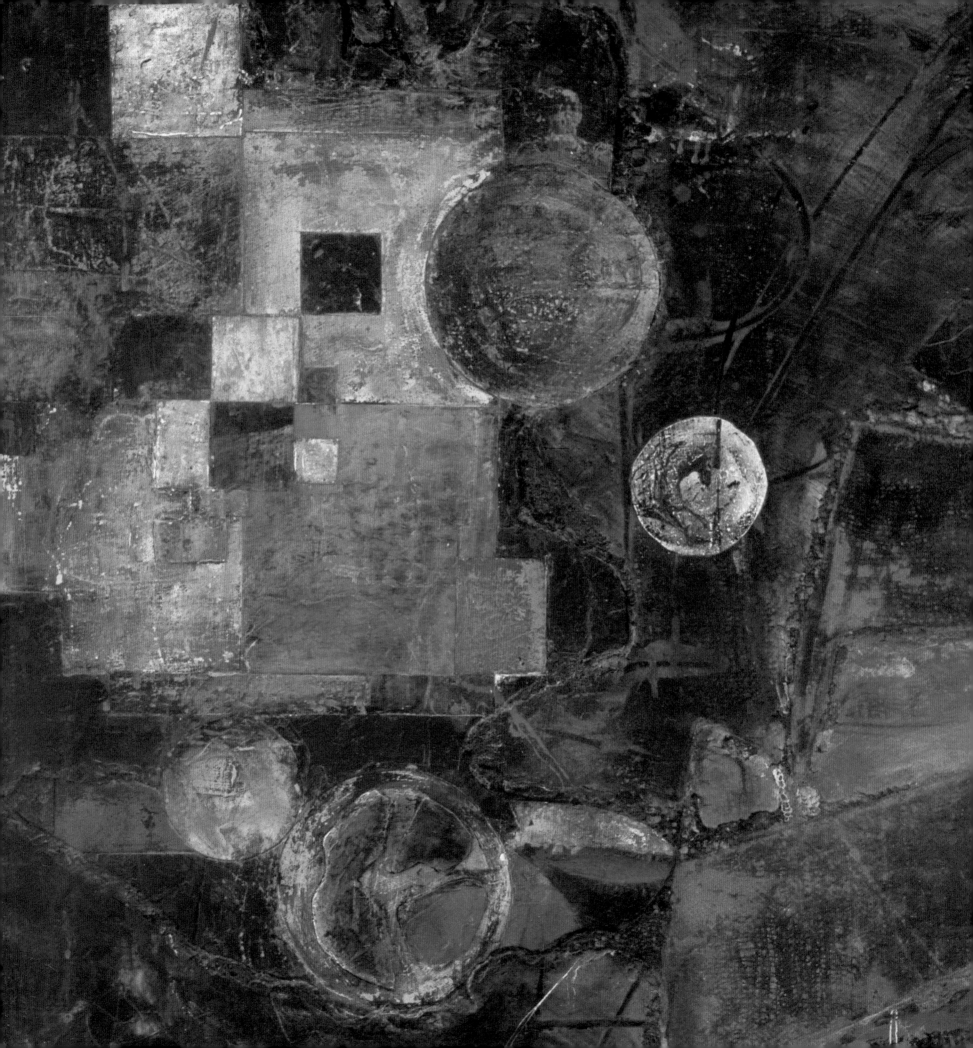

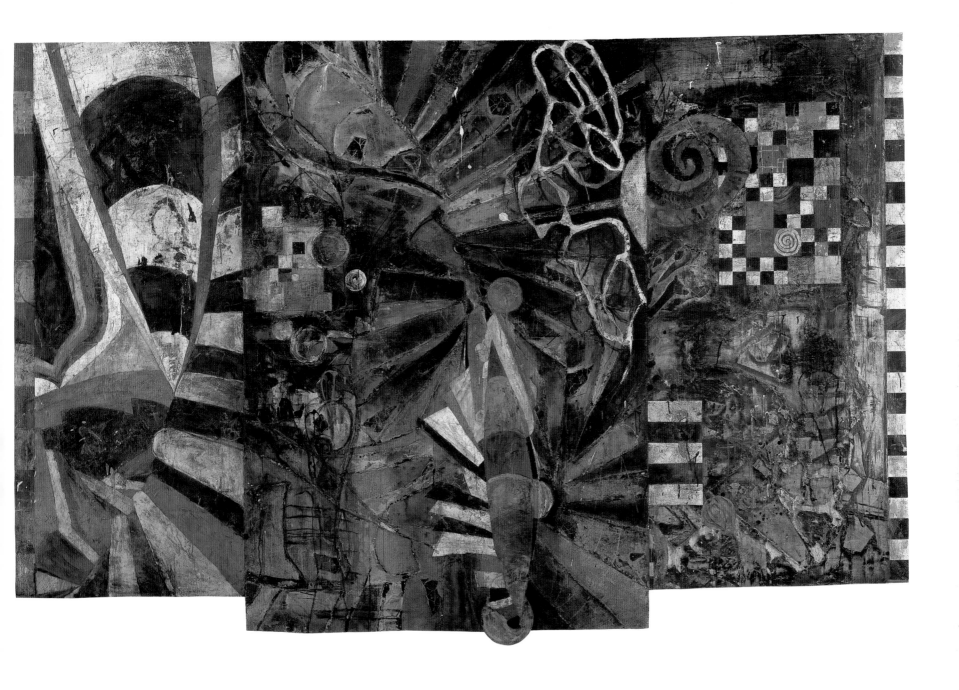

CASTLE OF THE WINDS: ATLANTIS, 1988–90
MIXED MEDIA ON CANVAS
86½ × 131½ INCHES

and prints. Using elaborate printing techniques, he explored the ideas of juxtaposition and disjunction by inserting vignettes of straight drawing within rich, sometimes overcharged compositions. The technique of engraving, congenial to this painter, who in any case worked in reverse by casting the supports for his paintings first in a mold, amplified La Noue's vocabulary and fed back into his painting. Like the Zen gardener, he was now absorbed by the principle of hide-and-reveal.

La Noue's experience with the various printing techniques starts with his knowledge of past masters such as Rembrandt and Picasso, who, as he says, picked up an instrument and became absorbed with what it could do. He has worked with the engraving tool to produce almost classic line drawings, which he sometimes inserts into other works, either printed or drawn on paper, and he knows the great range of colors and textures available in the classical lithograph, using the particular characteristics of a stone surface. But his natural impulse is to push beyond the conventions. In this he has been encouraged by the master printer Kenneth Tyler, of Tyler Graphics, in Mount Kisco, New York. At Tyler's extraordinary workshop La Noue found hundreds of aids to his restless formative instinct. Tyler has perfected machines for printing, has invented many new mechanical devices that facilitate new effects in printing, and has elaborated the art of paper making, evolving new printing forms from the suggestive procedures in the pulping technique. He has found an infinite variety of ways to tint pulp to an artist's specifications, and to devise paper textures that suit an artist's vision. La Noue was greatly excited by the plethora of new techniques available at Tyler's studio. Moreover, Tyler is a collaborator who revels in challenges. In 1987 La Noue produced the Ritual Series, in which he approximated the effects in his paintings with print techniques. Collaging, overprinting, embossing were procedures so close to his painting rituals that La Noue was able to forge ahead with Tyler in a fever of invention.

More recently, La Noue has embarked on another project with Tyler, this time working toward a pictorial clarity of a very special kind. In these prints incidents ride on the surface of the paper or sink, literally, into its very substance. He allows his etched lines great latitude as they plough through richly composed papers. He uses sections of plates to indent their contours so deeply that they appear to carve the paper. Each time he pulls a proof, sometimes of a detail to be collaged, La Noue finds something to suggest a further variation. The very elaborate procedures of the art of the multiple impression are peculiarly apt to incite shifts in his visual imagination, setting him off on a quest for different effects and, in some cases, new imagery. Since there are no limits to the way Tyler conceives of the art of

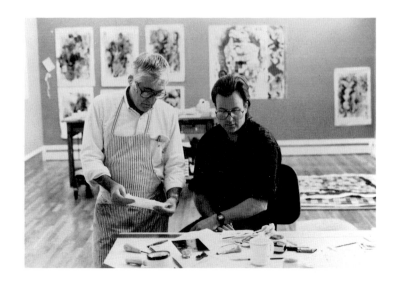

Ken Tyler and Terence La Noue at Tyler Graphics Ltd.

the print, La Noue is able to experiment happily in the Mt. Kisco studio, achieving enormously complicated spaces, through collage and relief printing and novel color effects, both in the specially prepared papers and through manipulation of printing inks.

The artist has also worked extensively with the Experimental Workshop in San Francisco, where he explored the art of the monoprint. Many of his more daring juxtapositions of fully saturated colors were first discovered as he developed surfaces in his monoprints.

9 IN 1989 LA NOUE was challenged by a task that forced him to consider painting to fit a given space. He was approached by the Barnett Bank of Jacksonville, Florida, to create a mural for the space behind the tellers' counter. Nothing in La Noue's character would seem to fit the notion of art for banks, which is usually as cleanly efficient as banking is supposed to be. For him, the commission represented an unusual opportunity to work in a large scale and for a permanent location and he set to work with an intensity that is visible in the final painting, installed in late 1990. There was little foreign to him about the Florida assignment. The tropics had long been a part of his visual repertory. It was a natural transition, iconographically, from his recent works to the Florida creation, titled *A Journey through the Tropics*. La Noue's journeys are always compounded of the interior voyages of his fertile imagination and the specific memories of real journeys. For Jacksonville, he imagined a central panel and two side panels in which motifs familiar to any denizen of Florida were stated in themes and variations.

In the Florida painting, La Noue's vision of theatrical space and his view of himself as a director who controls all the elements are superbly realized. Color becomes his voice, or instrument, and space his stage. A musical analogy can be employed for the ensemble of three panels: La Noue's deep interest in music is based on the idea that music "gives mood a focus" and creates "a resonance of moods." In this triptych of diverse images and sensations there is a distinctly musical rhythm, with the two side panels, like sheets of a score, bordered by key signatures, and a resonance of moods in the shifts from tonality to full chromaticism.

The imagery of the Florida painting is decisively drawn from La Noue's close attention to nature and reflects his perpetual need to be in touch with living, growing form and shifting atmosphere. "When I am stuck, I often look to biology or zoology for my subject matter," he says,

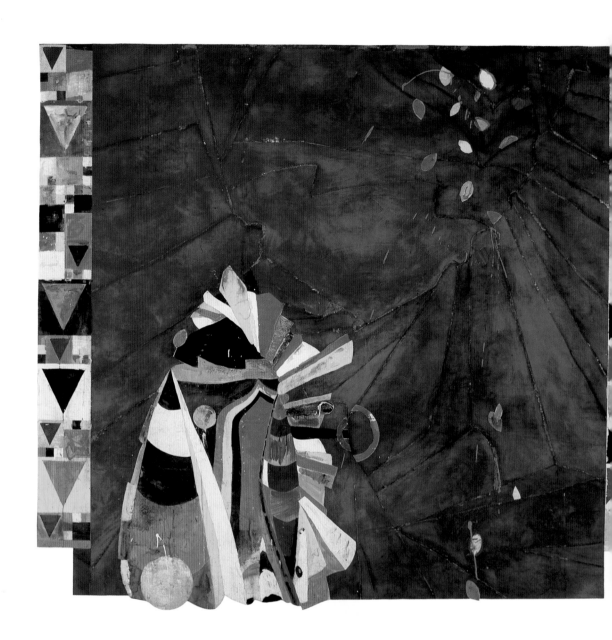

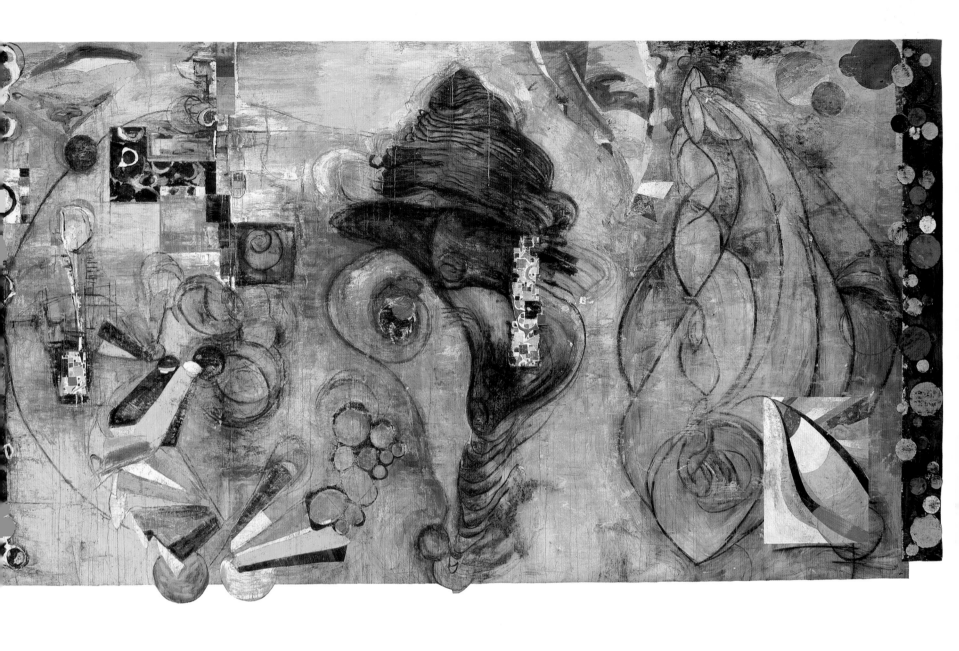

A JOURNEY THROUGH THE TROPICS, 1990
MIXED MEDIA ON CANVAS
LEFT PANEL, 121 × 133 INCHES; CENTER PANEL, 122 × 221 INCHES; RIGHT PANEL, 121 × 131 INCHES
COLLECTION BARNETT BANKS, INC., JACKSONVILLE, FLORIDA

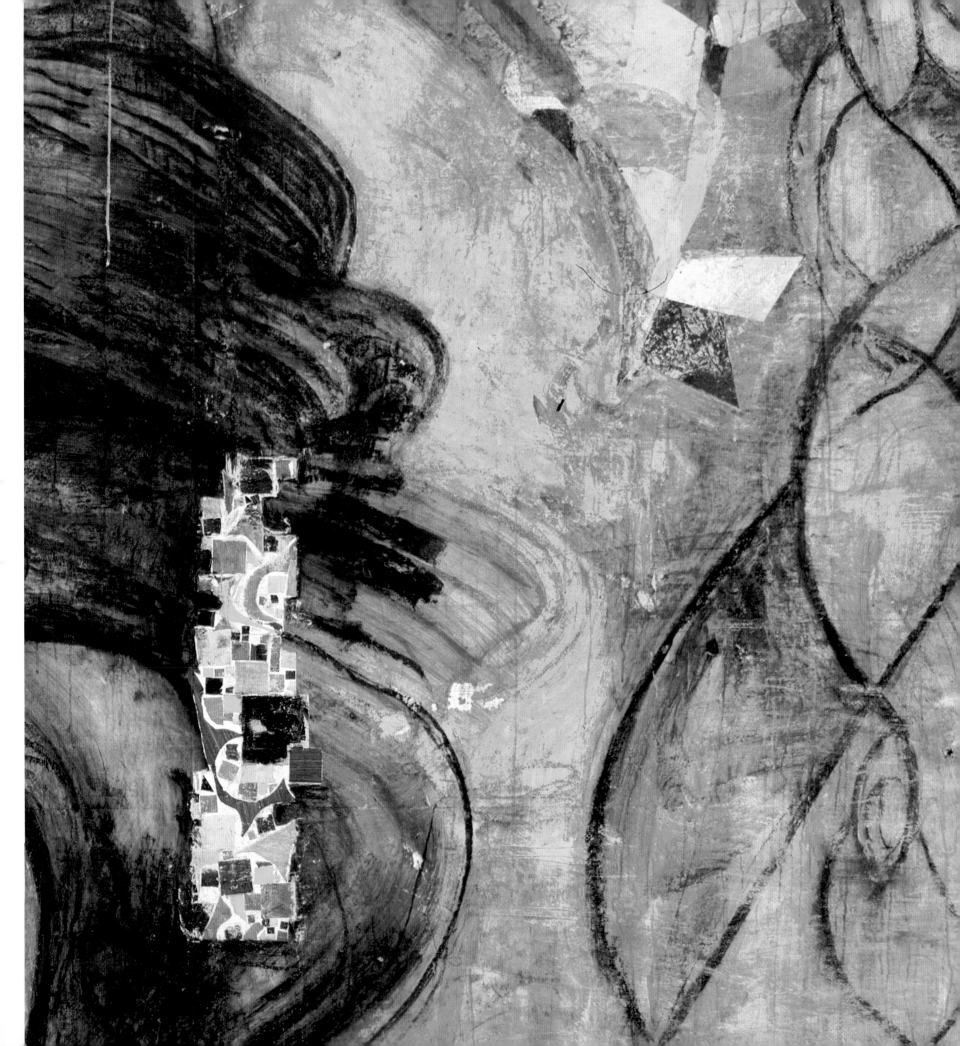

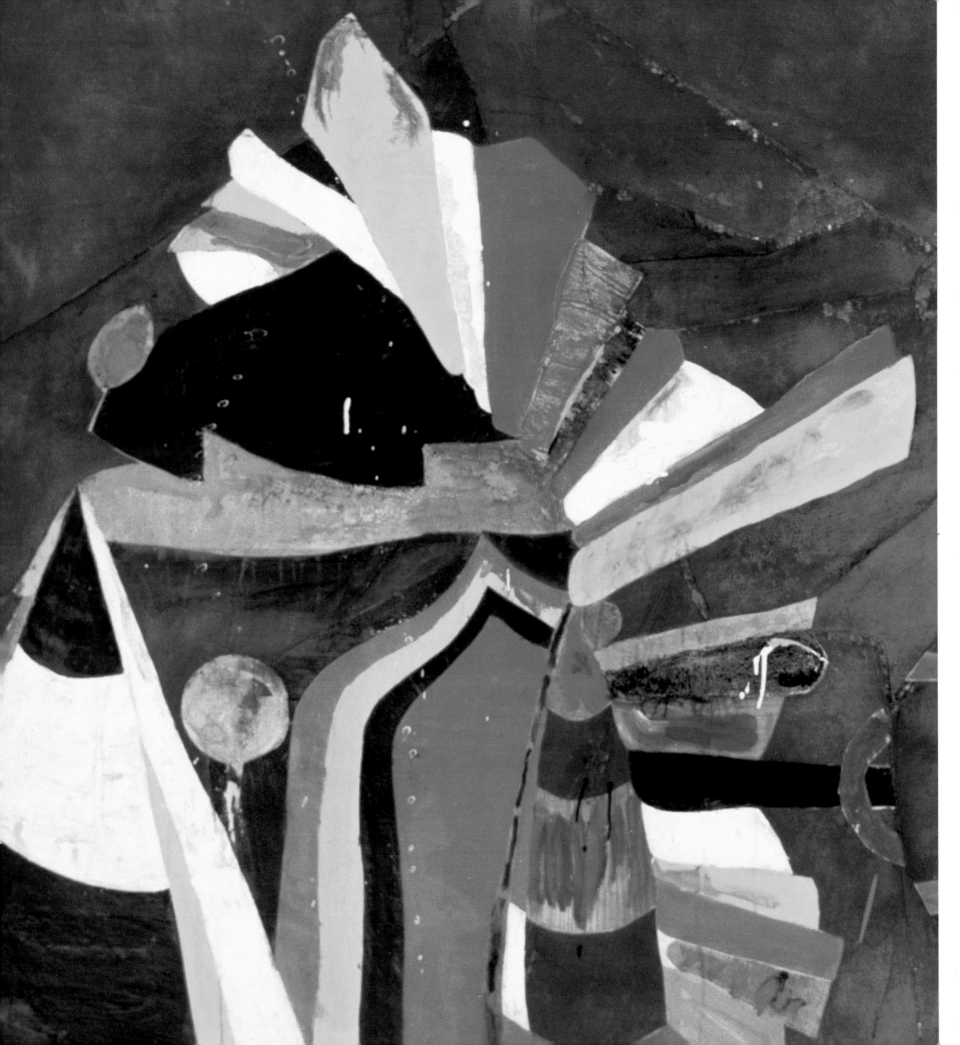

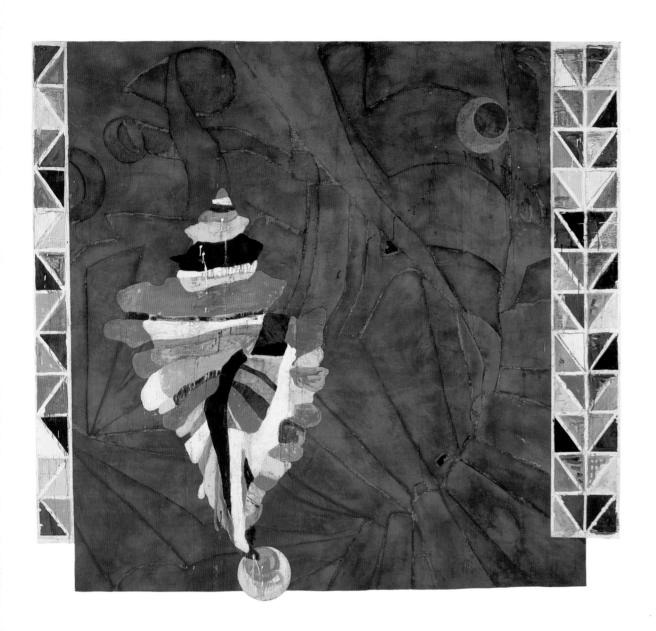

OVERLEAF, LEFT TO RIGHT:

A JOURNEY THROUGH THE TROPICS, Detail of LEFT PANEL

A JOURNEY THROUGH THE TROPICS, Detail of CENTER PANEL

A JOURNEY THROUGH THE TROPICS, Detail of RIGHT PANEL

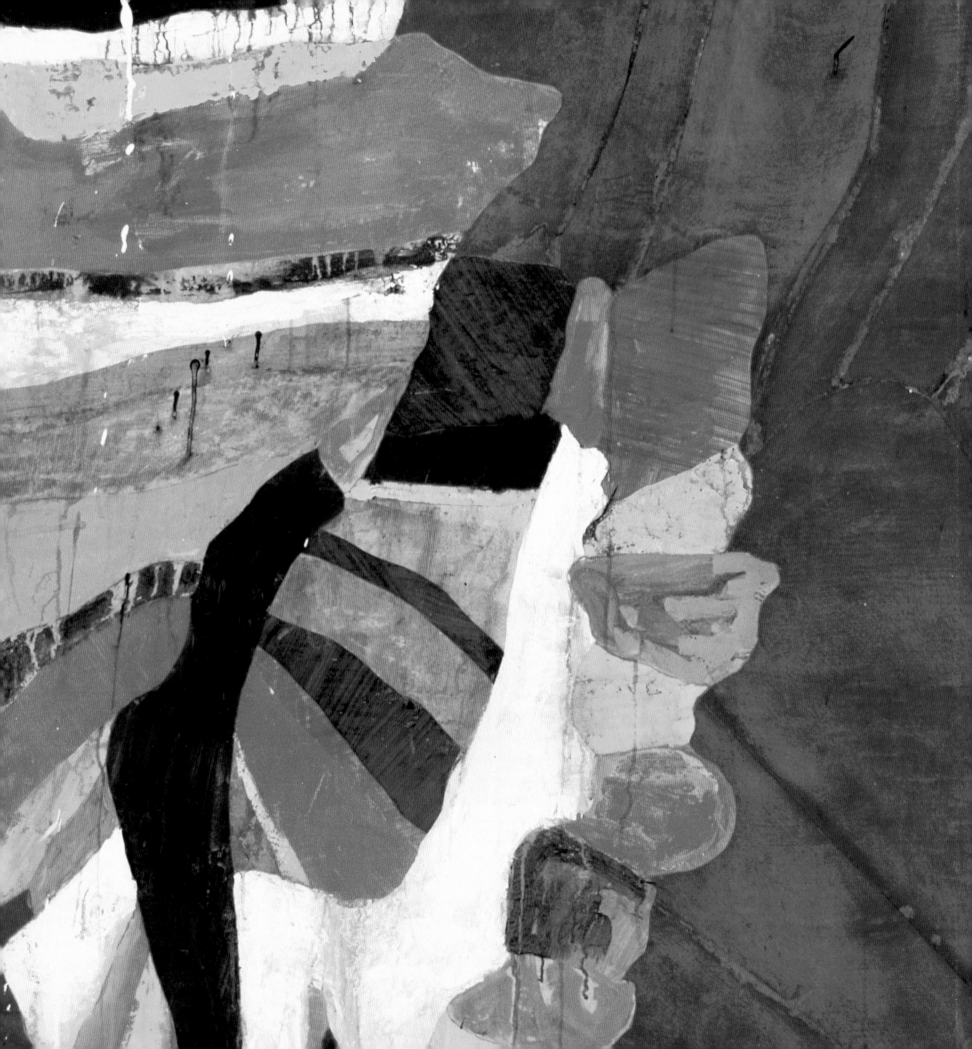

adding, "I've spent half my life in the country." His attachment to the land—to walking it, surveying it, feeling its presence against the sky—runs deep. A great deal of his thinking about his work, and some of his painting, takes place in his country home near the Hudson River—a warm, roomy house built of river stone, facing the mountains. When he rises at dawn, when he sits on the huge verandah at dusk, he can perceive the magnificence of the upper Hudson Valley through the sun's great performance. The transition from the gardens of summer in the Catskills to the rich tropical floriation in Jacksonville was therefore not difficult for La Noue, who is used to rhyming the basic natural forms he has encountered all over the world.

Even before making *A Journey through the Tropics*, La Noue had a long history of comparative studies; in earlier paintings he had investigated, for example, the uncanny structural similarities between the chambered nautilus and the spiral staircase—both forms based on an inner axis from which the final form emanates. Shuttle shells also can be seen all over the world, as can variants of the nautilus. Even the pre-Columbians had been fascinated by the shape of the conch shell, as many sculptures, some of monumental scale, attest. When he accepted the commission, La Noue visited the site of the new bank several times to ponder an appropriate motif; the shell presented itself naturally. It is a particularly fecund motif, since it is a living record of transformation: it spirals into life. For his central image, then, he chose the shell, exploring its myriad formal propensities in the ancillary variations. Since the entrance to the bank faces the painting, and since the interior has two pillars that more or less frame the center panel from that vantage, La Noue conceived of it as an intimate drawing that could be seen from the doorway, some 220 feet away, and then explored closely from near the tellers' windows. For the ground he chose a burnished golden tone, achieving a warmth similar to that of the glazes of sixteenth-century Renaissance painting, suitable for the display of the center drawing. The portrait of the spiral shell was drawn in charcoal on the studio floor, so that when the painting was pulled from the mold the rich quality of the charcoal line was sealed within the sand-hued ground. The metamorphic character of this central drawing is explored in many modes—in the curvilinear drawing to its right, in which sinuous lines flow almost like a medieval interlace pattern; in the vignette in bright colors at lower right, echoing the variations on the spiral staircase; on the left, in almost geometric sequences that suggest, in the artist's words, "various rhythms and balances, and many geometries." The many layers of gold and ocher underlying the final surface lend a unity to the whole without dimin-

ishing the painting's demand that the spectator scan its every inch in order to derive its true content.

La Noue considered the function of the side panels to be almost architectural, providing the necessary frame for such a large-scale painting; in them he used an unaccustomed simplicity. The largest areas suggest a consistent ground, beneath which hints of other activities discreetly appear and disappear. The warm copper green, with its radiating vectors slightly edged by red underpainting, provides a foil for brilliantly colored variations on the shell forms, which in turn encompass the spiral staircase and a hint of Seminole textile patterns. Here La Noue, using his habitual casting technique, has found a new level of expression. By dusting the first mold with graphite, into which he worked green and then red, he created a painterly support for the extraordinary color forms of the central figures (perhaps enriched by his recent experiences with color monoprints). Most of the interior history of these paintings lies beneath this copper green surface, allowing a far more sweeping sense of space than is usual for La Noue. No doubt the rich bronze tonality carried associations for him, ranging from sea depths to European roofs; and no doubt the cinnabar hues, so fresh and arresting, derive from his many tropical journeys; but the final impression is of a uniquely specific place. The rosewood paneling of the bank and the deep green stone of the tellers' counter set off the painting, which in turn honors the innate beauty of those materials.

The clearings that appear in the Florida project have had bearing on subsequent paintings. Contrasts of large and small, empty and full have become more emphatic, and La Noue quite often, now, includes large, uncluttered areas concealing secret traceries. The large 1990–91 painting *The Monarch's Cave*, for instance, has a broad, ribbed surface of rich cordovan hues in which brilliant color incidents erupt, such as the mineral green form at the far left edge. Color often seems impregnated rather than painted, and there are frequent oblique lights caught in the glazelike depths. Even in one of his darker moods, such as his somber image of prison and torture, *The Prisoner within Us All,* La Noue has charged his surface with pure, high-keyed color, while maintaining a brooding tone in the copper greens behind. The major shape, with its prison-stripe motif and its dangling pose, is incorporated into a composed whole, despite its uneasy equilibrium. The staircase image, transformed by the Piranesi-like atmosphere, serves to unite the painting's various commentaries in a way not seen in paintings made before the Florida project.

A magnificent painting of 1990–91, *Kyoto Dreams*, has clearly benefited from the artist's Florida experience. Here La Noue uses the deep red ground,

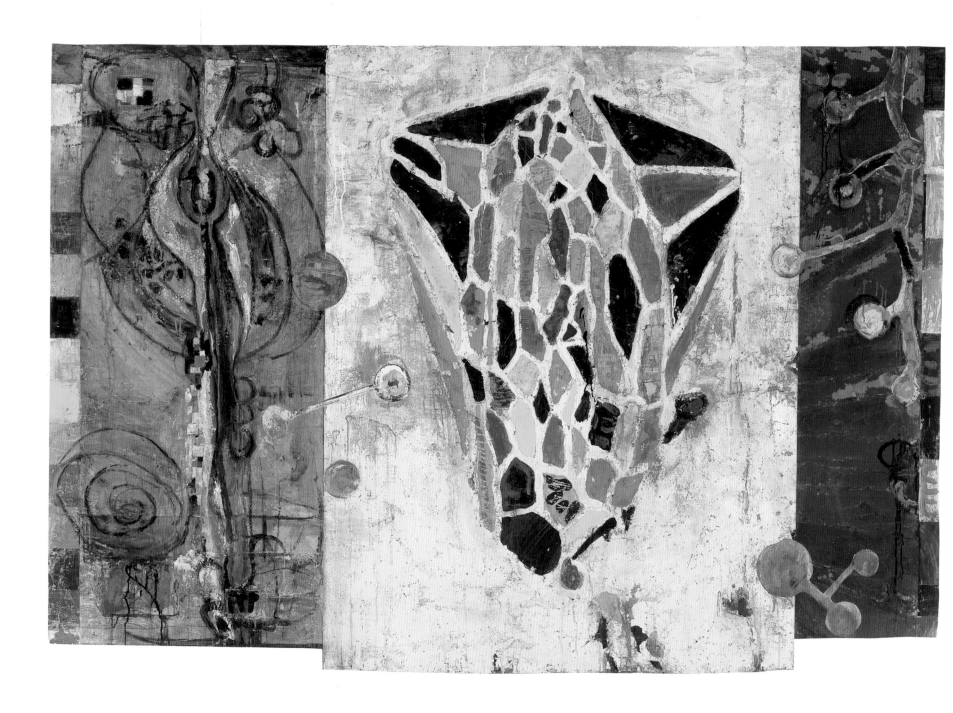

FOUNTAIN: GEMSTONE, 1988–89
MIXED MEDIA ON CANVAS
59¾ × 87 INCHES
COURTESY ANDRE EMMERICH GALLERY, NEW YORK

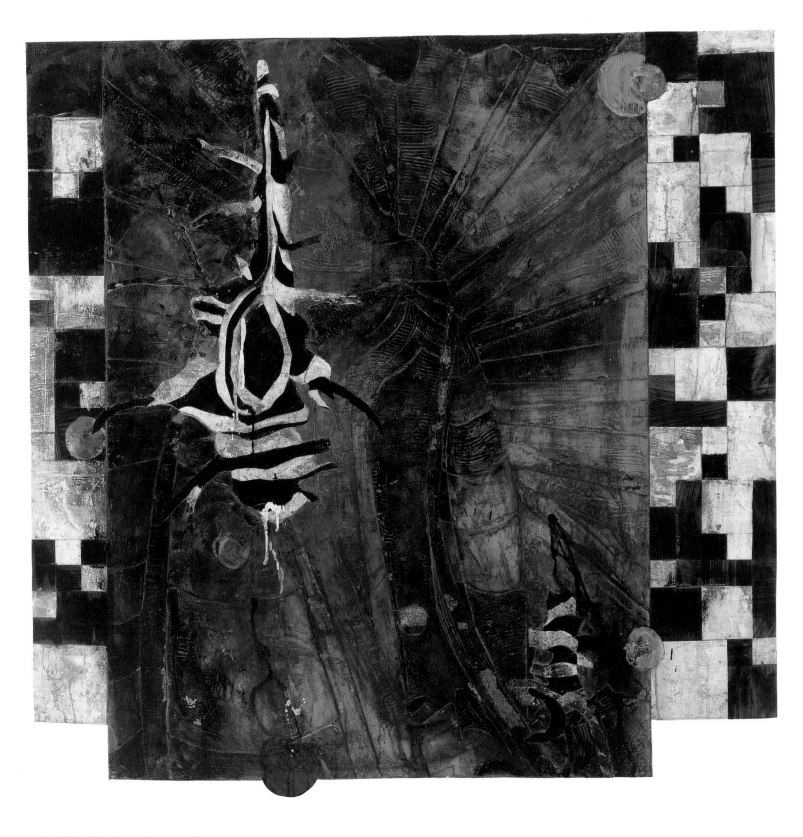

THE PRISONER WITHIN US ALL, 1991
GRAPHITE AND MIXED MEDIA ON CANVAS
58 × 58 INCHES
COURTESY ANDRE EMMERICH GALLERY, NEW YORK

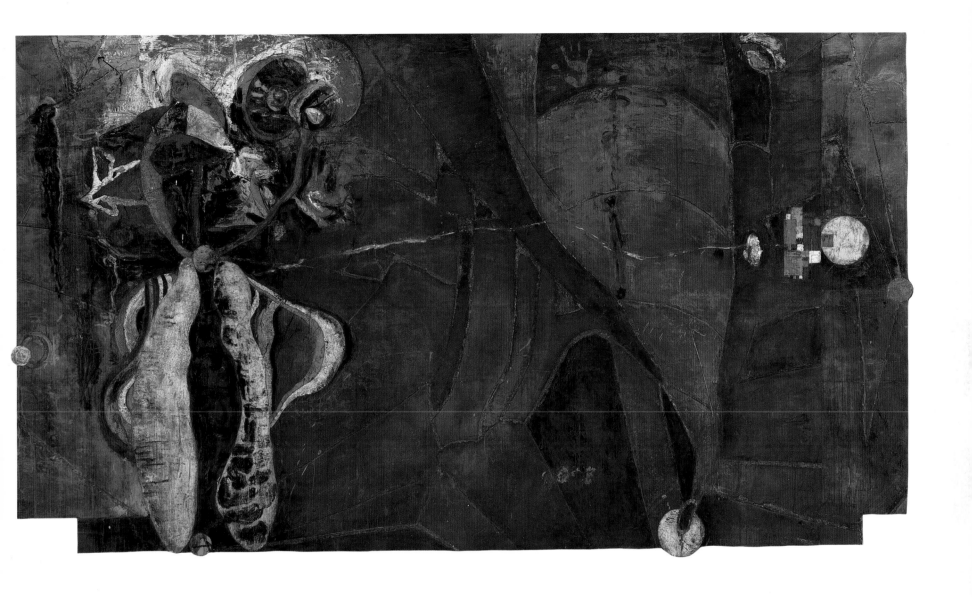

Detail of THE MONARCH'S CAVE

THE MONARCH'S CAVE, 1990–91
GRAPHITE AND MIXED MEDIA ON CANVAS
85 × 149 INCHES
COURTESY ANDRE EMMERICH GALLERY, NEW YORK

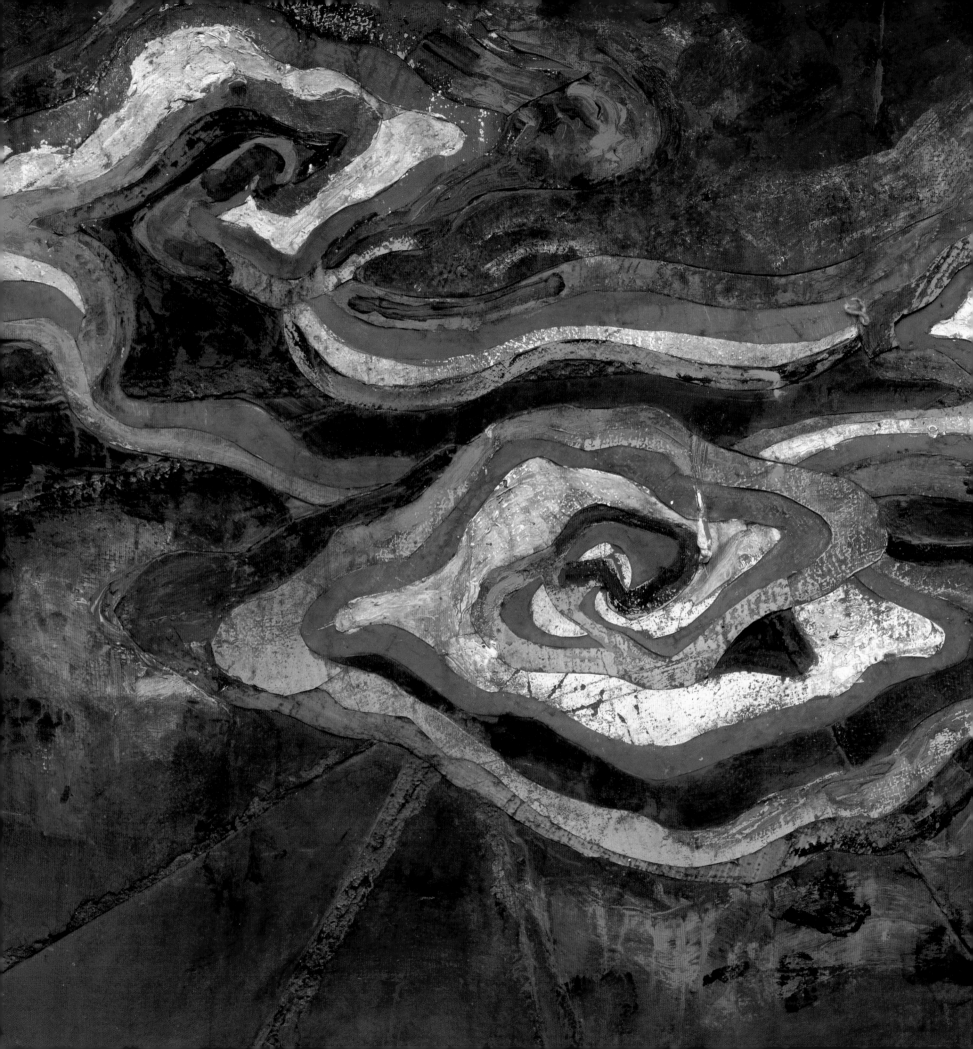

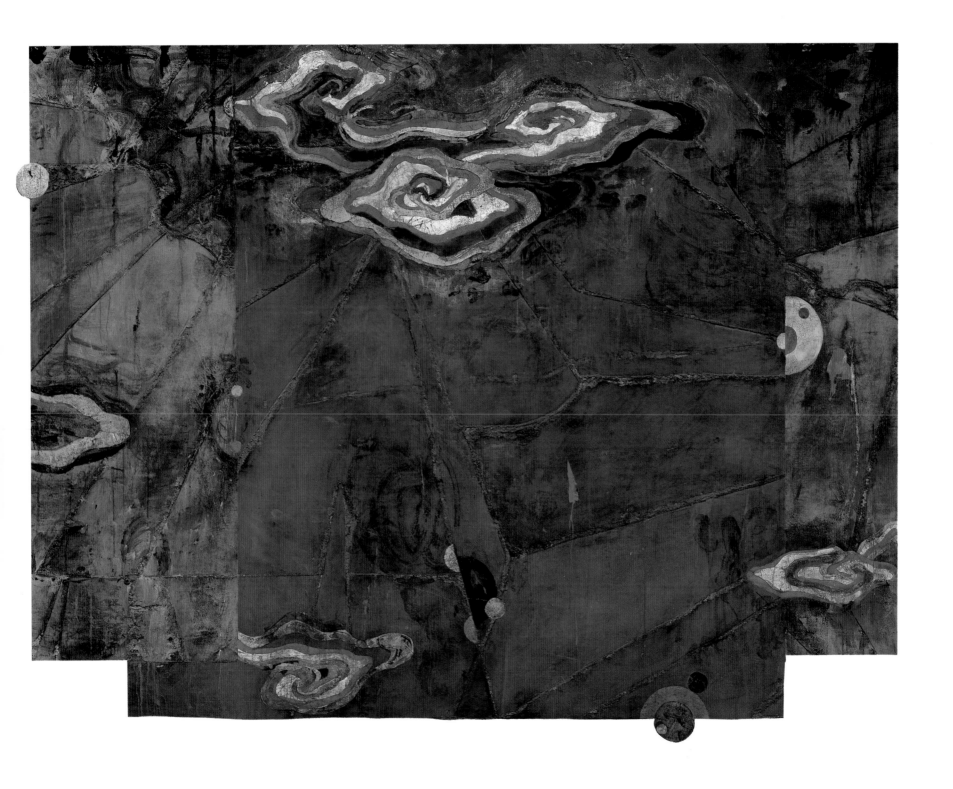

Detail of KYOTO DREAMS

KYOTO DREAMS, 1990–91
GRAPHITE AND MIXED MEDIA ON CANVAS
74½ × 97 INCHES
COURTESY ANDRE EMMERICH GALLERY, NEW YORK

with its segmented planes fanning out across the entire picture plane, to unify an unusually clear group of images. The dominant cloud image at upper center, in ringing, full color, is laid into the ground with crisp precision, as though it were cut into wood. Elements of the cloud configuration are picked up at the far left in jade green details laid into copper greens, or scattered lightly in unobtrusive details near other edges. The general impression is that the kind of perspective used in traditional Japanese painting has been put to the service of modern painting. The very shape of the cloud, with its sinuous, calligraphic lines, suggests Japan, although it also suggests a motif seen in ancient Mesoamerican art, referred to as the "cloud snake." In the clarity of his color and detail, La Noue has achieved a different effect—one that comes close to what Matisse sought in his late years, when he said he wished to cut into color itself, to chisel color like a sculptor. What La Noue refers to as the "interruption of the surface," which he has always maintained as important to his vision, is not a true interruption, but rather a virtuoso delivery of the sensation of color itself.

10 IT WOULD BE IMPRUDENT to attempt to summarize La Noue's oeuvre. He is at a moment in a painter's life when the full force of his creative means can be felt. At fifty, he is still vigorously exploring the many avenues he has discerned during some thirty years of work. One characteristic of his work is its inherent continuity, no matter how varied his means and motifs may be. In some ways, La Noue's paintings can be understood as a long and lapidary tale; in others, as a single, synoptic vision such as the early Renaissance painters projected when they painted the incidents in a saint's life on a single panel. The fabulist in La Noue has spun out his story in arcane symbols that, finally, can be deciphered—to use one of his own favorite words. He works at the point of juncture where instinct and intelligence meet, prolonging a venerable modern tradition.

Along the way La Noue has invented a highly personal point of view. That is, he has found various ways of inducing the viewer to enter a work of art and to experience its spaces and depths almost physically as he gazes at troughs and gullies or ridges and plains at different levels in space. The hundreds of cross-references and repeated allusions found throughout his oeuvre serve to unfold La Noue's vision and captivate his audience

with the impression of a fully furnished, active universe. He has sustained many of his devices for years, as well as certain of his early impressions. When, as a youth, he noticed Max Beckmann's way "of moving things around, like body parts that go backward and forward," he began to think of alternative ways of approaching the picture plane, finding his own means through the insight of an admired master. The way he assimilates the approaches of other painters has always been intelligent, tested against his own feelings and thoughts. Sometimes an encounter with paintings of other eras or other cultures has entered his thoughts only years later. Need and deeper understanding have called them back. At one point, for instance, he found himself painting an homage to the Japanese film director Akira Kurosawa, whose "secret paths" he had come to understand. Later, at certain moments, the memory of Japanese painting, which had interested him desultorily for years, again surfaced. Recently, the legacy of the Muromachi screen painters of the sixteenth century has struck him and he has taken both the folding screen and the *fusuma*, or sliding screen, as a remote model. Like the Muromachi artists, he has used several panels for a single painting and has combined both landscape motifs and rectangular pictographic inscriptions in some works. In others, the multiple-screen idea so often undertaken by the Muromachi painters—the depiction, in a series of panels, of the four seasons, with both sun and moon represented—seems dominant. The great variations in these wonderful Japanese screen paintings could not fail to stir La Noue, whose own tastes are so similar. Certainly, when La Noue floats gold clouds over an image, or when he flecks his surfaces with colored tesserae—which were also used by the Japanese painters to provide atmospheric touches—La Noue is harking back to a tradition with which he feels an affinity.

Yet, no matter how far-flung his associations are, La Noue is faithful to his cultural and aesthetic mission, which rests firmly in the modern abstract painter's tradition. While he does not flinch from literal representation (he has made drawings with realistically rendered birds in them, for example), his whole being is oriented toward the more subtle, universal truths he uncovers in the process of abstraction. Unquestionably he is seeking the kind of truth that exists within the history of painting and that cannot easily be expressed in words. Underlying his whole endeavor is the ethical imperative that sustained the spirits of the early modernists: a demand that sensations and thoughts be shaped in metaphorical, rather than literal, terms. La Noue can cast his net widely by using the most condensed means and can answer to his own views of existence through symbolic vi-

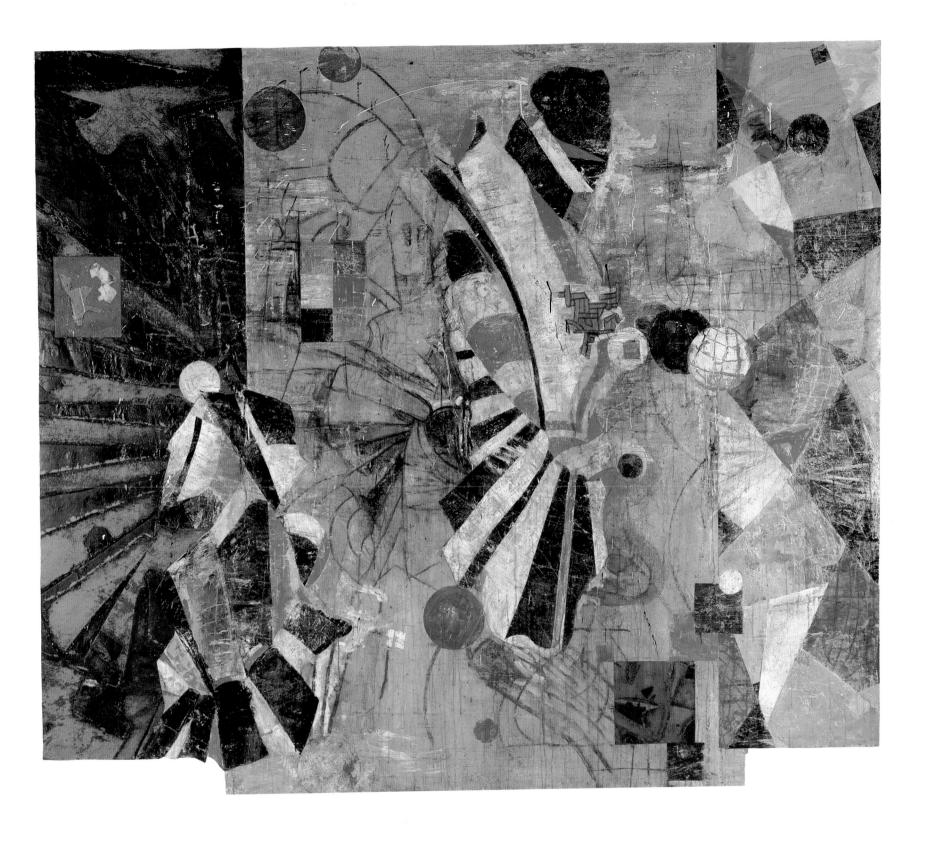

Detail of HOMAGE TO KUROSAWA

HOMAGE TO KUROSAWA, 1989
MIXED MEDIA ON CANVAS
88 × 90¾ INCHES
COLLECTION TEMMA AND JOSEPH MERBACH, MALIBU, CALIFORNIA

sual equivalents of his thoughts. In his personal ethic, the idea of what he calls a "signature style" is repugnant and many of his studio rituals are conceived to circumvent it. A personal ethic, La Noue says, is a path, and cannot be avoided in a painter's life. "Ethics as a structure is as complex as any maze, because ethics is usually learned from institutions. But a personal ethic, a path, must be found." In his pursuit of certain universal truths, La Noue has found not one, but many paths, and has marked them unmistakably in his oeuvre.

NOTES

1 Ellen Lee Klein, "Beneath the Surface: An Interview with Terence La Noue," *Arts Magazine* (January 1986).

2 Henri Focillon, *The Art of the West*, ed. Jean Bony, vol. 2 (London: 1963).

3 Michel de Montaigne, *The Complete Essays of Montaigne*, tr. Donald Frame (Stamford, 1965).

4 Wilhelm Worringer, *Abstraction and Empathy: A Contribution to the Psychology of Style*, tr. Michael Bullock (New York: International Universities Press, 1953).

5 Wassily Kandinsky, *On the Spiritual in Art* (Museum of Non-Objective Art, 1946).

6 Wassily Kandinsky and Franz Marc, *The Blaue Reiter Almanach* (New York, 1974).

7 La Noue, quoted in Noel Frackman, "Layers of Significance: Meaningful Transformation in the Work of Terence La Noue," *Arts Magazine* (November 1983).

8 Kandinsky, *On the Spiritual in Art*.

9 All remarks by the artist not otherwise attributed are from conversations with the author.

10 Heinz Ohf, "Art in Berlin since 1945," *Art Now* (New York, 1977).

11 Will Grohmann, review, *Frankfurter Algemeine Zeitung*, 23 July 1965.

12 Eberhard Roters, foreword to *Terence La Noue*, exh. cat. (Berlin: Galerie Springer, 1965).

13 "Der Mensch als Massenartikel," *Die Welt* (Hamburg) (July 1965).

14 Ohf, review, *Der Tagesspiegel* (Berlin), 13 July 1965.

15 Max Beckmann, "On My Painting," translation of a lecture at the New Burlington Galleries, London, 21 July 1938 (New York: Bucholz Gallery, ca. 1941).

16 Francis Bacon, interview with David Sylvester on the BBC, London, 21 October 1962, reprinted in an exh. cat. (London: Marlborough Gallery, March–April 1967).

17 Bacon, interview with David Sylvester, London, May 1966. Reprinted in an exh. cat. (London: Marlborough Gallery, March–April 1967).

18 Klein, "Beneath the Surface."

19 This and following quotations are from Rudolf Arnheim, *The Power of the Center*, rev. ed. (Berkeley, 1983).

20 Cited by Claude Roy in *The Art of the Savages*, tr. E. S. Selden (New York, 1958).

21 Giorgio de Chirico, *On Metaphysical Art*, 1919, tr. Joshua Taylor. Reprinted in *Theories of Modern Art* (Berkeley, 1968).

22 Terence La Noue, note, Paris, 5 June 1977, published in an exh. cat. (Stockholm: Heland Wetterling Gallery, 3–21 October 1990).

23 Ibid.

24 Octavio Paz, introduction to *Mexico: Splendors of Thirty Centuries* (New York, 1990).

25 Terence La Noue, "Des Cultures pénétrées par l'abstrait," *Art Presse* (March 1979).

26 Klein, "Beneath the Surface."

27 Carter Ratcliff, introduction to *Terence La Noue: Paintings and Works on Paper, 1981–1983*, exh. cat. (New York: Siegel Contemporary Art, October–November 1983).

28 Frackman, "Layers of Significance."

29 Kandinsky, *On the Spiritual in Art*.

30 Daisetsu Suzuki, *Zen and Japanese Culture* (New York, 1959).

31 Klein, "Beneath the Surface."

32 James Hall, *Dictionary of Subjects and Symbols in Art*, rev. ed. (New York, 1979).

33 Klein, "Beneath the Surface."

34 Terence La Noue, statement, 16 August 1990, published in exh. cat. for an exhibition of paintings and works on paper at Heland Wetterling Gallery, Stockholm.

ANKARA, 1970

LATEX, WOOD, METAL, AND RUBBER

108 × 84 INCHES

COLLECTION NEUBERGER MUSEUM OF ART,
STATE UNIVERSITY OF NEW YORK, PURCHASE

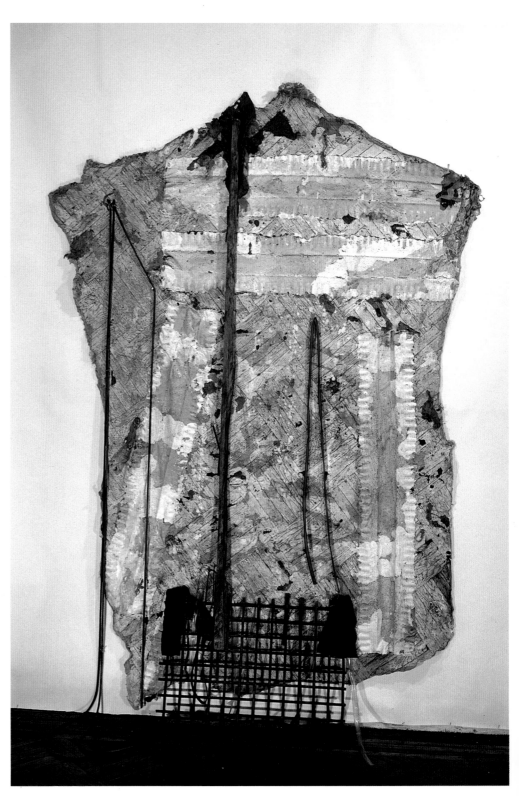

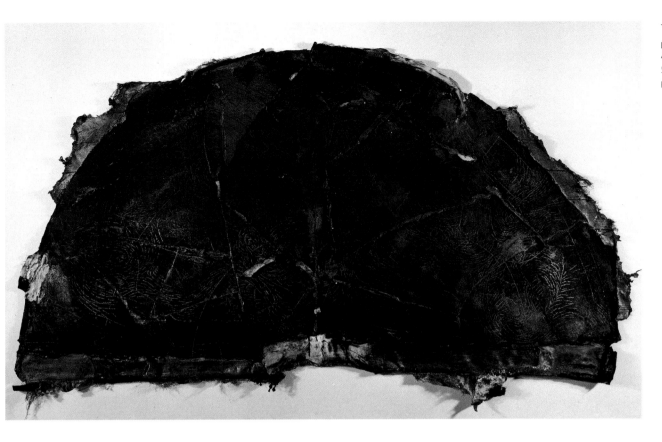

TASSILI I, 1974
LATEX, RUBBER, FIBER, ACRYLIC, METALLIC POWDER, AND TOBACCO CLOTH
52 × 100 INCHES
PRIVATE COLLECTION

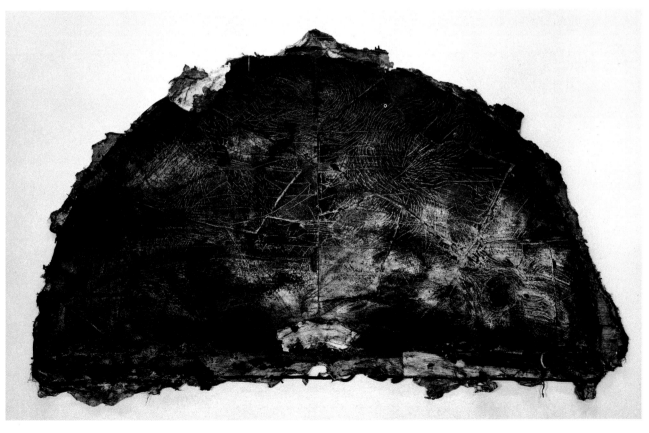

TASSILI II, 1974
LATEX, RUBBER, HARDBOARD, ACRYLIC, METALLIC POWDER, AND TOBACCO CLOTH
CA. 52 × 100 INCHES
PRIVATE COLLECTION

SHANGHAI, 1974
LATEX, ACRYLIC, HARDBOARD,
AND TOBACCO CLOTH
55 × 99 INCHES
PRIVATE COLLECTION

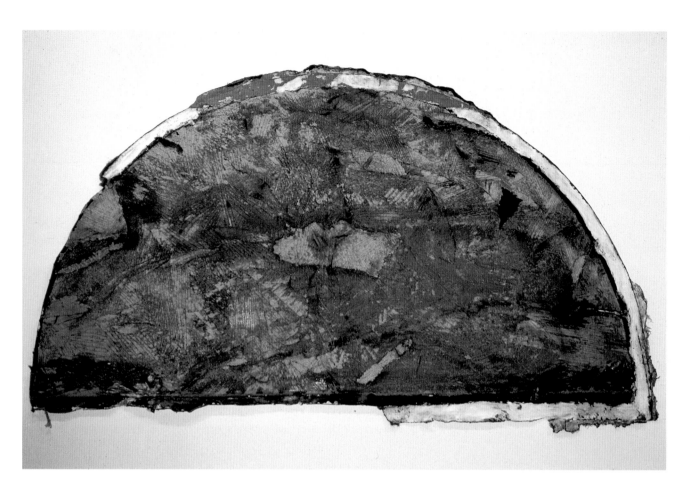

ZIMBABWE, 1974
LATEX, RUBBER, FIBER, ACRYLIC,
METALLIC POWDER, AND TOBACCO CLOTH
60 × 102 INCHES
COLLECTION CORCORAN GALLERY OF ART,
WASHINGTON, D.C.

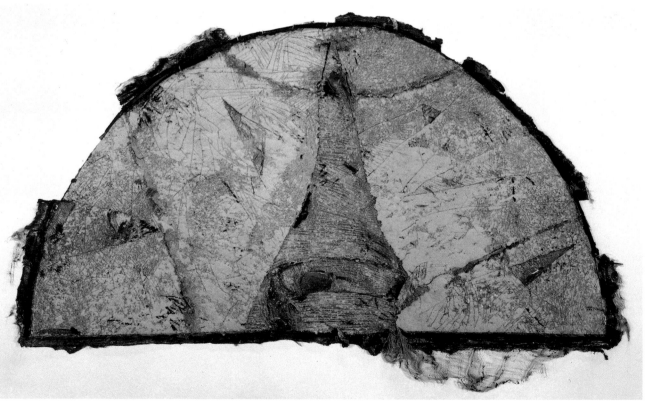

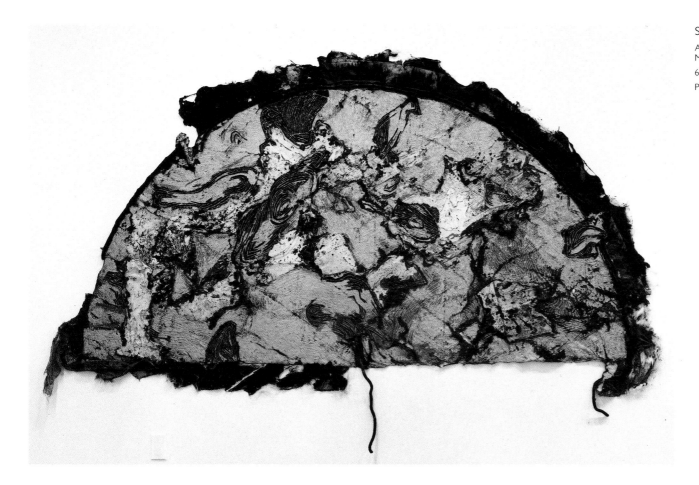

SEPIK, 1975
ACRYLIC, FIBER, LATEX, RUBBER, AND
METALLIC PAINT
60 × 112 INCHES
PRIVATE COLLECTION

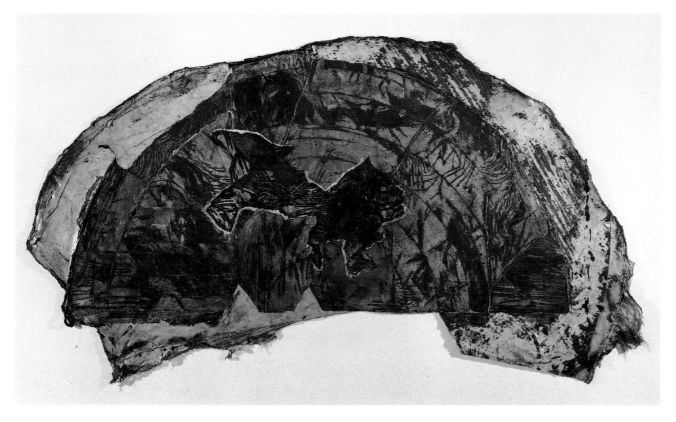

CHICHENITZA, 1976
LATEX, RUBBER, ACRYLIC, FIBER, AND
METALLIC POWDER
60 × 112 INCHES
COLLECTION KANSAS CITY ART INSTITUTE

TUEREG, 1978

RHOPLEX, ACRYLIC, METALLIC POWDER,
AND TOBACCO CLOTH

55 × 106 INCHES

COLLECTION THE ARTIST

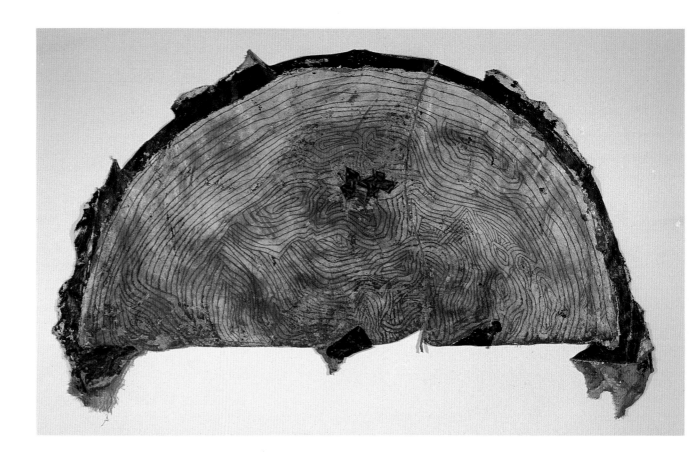

ISFAHAN, 1977

RHOPLEX, ACRYLIC, METALLIC POWDER,
AND TOBACCO CLOTH

64 × 116 INCHES

COLLECTION THE ARTIST

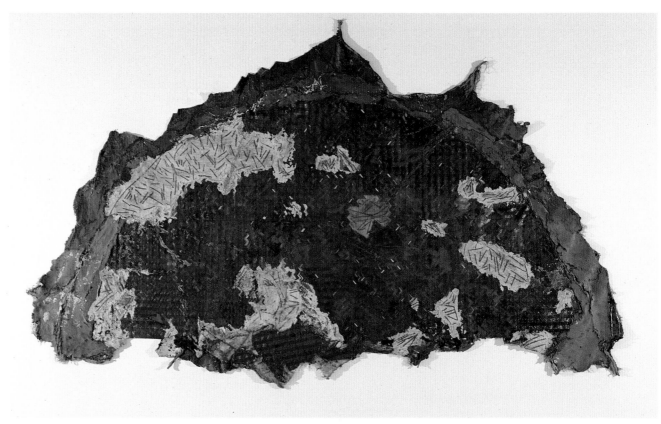

MACHU PICCHU, 1978
RHOPLEX, ACRYLIC, METALLIC POWDER,
AND TOBACCO CLOTH
57 × 108 INCHES
PRIVATE COLLECTION

TIGRIS, 1978
RHOPLEX, ACRYLIC, METALLIC POWDER,
AND TOBACCO CLOTH
48 × 84 INCHES
COLLECTION THE ARTIST

HELSINKI, 1980
ACRYLIC, RHOPLEX, METALLIC POWDER, AND TOBACCO CLOTH ON CANVAS
92 × 84 INCHES
COLLECTION PRUDENTIAL INSURANCE COMPANY OF AMERICA, NEWARK

LUXOR, 1981
MIXED MEDIA ON CANVAS
95 × 83½ INCHES
COLLECTION ASHER B. EDELMAN, NEW YORK

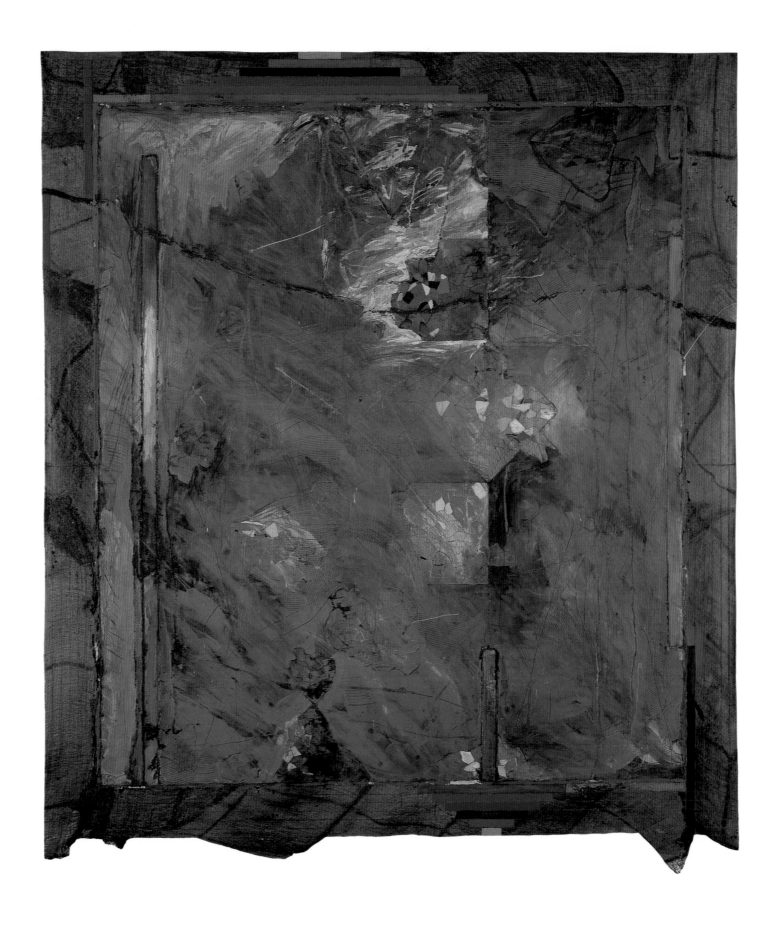

SEDONA, 1981
MIXED MEDIA ON CANVAS
96 × 71 INCHES
PRIVATE COLLECTION

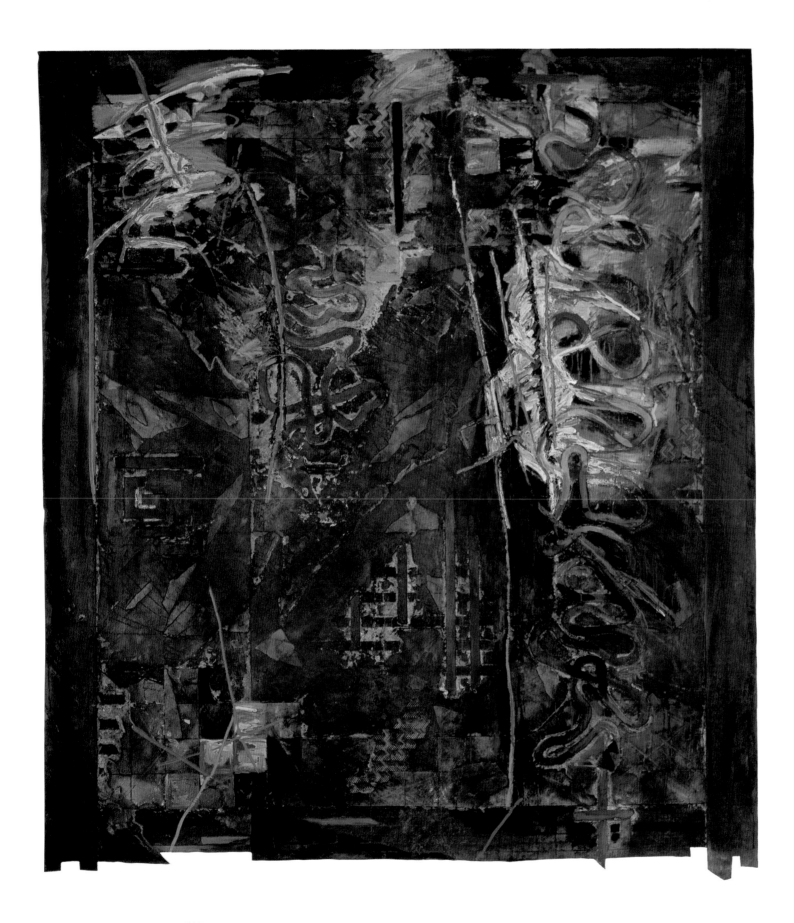

WINTERKILL: MOONLIGHT, 1982
MIXED MEDIA ON CANVAS
94 × 84 INCHES
PRIVATE COLLECTION

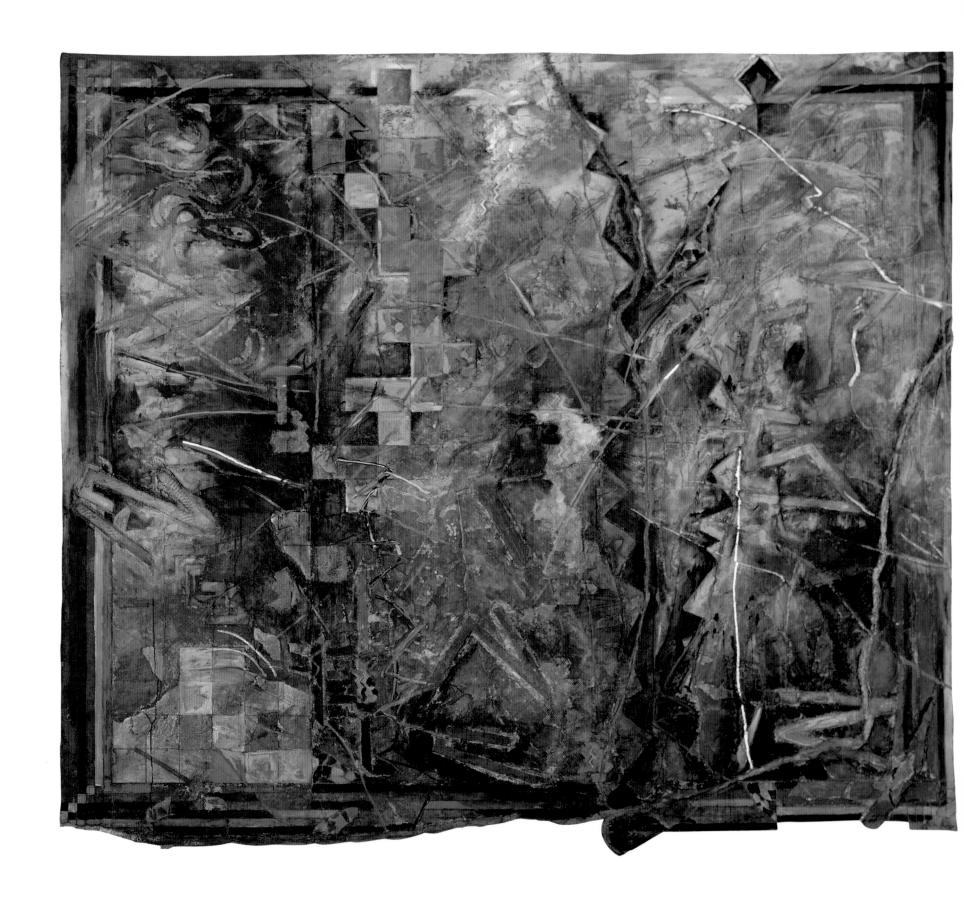

WINTERKILL: DAWN, 1981–83
ACRYLIC, GRAPHITE, METALLIC POWDER, AND OTHER MATERIALS ON CANVAS
93 × 108 INCHES
COLLECTION MR. AND MRS. DANIEL CANNOLD, NEW YORK

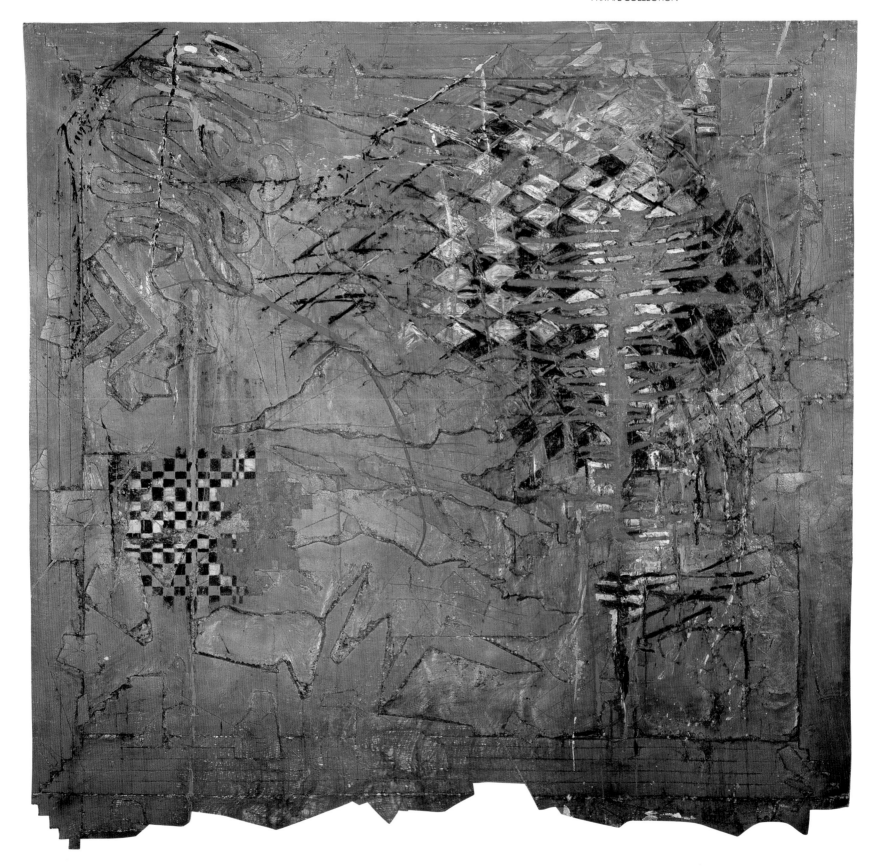

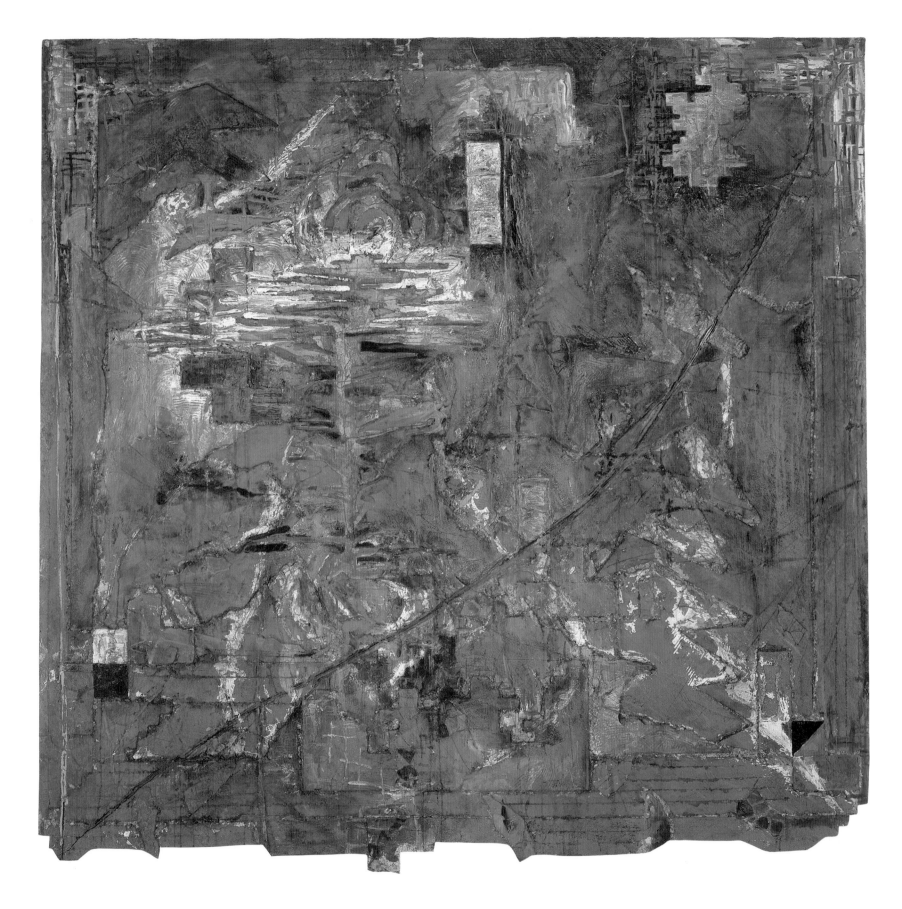

VARIETIES OF CORAL: EUPHORIA, 1984
ACRYLIC, METALLIC POWDER, AND OTHER MATERIALS ON CANVAS
71¾ × 73½ INCHES
PRIVATE COLLECTION

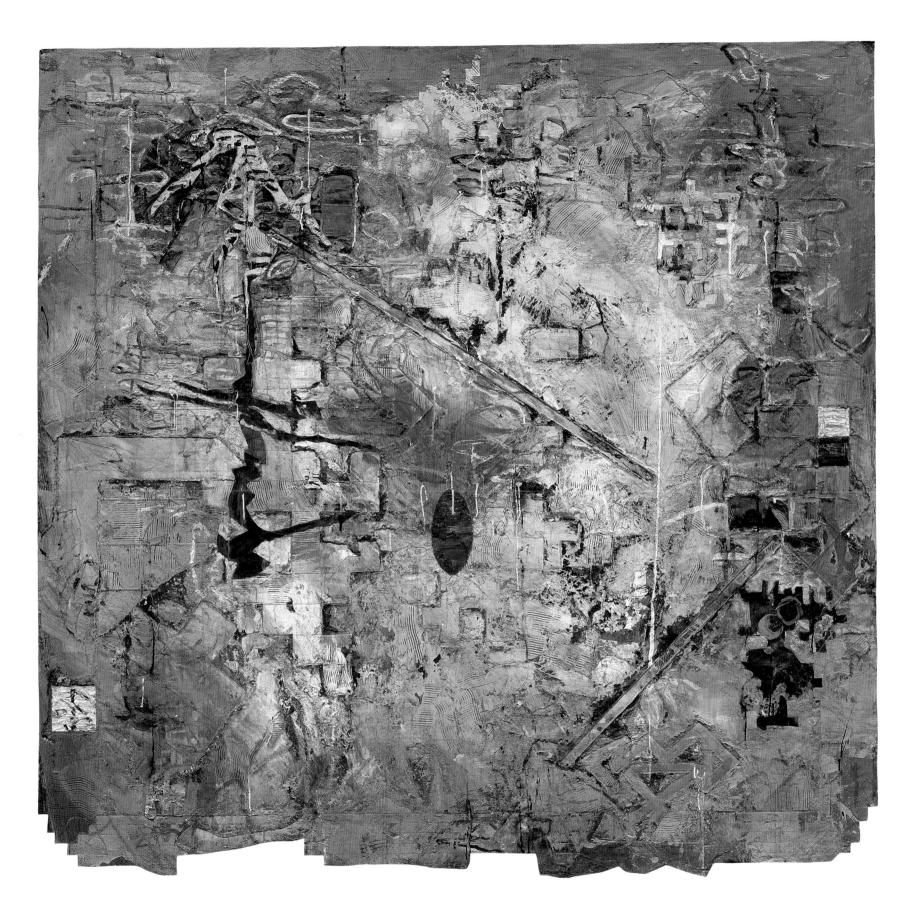

THE TARANTELLA AND THE LINGAM, 1985–86
ACRYLIC ON CANVAS
81 × 84 INCHES
PRIVATE COLLECTION

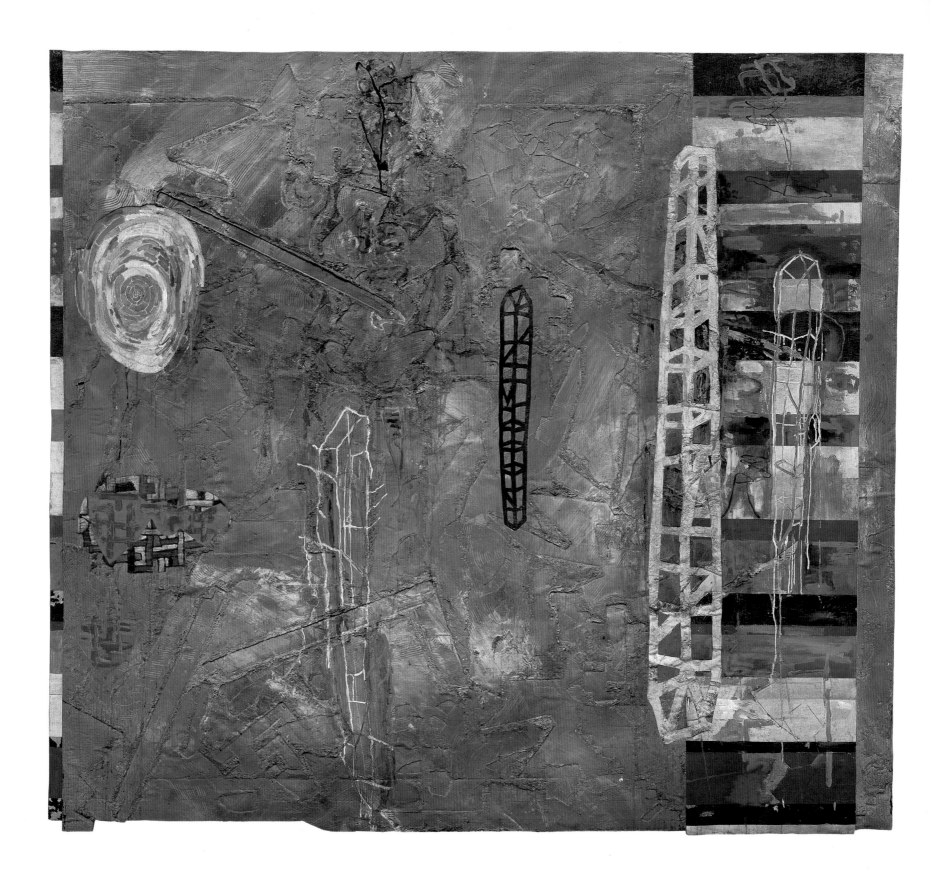

LORD OF THE UNDERWORLD, 1985–86

ACRYLIC ON CANVAS

74 × 83½

NYNEX CORPORATION, WHITE PLAINS, NEW YORK

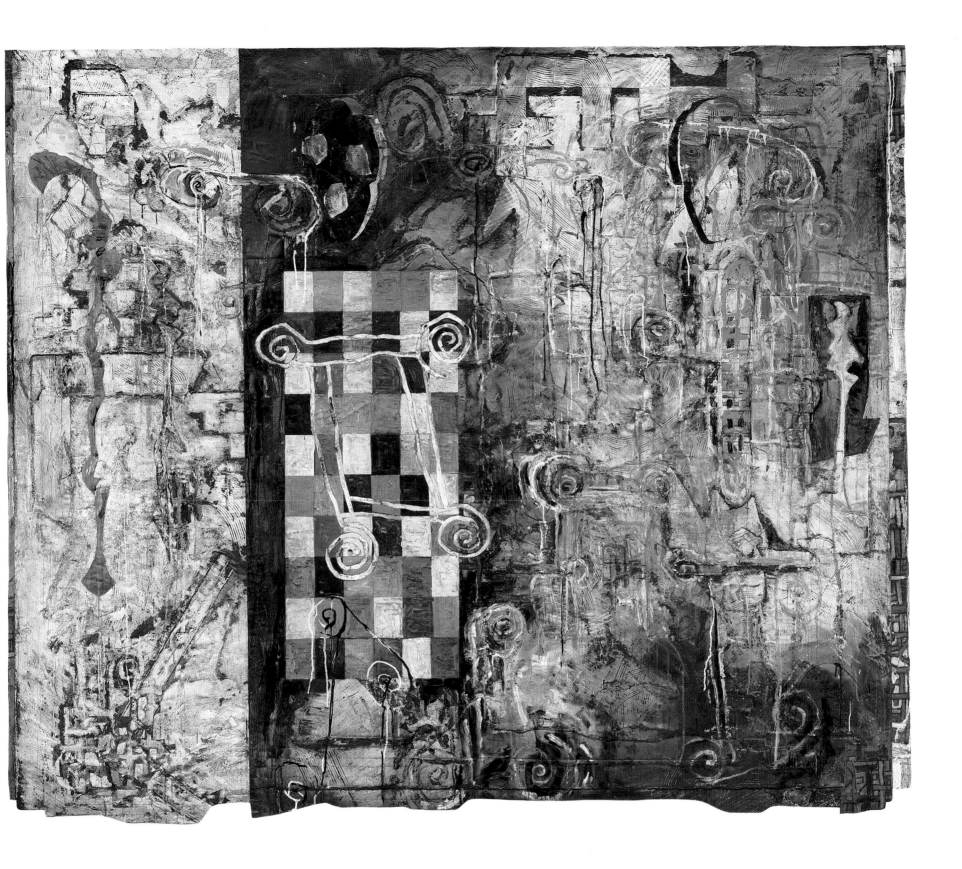

SOMNAMBULIST NARRATIVE, 1985–86
ACRYLIC ON CANVAS
77⅜ × 92½ INCHES
PRIVATE COLLECTION

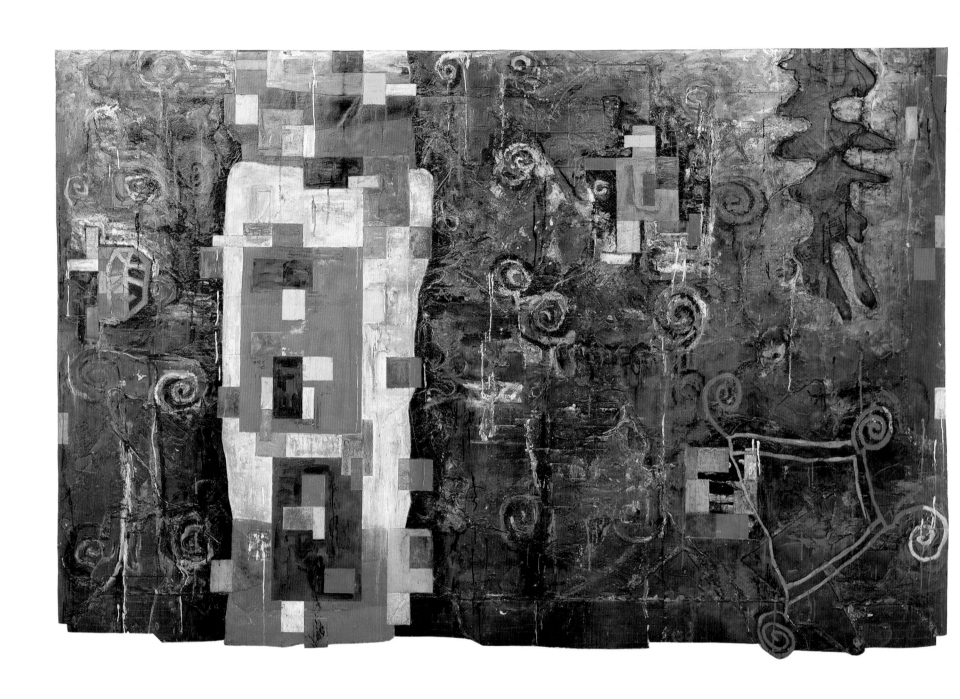

ORIENT EXPRESS: SARAJEVO, 1986

MIXED MEDIA ON CANVAS

76½ × 116½ INCHES

PRIVATE COLLECTION, NEW YORK

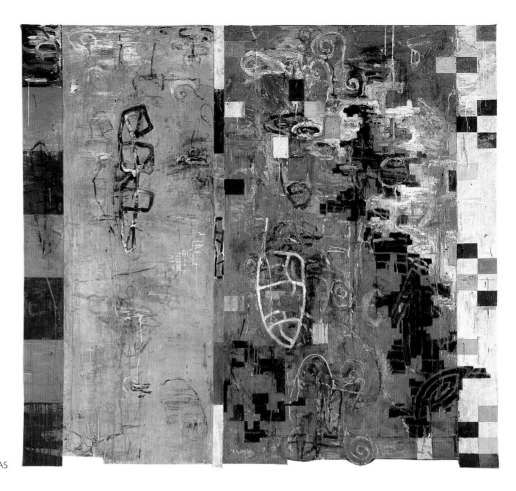

THE OPIUM WARS, 1985–87
MIXED MEDIA ON CANVAS
83½ × 95½ INCHES
COLLECTION MR. AND MRS. ALFRED L. FRIEDLANDER, TEXAS

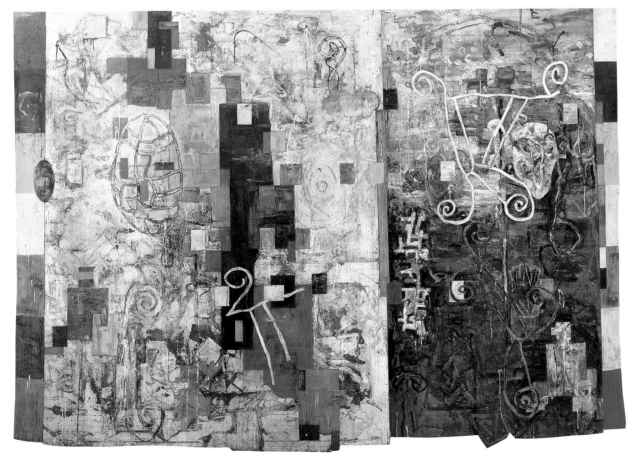

TEN DAYS THAT SHOOK THE WORLD, 1985
MIXED MEDIA ON CANVAS
86¼ × 124 INCHES
COLLECTION MR. EDWARD C. STANTON III, NEW YORK

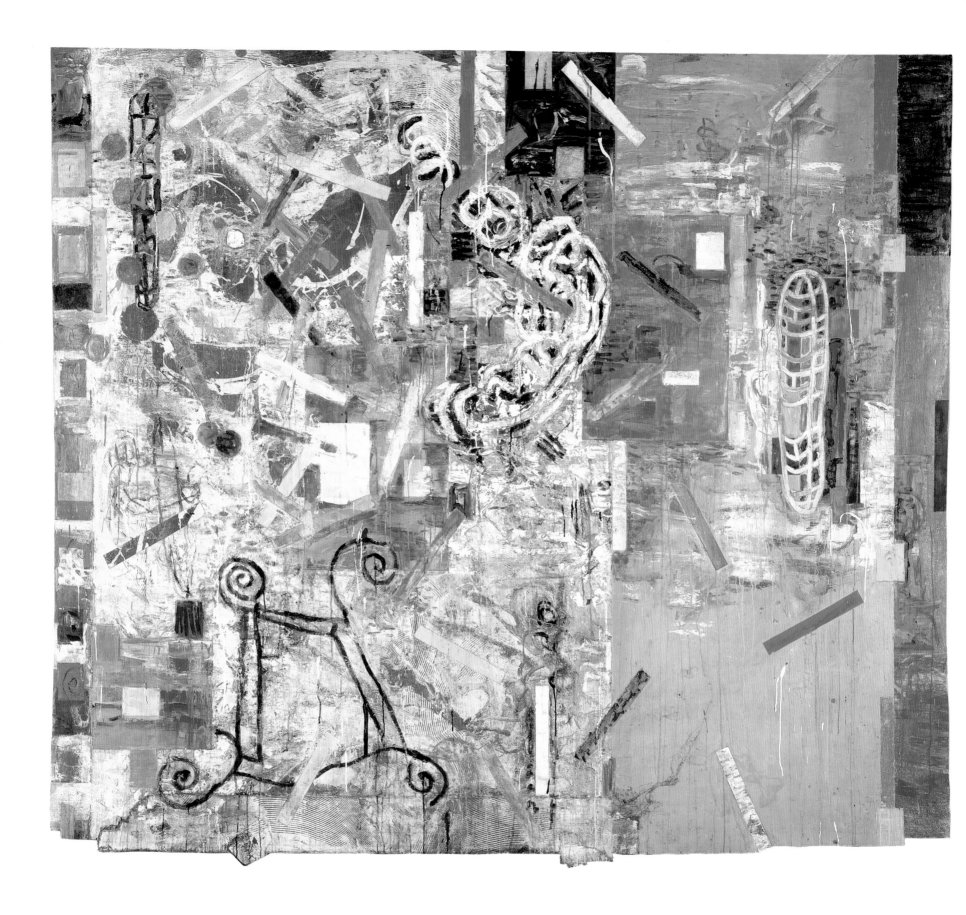

PEARL FISHERS, 1985–87
MIXED MEDIA ON CANVAS
87 × 99 INCHES
COLLECTION BARBARA AND SKIP VAUGHAN, HOUSTON

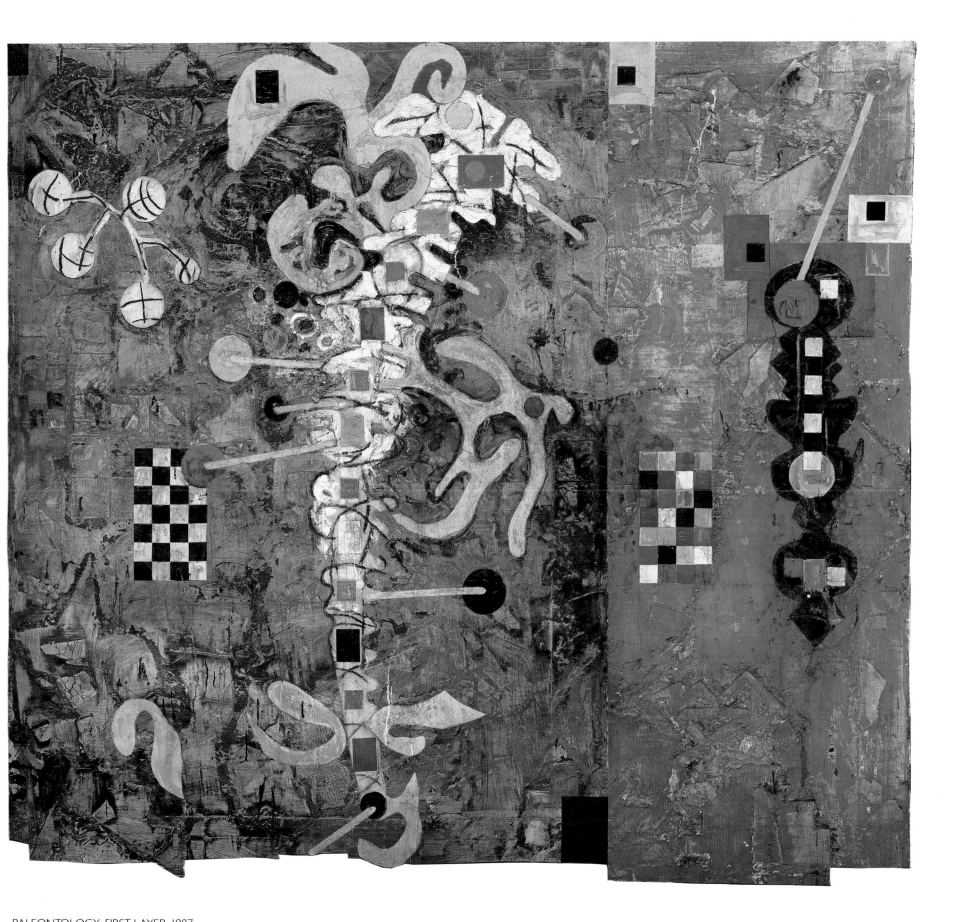

PALEONTOLOGY: FIRST LAYER, 1987

MIXED MEDIA ON CANVAS

89 × 98½ INCHES

COLLECTION COCA-COLA COMPANY, ATLANTA

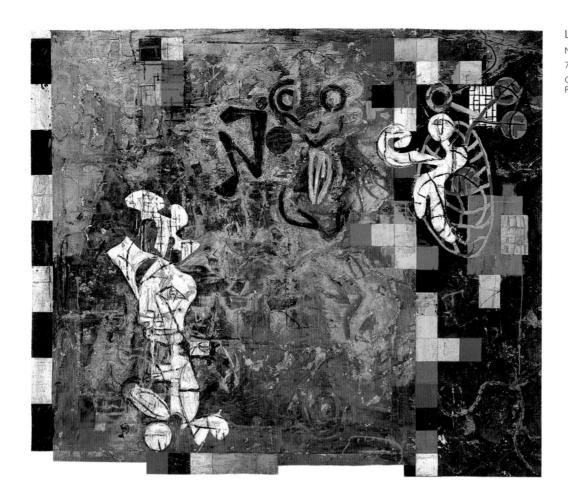

LA CALIFORNIE, 1987
MIXED MEDIA ON CANVAS
78½ × 93½ INCHES
COLLECTION MR. AND MRS. ROBERT R. TAYLOR,
PALM BEACH GARDENS, FLORIDA

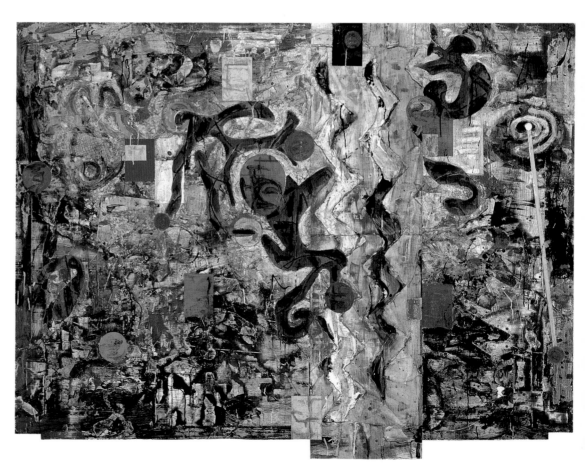

BOLSHEVIKS, 1987
MIXED MEDIA ON CANVAS
70 × 92½ INCHES
PRIVATE COLLECTION

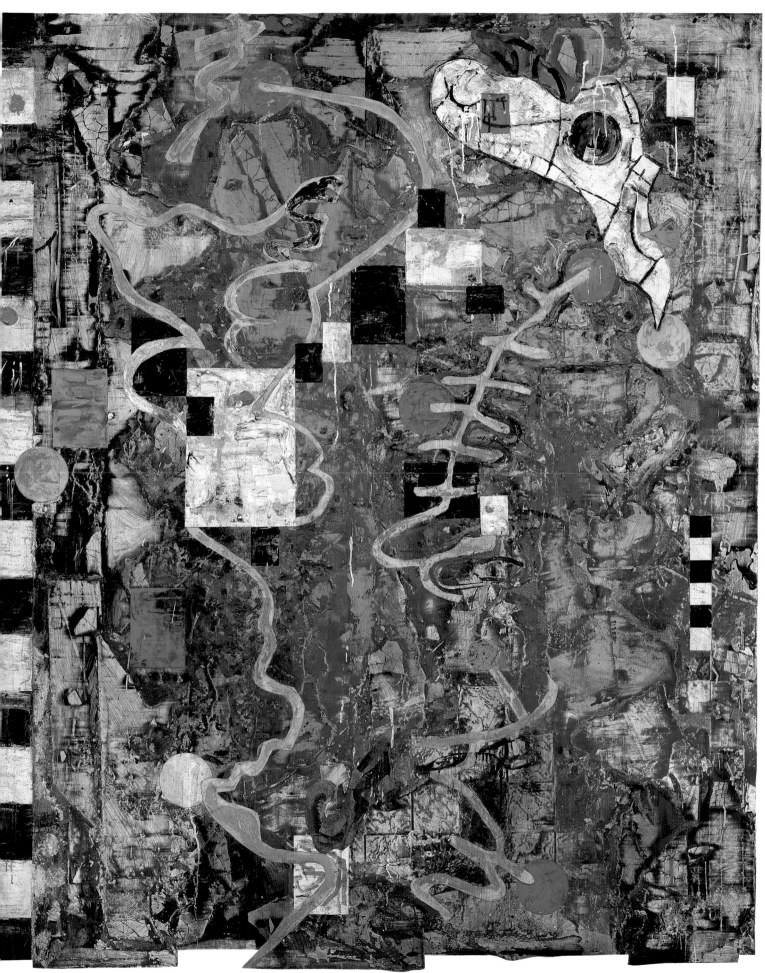

FOSSIL GARDEN, 1987
MIXED MEDIA ON CANVAS
85 × 68 INCHES
PRIVATE COLLECTION

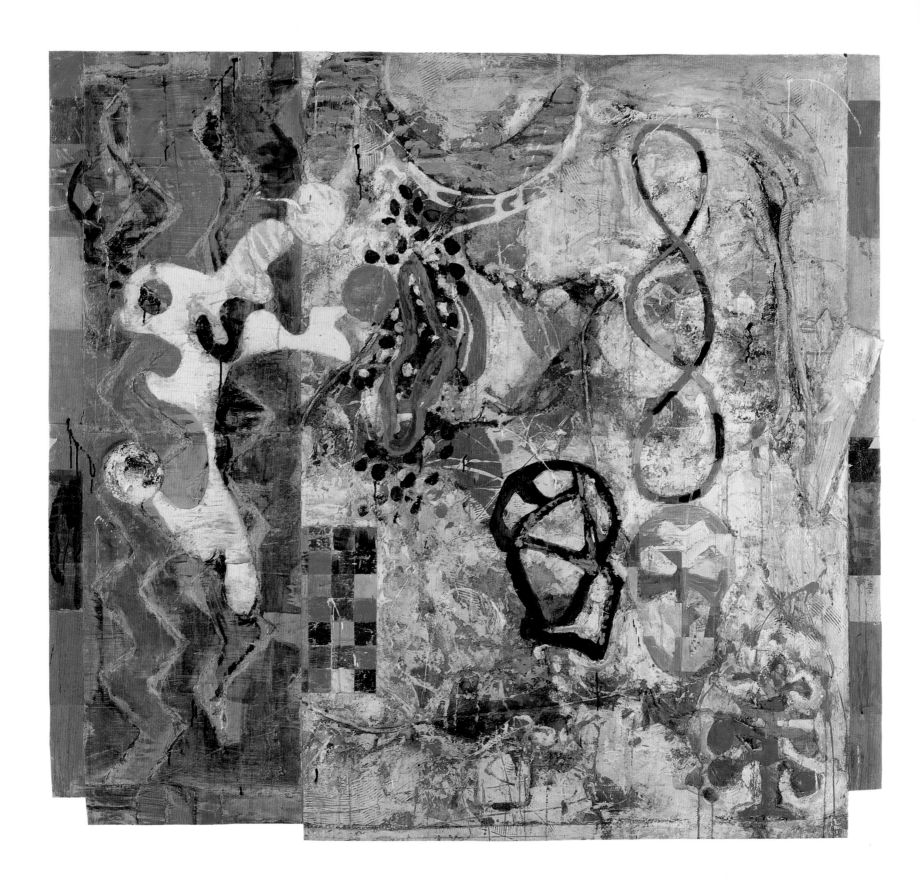

WHITE RABBIT: THE MIRROR, 1987–88
MIXED MEDIA ON CANVAS
68½ × 73½ INCHES
PRIVATE COLLECTION, STOCKHOLM

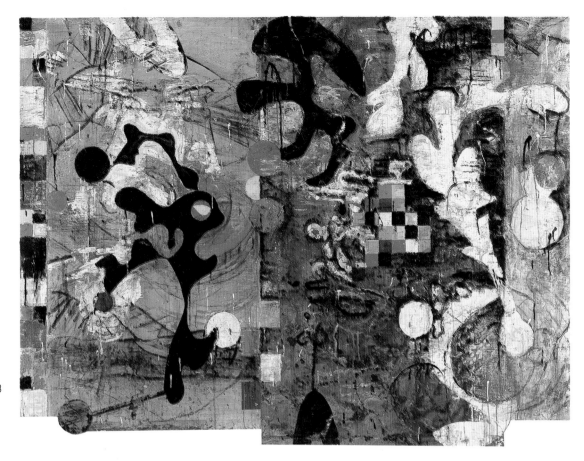

BLACK RABBIT: BEHIND THE MIRROR, 1987–88
MIXED MEDIA ON CANVAS
64½ × 88 INCHES
PRIVATE COLLECTION, STOCKHOLM

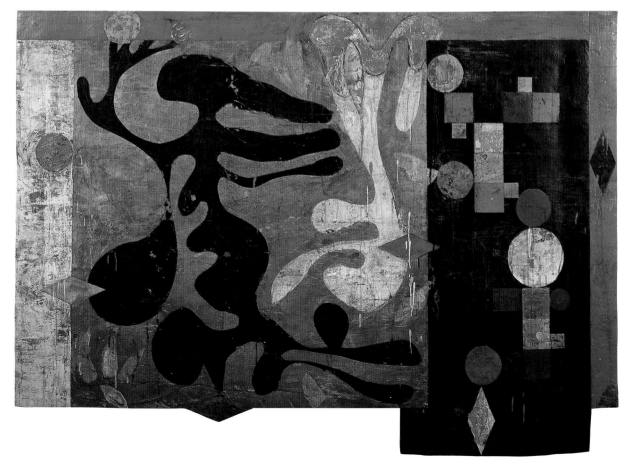

THE BLACK WIDOW, 1987–88
MIXED MEDIA ON CANVAS
59 × 83 INCHES
PRIVATE COLLECTION, DÜSSELDORF

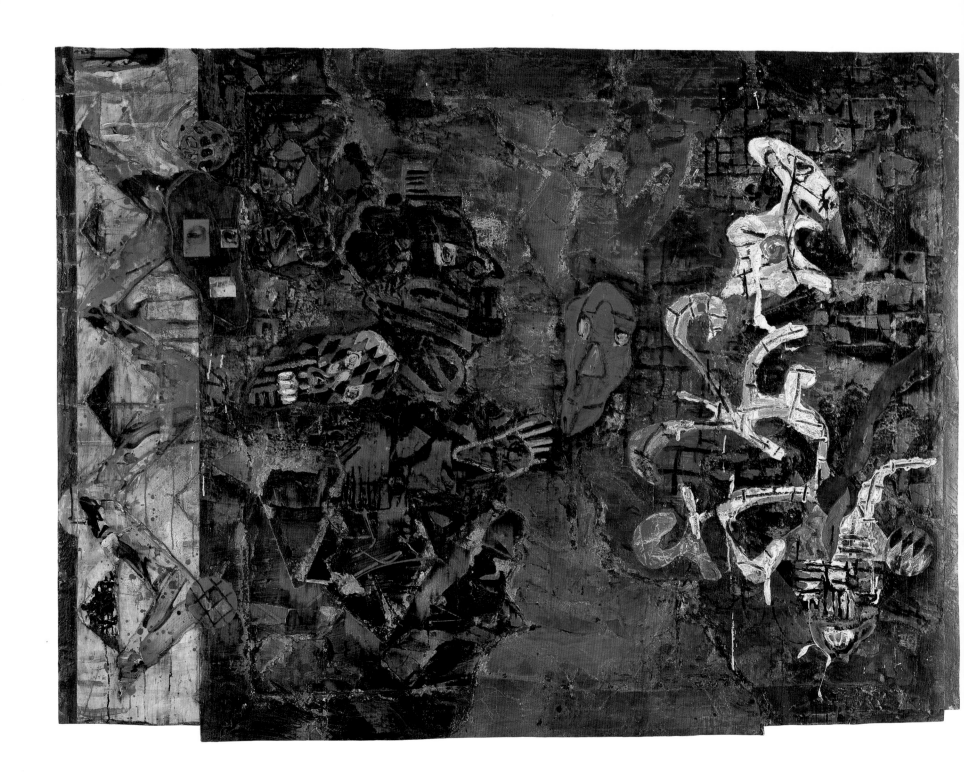

THE JUDGMENT OF CHAC, 1987–88
MIXED MEDIA ON CANVAS
66 × 89 INCHES
PRIVATE COLLECTION

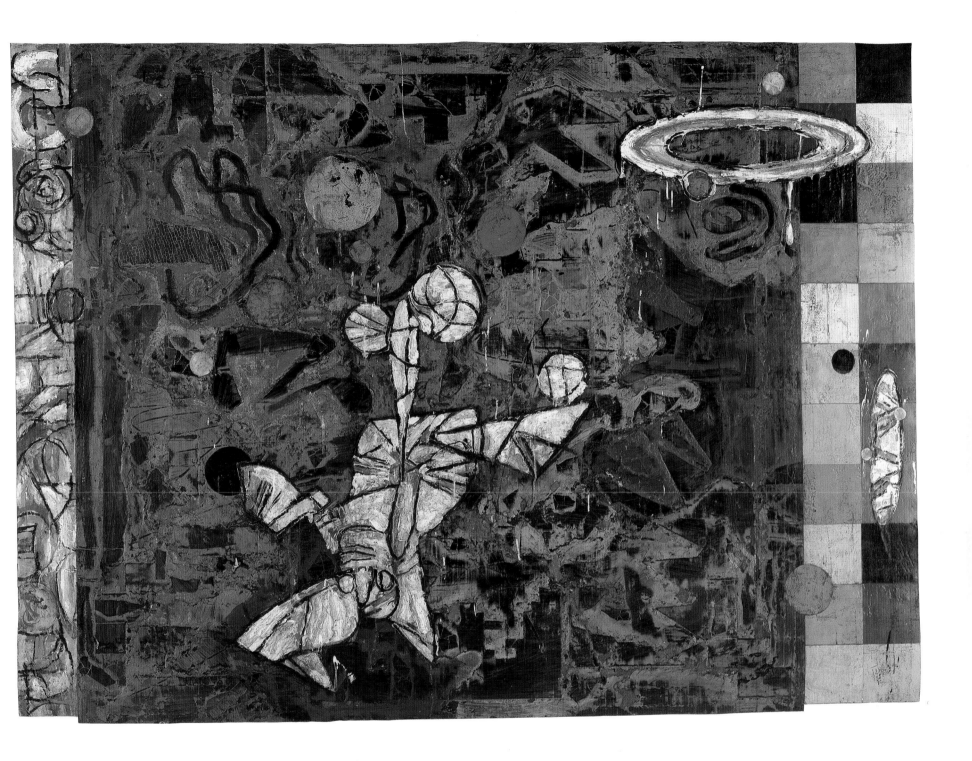

THE CELESTIAL MATADOR, 1987–88

MIXED MEDIA ON CANVAS

67 × 92 INCHES

COLLECTION RICHARD KAHM, STOCKHOLM

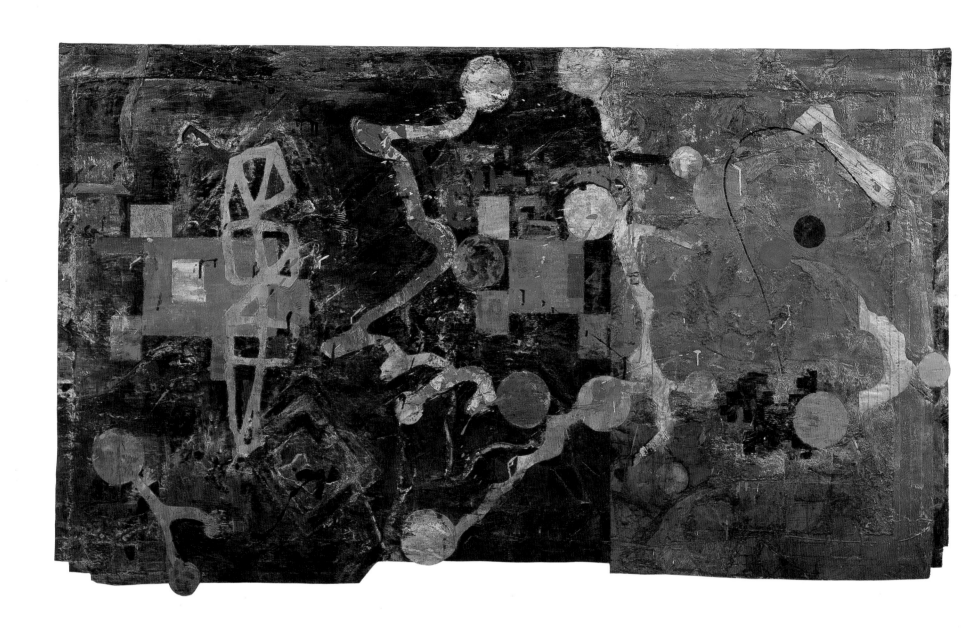

THE ABSENT TWIN: LAGOON, 1986–88
MIXED MEDIA ON CANVAS
50 × 83¾ INCHES
PRIVATE COLLECTION

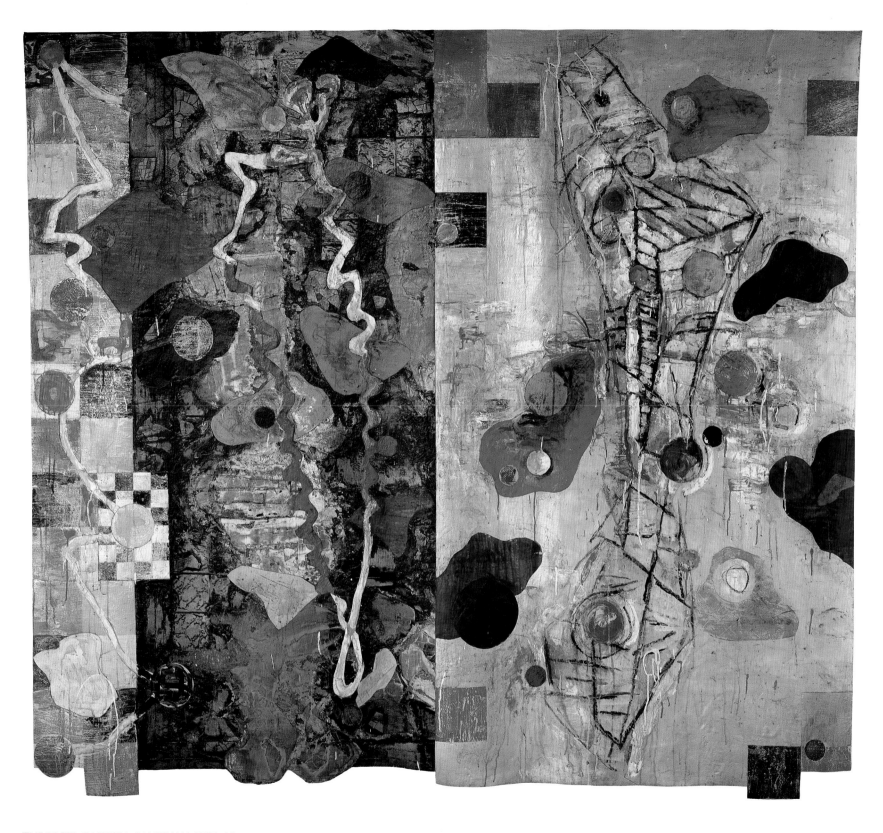

THE FOSSIL GARDEN: CAMBRIAN, 1987–88

MIXED MEDIA ON CANVAS

84¼ × 95 INCHES

COLLECTION LAILA TWIGG-SMITH, HONOLULU

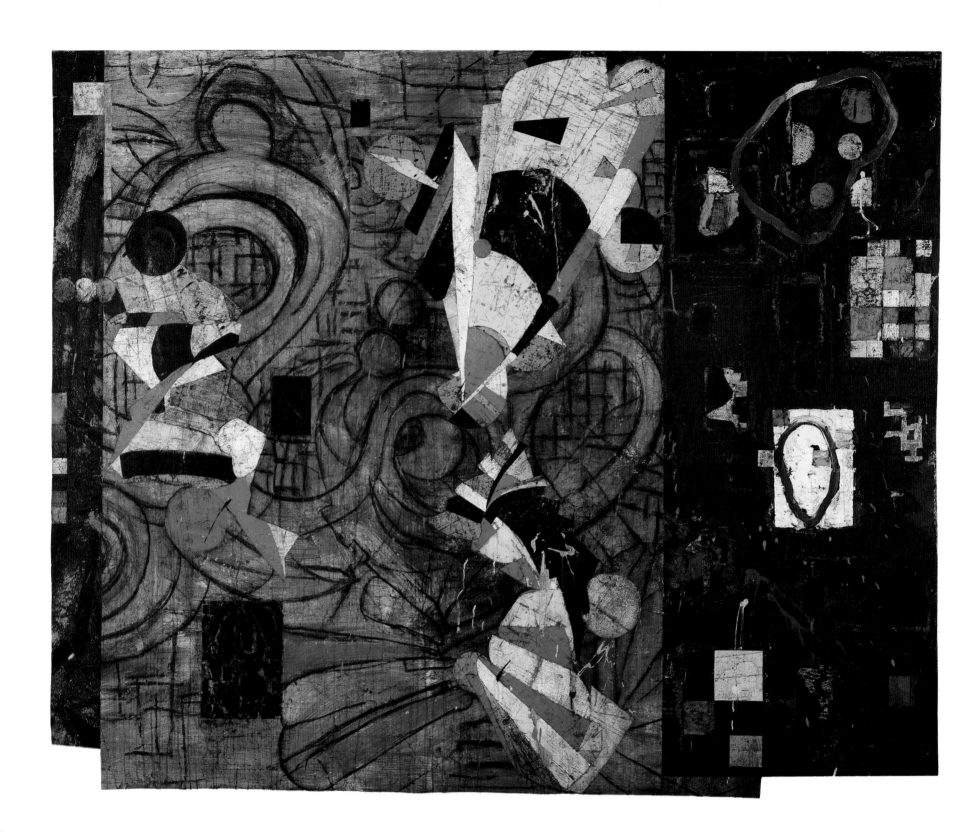

HAUNTING QUESTIONS: MISPLACED PICTURES, 1989

MIXED MEDIA ON CANVAS

90 × 111 INCHES

COLLECTION DR. ALTON STEINER, HOUSTON

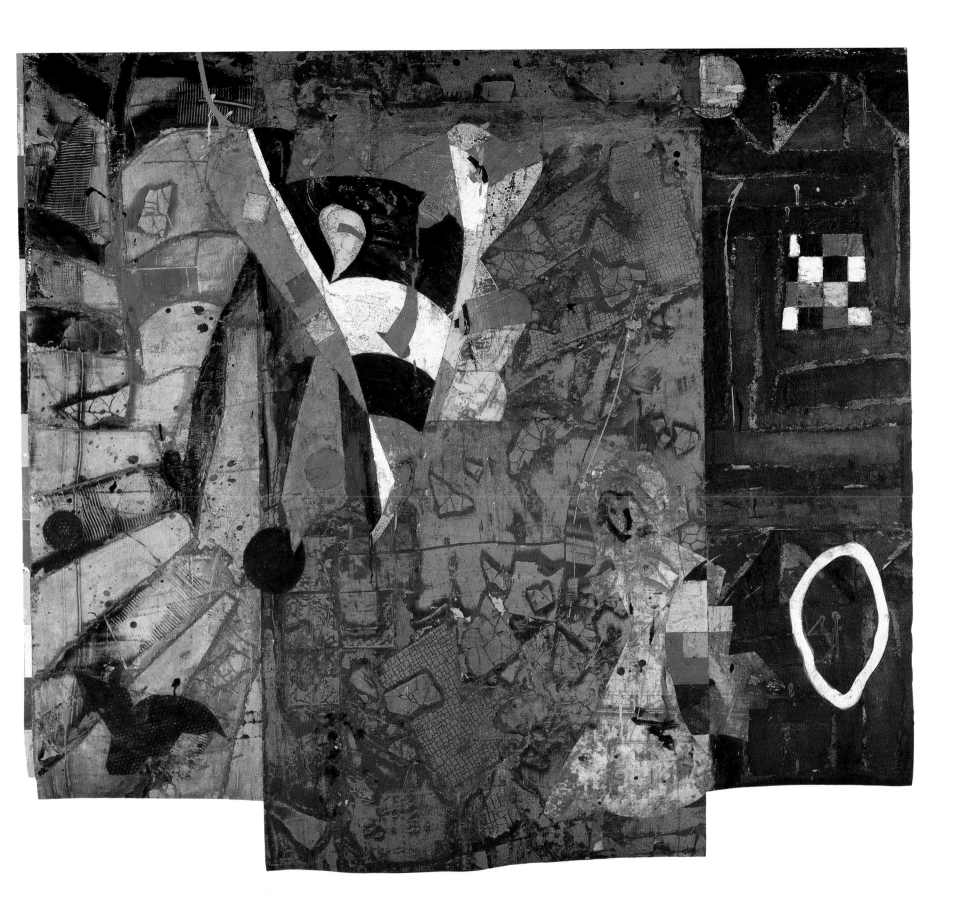

HIS MASTER'S VOICE, 1988–89
MIXED MEDIA ON CANVAS
69¼ × 72 INCHES
COLLECTION FRANK RIBELIN, DALLAS

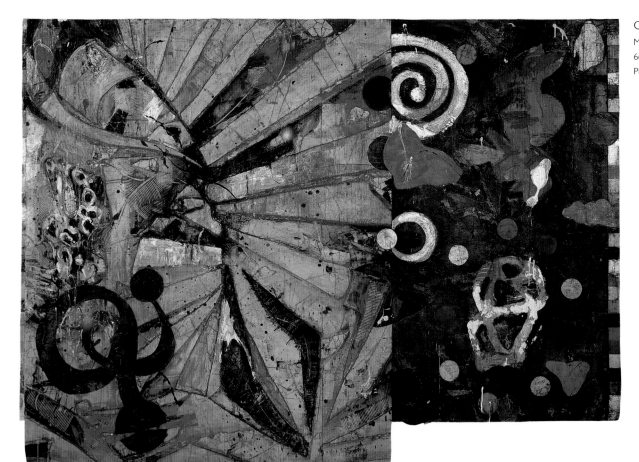

CASTLE OF THE WINDS: GUARDING, 1988–90
MIXED MEDIA ON CANVAS
66¼ × 93¾ INCHES
PRIVATE COLLECTION

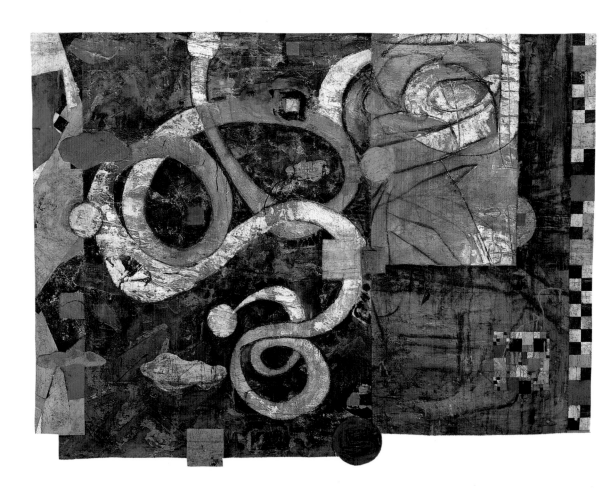

ROAD NOT TRAVELED: LANTERN, 1987–89

MIXED MEDIA ON CANVAS

67½ × 90½ INCHES

COURTESY ANDRE EMMERICH GALLERY, NEW YORK

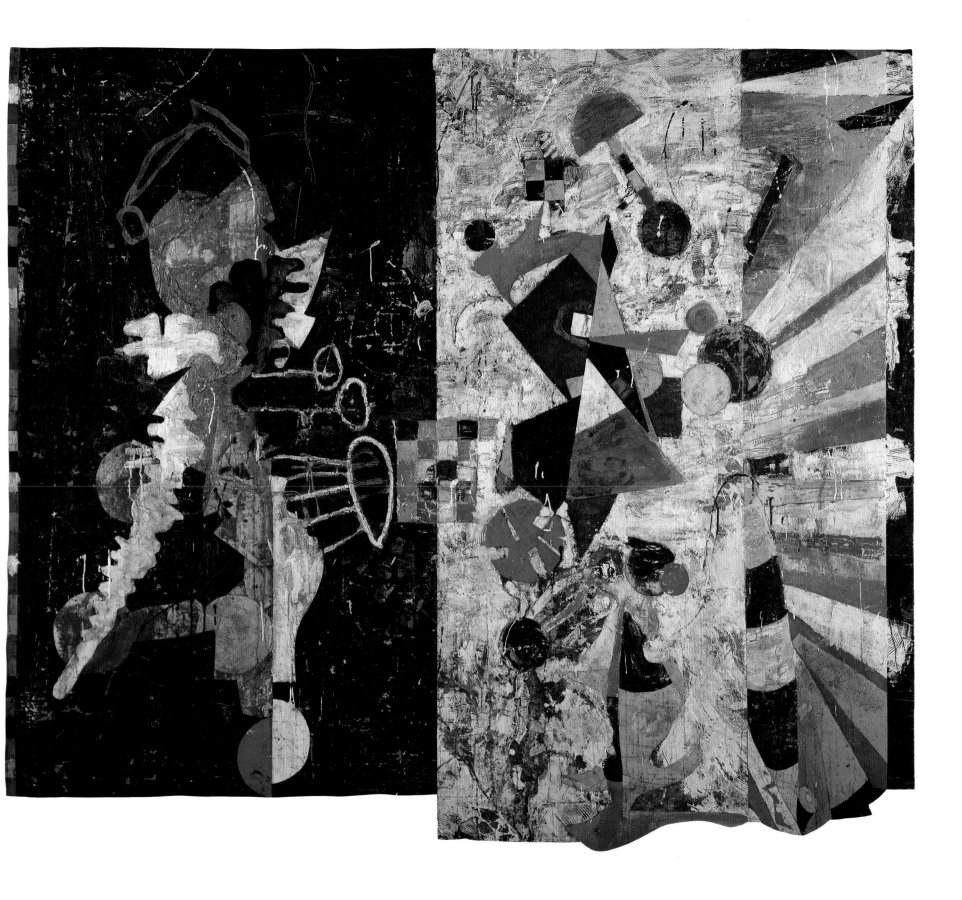

TRANSFORMATION OF SELF, 1988–90

MIXED MEDIA ON CANVAS

78¾ × 91 INCHES

COLLECTION STEVE CHASE, RANCHO MIRAGE, CALIFORNIA

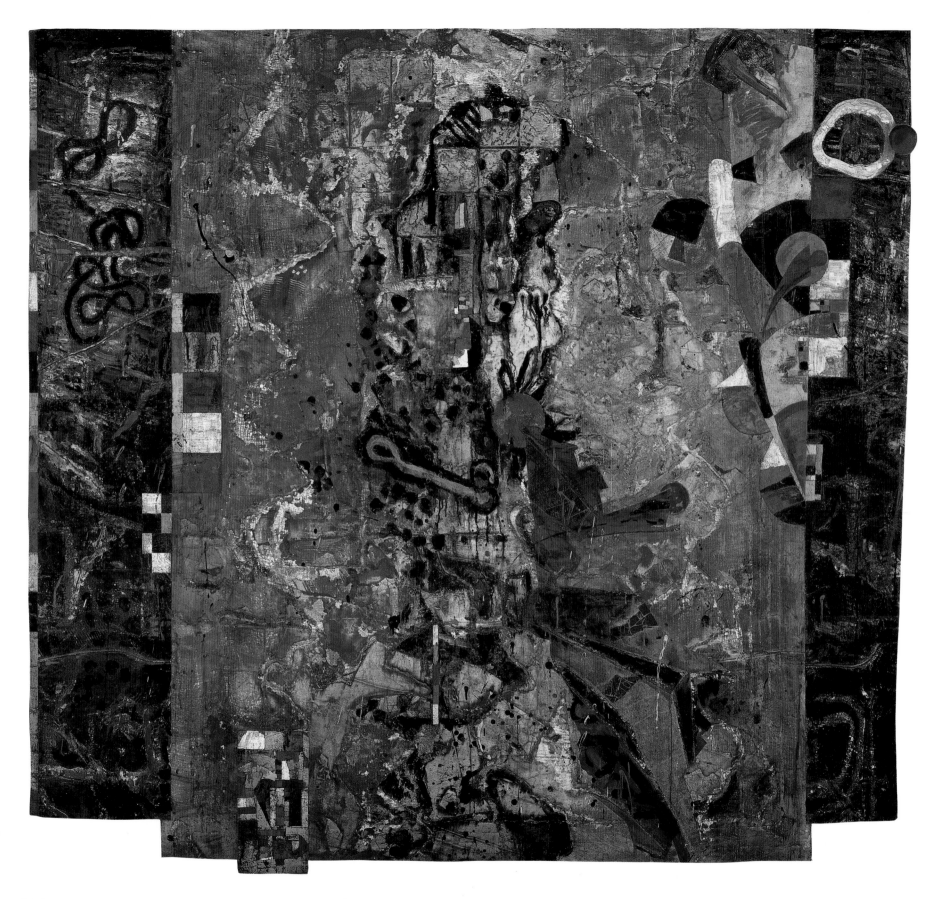

BALZAC IN SHANGRILA, 1988–89

MIXED MEDIA ON CANVAS

84½ × 91¾ INCHES

PRIVATE COLLECTION

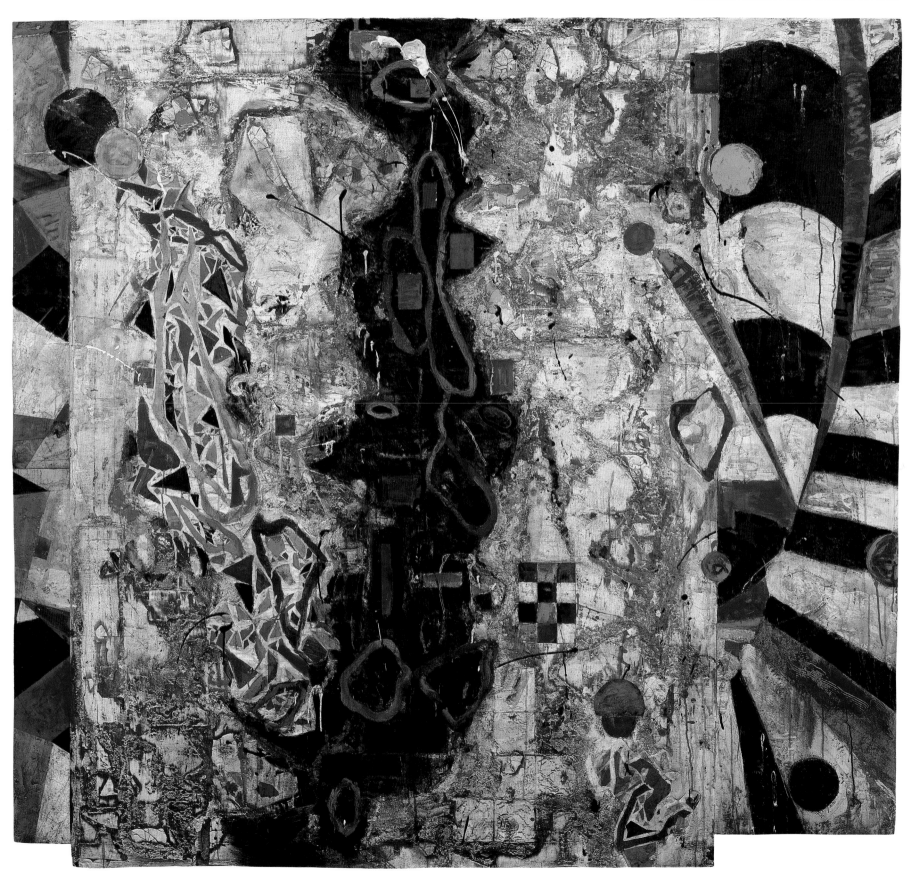

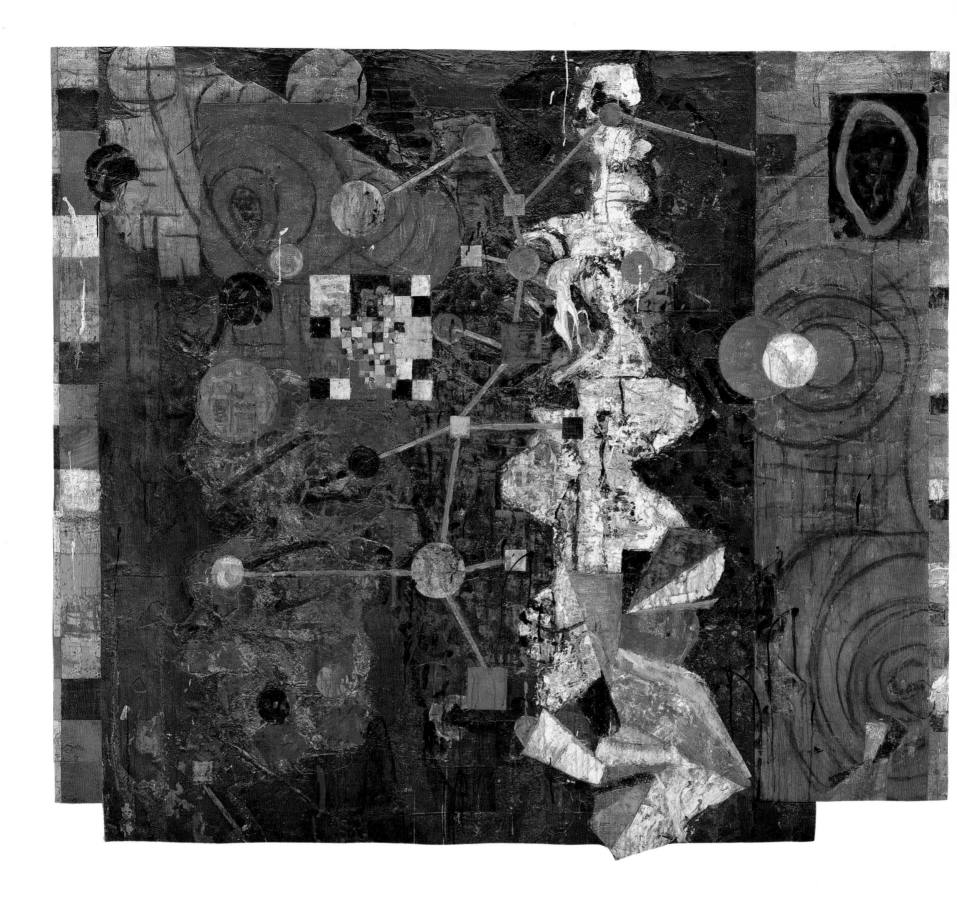

COMMUNICATION BETWEEN EQUALS, 1988–89

MIXED MEDIA ON CANVAS

77½ × 88 INCHES

COLLECTION JILL AND JOHN C. BISHOP, JR., SANTA BARBARA, CALIFORNIA

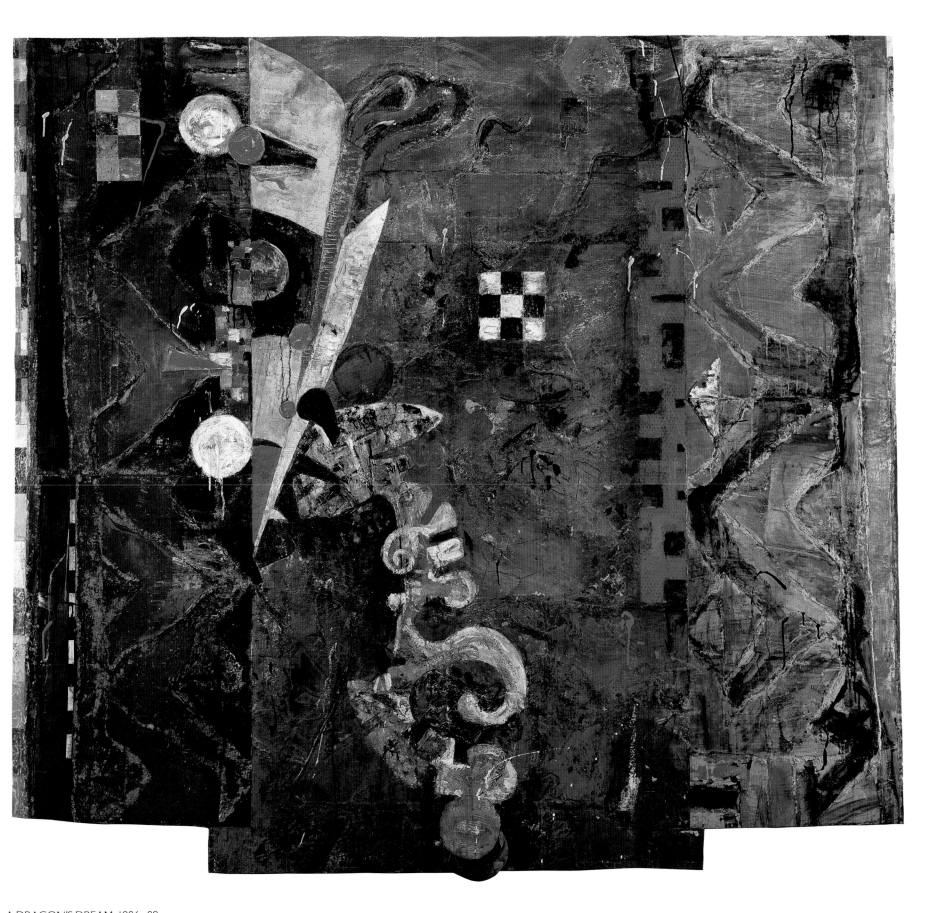

A DRAGON'S DREAM, 1986–89
MIXED MEDIA ON CANVAS
72½ × 79 INCHES
PRIVATE COLLECTION, WINTER PARK, FLORIDA

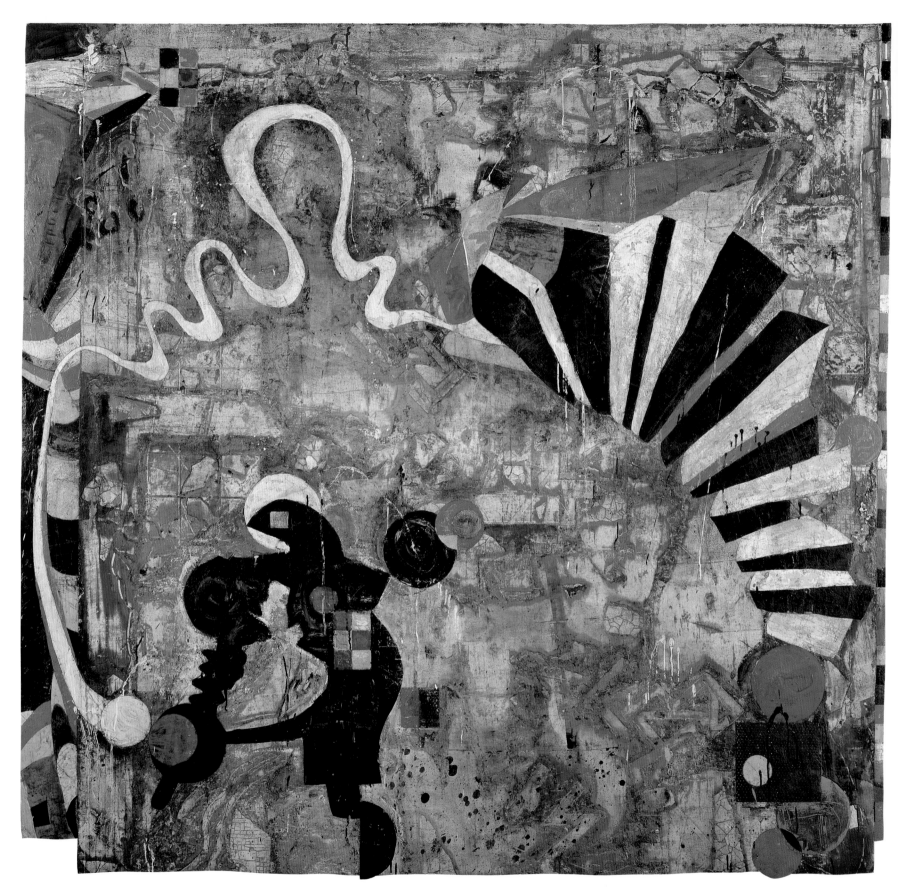

PANDORA'S BOX, 1988–89

MIXED MEDIA ON CANVAS

88 × 90 INCHES

PRIVATE COLLECTION

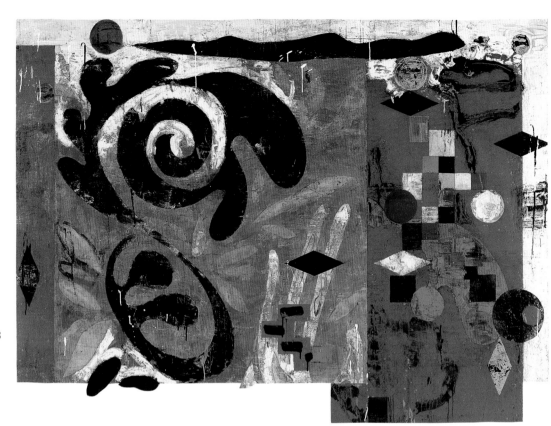

CREATING ANCESTORS: STILL LIFE, 1988
MIXED MEDIA ON CANVAS
60¾ × 82¼ INCHES
PRIVATE COLLECTION, STOCKHOLM

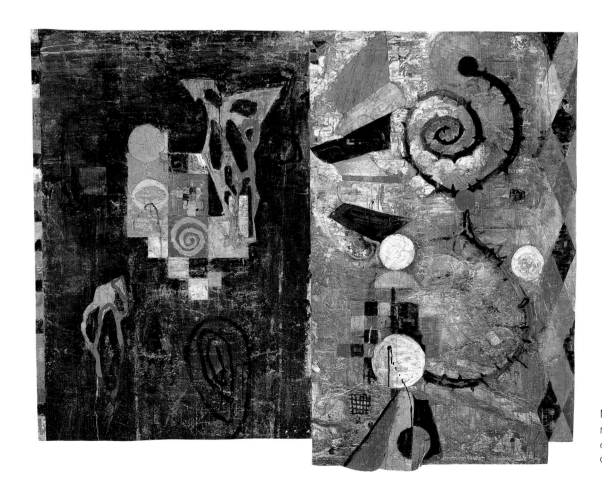

MIDNIGHT GARDENS, 1988–89
MIXED MEDIA ON CANVAS
64 × 81 INCHES
COURTESY ANDRE EMMERICH GALLERY, NEW YORK

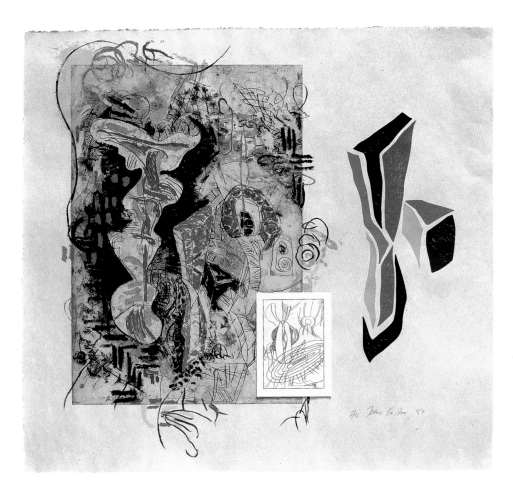

THE FOSSIL GARDEN, from THE RITUAL SERIES, 1987

ETCHING, AQUATINT, LITHOGRAPH, WOODCUT, ENGRAVING, DRYPOINT, AND COLLAGE ON PAPER

36 × 39½ INCHES

COURTESY OF TYLER GRAPHICS LTD., MOUNT KISCO, NEW YORK

PAPUAN GULF, FROM THE RITUAL SERIES, 1987

ETCHING, AQUATINT, LITHOGRAPH, WOODCUT, ENGRAVING, DRYPOINT, AND COLLAGE ON PAPER

36 × 39½ INCHES

COURTESY OF TYLER GRAPHICS LTD., MOUNT KISCO, NEW YORK

PALACE OF QUETZALCOATL, STATE I, from THE RITUAL SERIES, 1987

ETCHING, AQUATINT, AND ENGRAVING ON PAPER

29¾ × 22 INCHES

COURTESY OF TYLER GRAPHICS LTD., MOUNT KISCO, NEW YORK

THE TALKING DRUMS, FROM THE RITUAL SERIES, 1987

ETCHING, AQUATINT, WOODCUT, DRYPOINT, AND COLLAGE
WITH HAND COLORING ON PAPER

36 × 39½ INCHES

COURTESY OF TYLER GRAPHICS LTD., MOUNT KISCO, NEW YORK

THE DREAMS OF GODS, from THE RITUAL SERIES, 1987
LITHOGRAPH, WOODCUT, AND COLLAGE ON PAPER
44⅛ × 49 INCHES
COURTESY OF TYLER GRAPHICS LTD., MOUNT KISCO, NEW YORK

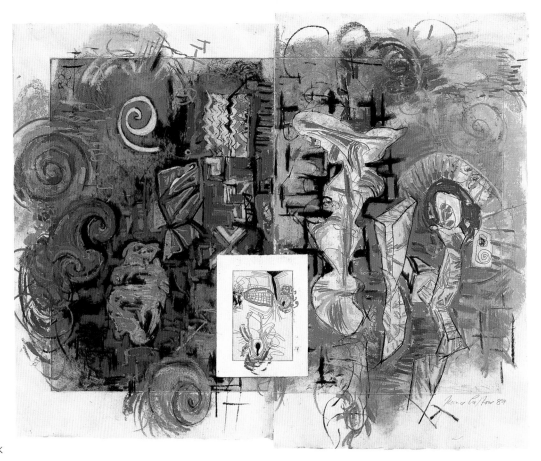

XII, from THE RITUAL SERIES, 1987

MONOPRINT, ETCHING, DRYPOINT, AND COLLAGE
WITH HAND COLORING ON PAPER

36 × 44 INCHES

COURTESY OF TYLER GRAPHICS LTD., MOUNT KISCO, NEW YORK

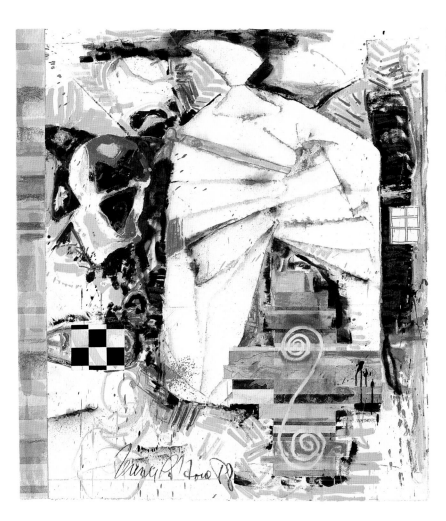

I, from THE CASTLE OF THE WINDS SERIES, 1989
COLORED, PRESSED PAPER PULP, MONOPRINT, AND COLLAGE
WITH HAND COLORING
65 × 57⅞ INCHES
COURTESY OF TYLER GRAPHICS LTD., MOUNT KISCO, NEW YORK

XV, from THE CASTLE OF THE WINDS SERIES, 1989
COLORED, PRESSED PAPER PULP, MONOPRINT, AND COLLAGE
WITH HAND COLORING
39¼ × 60½ INCHES
COURTESY OF TYLER GRAPHICS LTD., MOUNT KISCO, NEW YORK

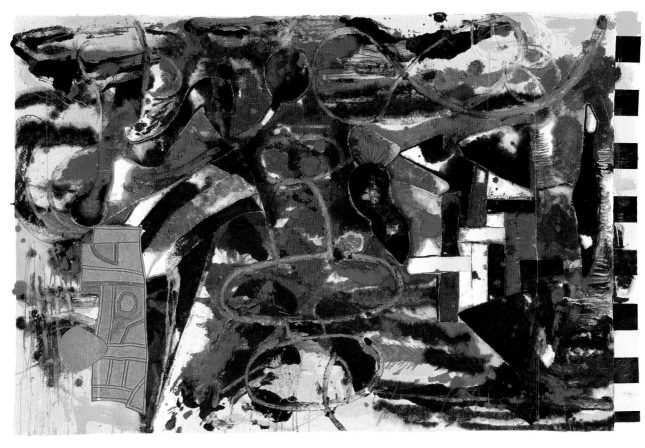

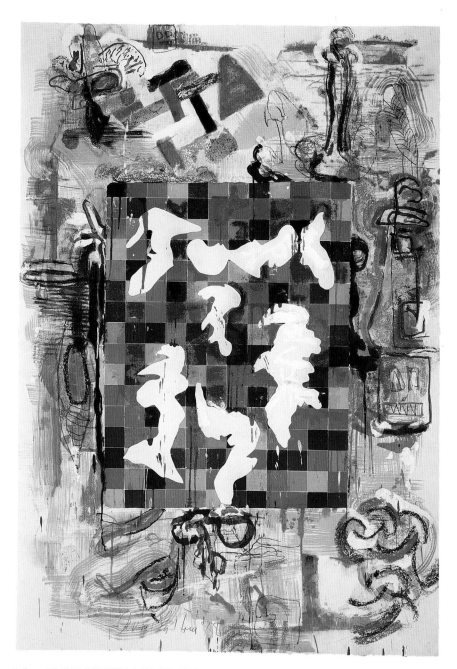

II, from THE TARANTELLA SERIES, 1988
COLORED, PRESSED PAPER PULP, AND COLLAGE WITH HAND COLORING
75¼ × 51½ INCHES
COURTESY OF TYLER GRAPHICS LTD., MOUNT KISCO, NEW YORK

III, from THE TARANTELLA SERIES, 1988
COLORED, PRESSED PAPER PULP, AND COLLAGE WITH HAND COLORING
79½ × 52 INCHES
COURTESY OF TYLER GRAPHICS LTD., MOUNT KISCO, NEW YORK

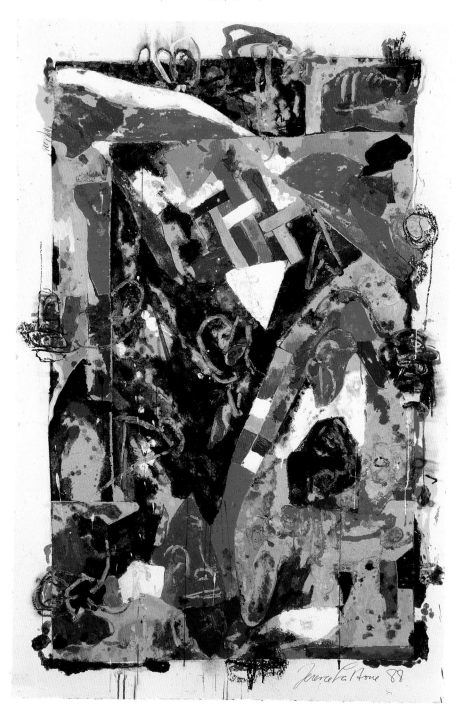

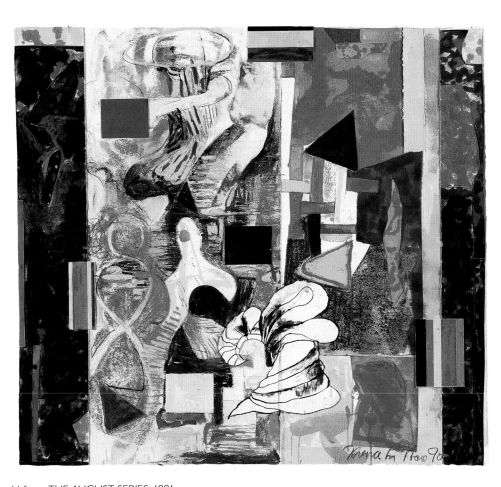

V, from THE AUGUST SERIES, 1991

COLORED, PRESSED PAPER PULP, MONOPRINT, AND COLLAGE
WITH HAND COLORING

56½ × 62⅛

COURTESY OF TYLER GRAPHICS LTD., MOUNT KISCO, NEW YORK

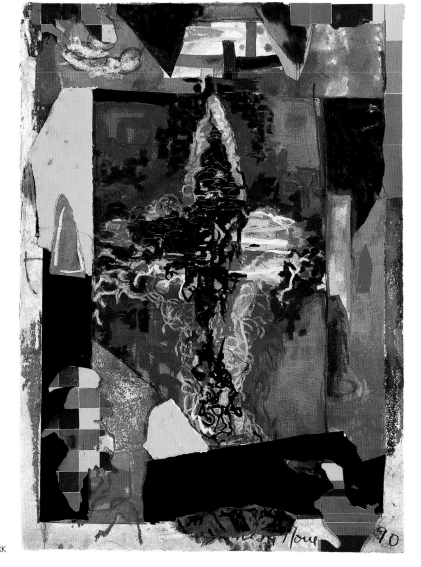

VII, from THE AUGUST SERIES, 1991

COLORED, PRESSED PAPER PULP, MONOPRINT, AND COLLAGE
WITH HAND COLORING

66 × 47½ INCHES

COURTESY OF TYLER GRAPHICS LTD., MOUNT KISCO, NEW YORK

FINGAL'S CAVE, 1991
LITHOGRAPH ON PAPER
44 × 49 INCHES
COURTESY OF TYLER GRAPHICS LTD., MOUNT KISCO, NEW YORK

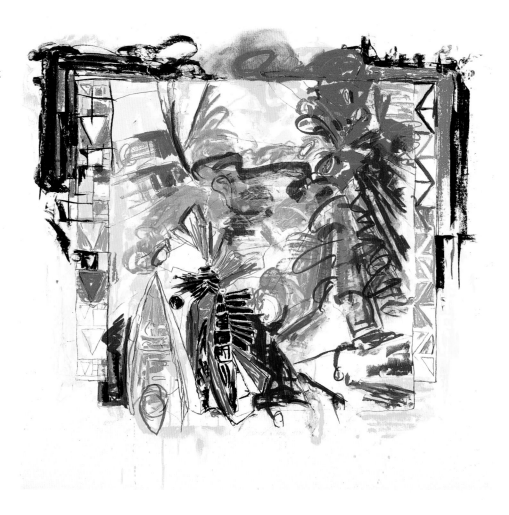

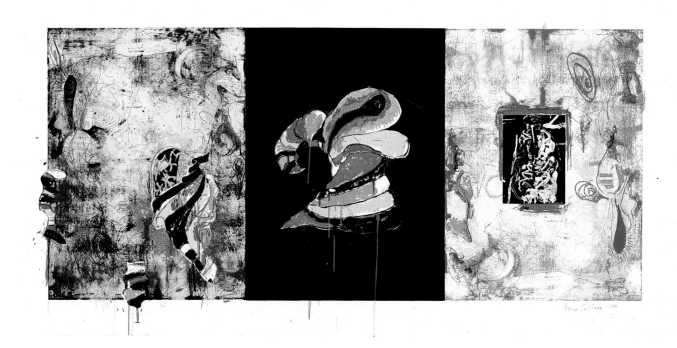

PROSPEROUS VOYAGE, 1991

ETCHING, MEZZOTINT, AQUATINT,
LITHOGRAPH, AND COLLAGE

39¾ × 79⅛ INCHES

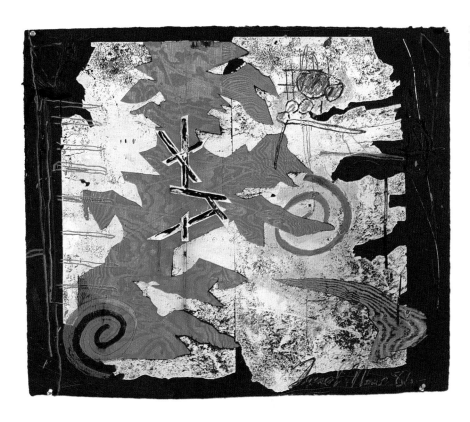

UNTITLED I, 1986–87
MIXED MEDIA ON PAPER
24½ × 29½ INCHES

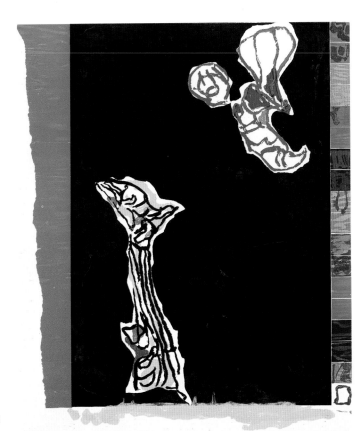

THE SORCERER'S APPRENTICE, 1991
MEZZOTINT, AQUATINT, WOODCUT, AND COLLAGE ON PAPER
50¼ × 39½ INCHES

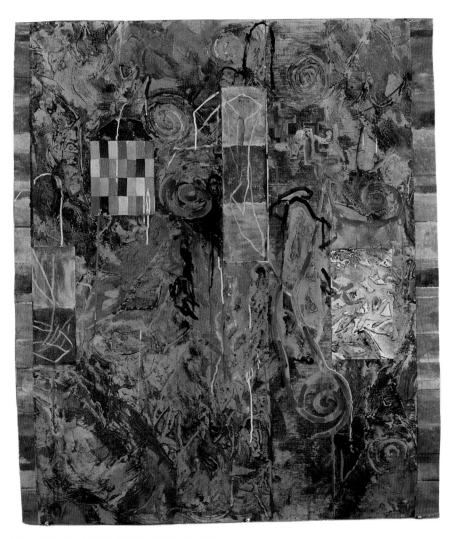

NEW GUINEA HIGHLANDS SUITE #9, 1987

MIXED MEDIA ON PAPER

54¼ × 46½ INCHES

CHINA SEA: ISLANDS OF THE MOON, 1989–90

MIXED MEDIA ON PAPER

41 × 36 INCHES

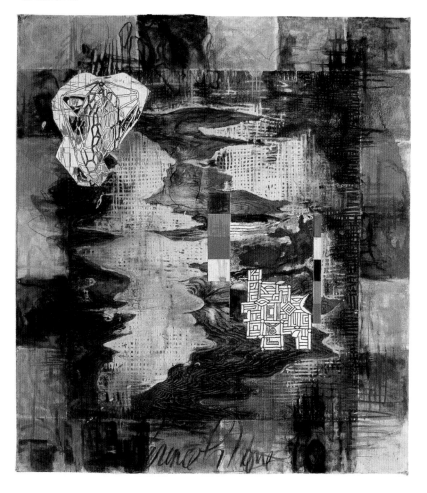

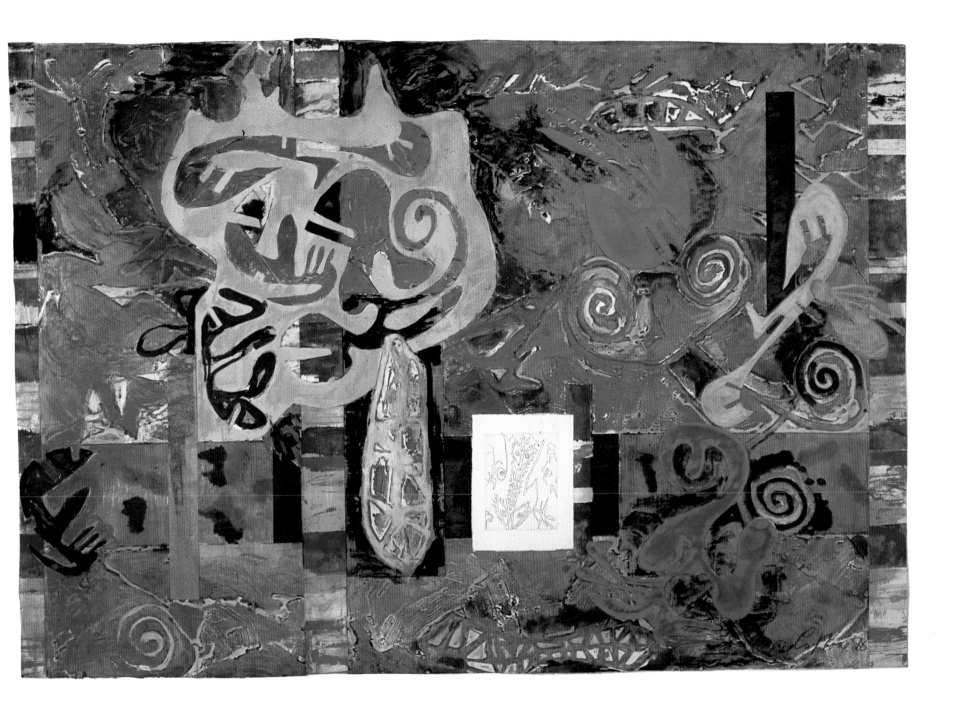

#5, from THE MATISSE IN AFRICA SERIES, 1988

MIXED MEDIA ON PAPER

42½ × 61¾ INCHES

COLLECTION MCCUTCHEN, DOYLE, BROWN, AND ENERSEN, SAN FRANCISCO

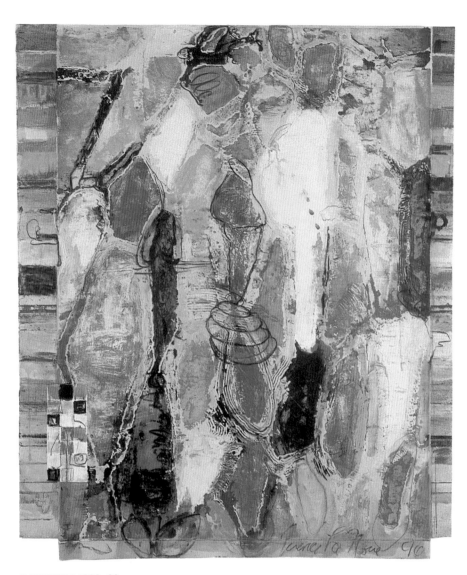

INTERIOR I, 1989–90
MIXED MEDIA ON PAPER
58¼ × 49 INCHES

STAIRCASE: VISION, 1990
MIXED MEDIA ON PAPER
59¼ × 50 INCHES
COURTESY OF EXPERIMENTAL WORKSHOP, SAN FRANCISCO

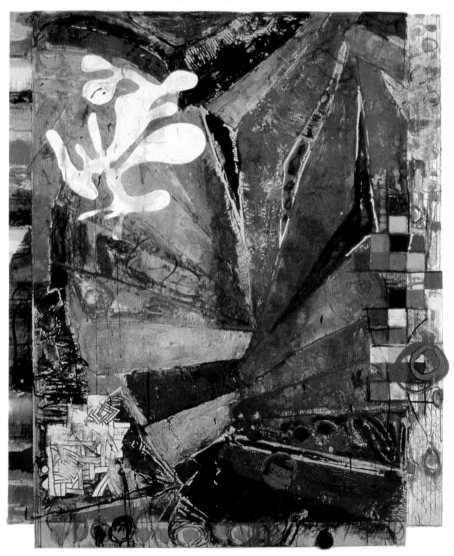

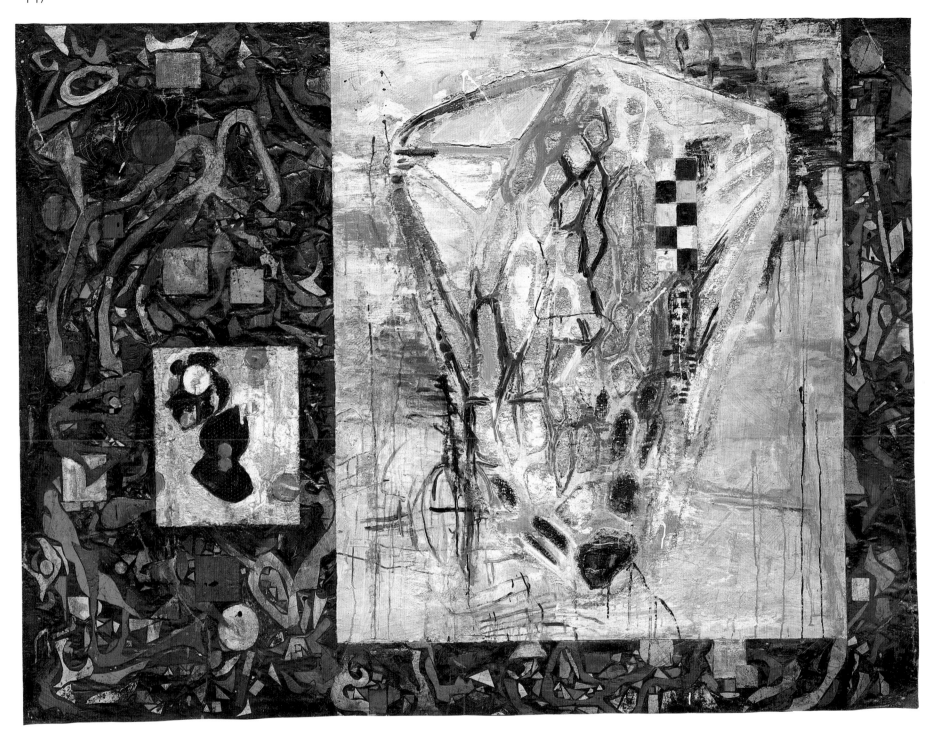

THREE WINDOWS: GEMSTONE, 1988–90
MIXED MEDIA ON CANVAS
61½ × 81½ INCHES
COURTESY ANDRE EMMERICH GALLERY, NEW YORK

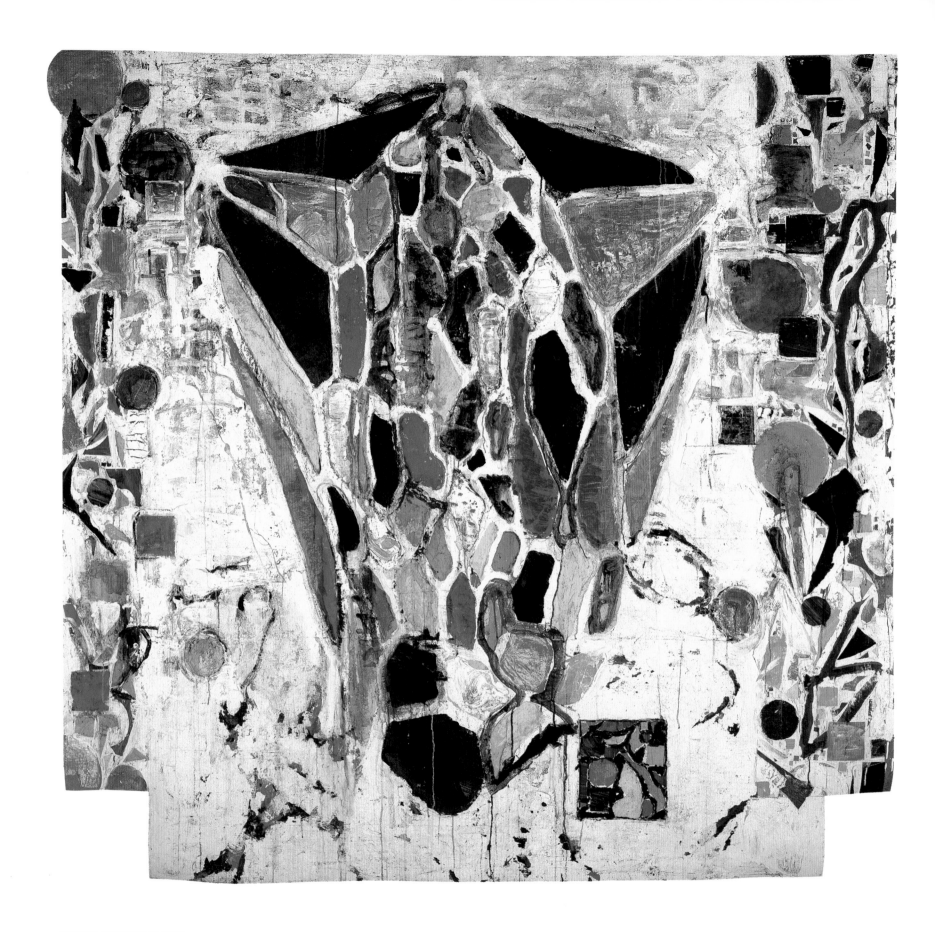

ARCTIC GEMSTONE, 1990
MIXED MEDIA ON CANVAS
88 × 83½ INCHES
PRIVATE COLLECTION

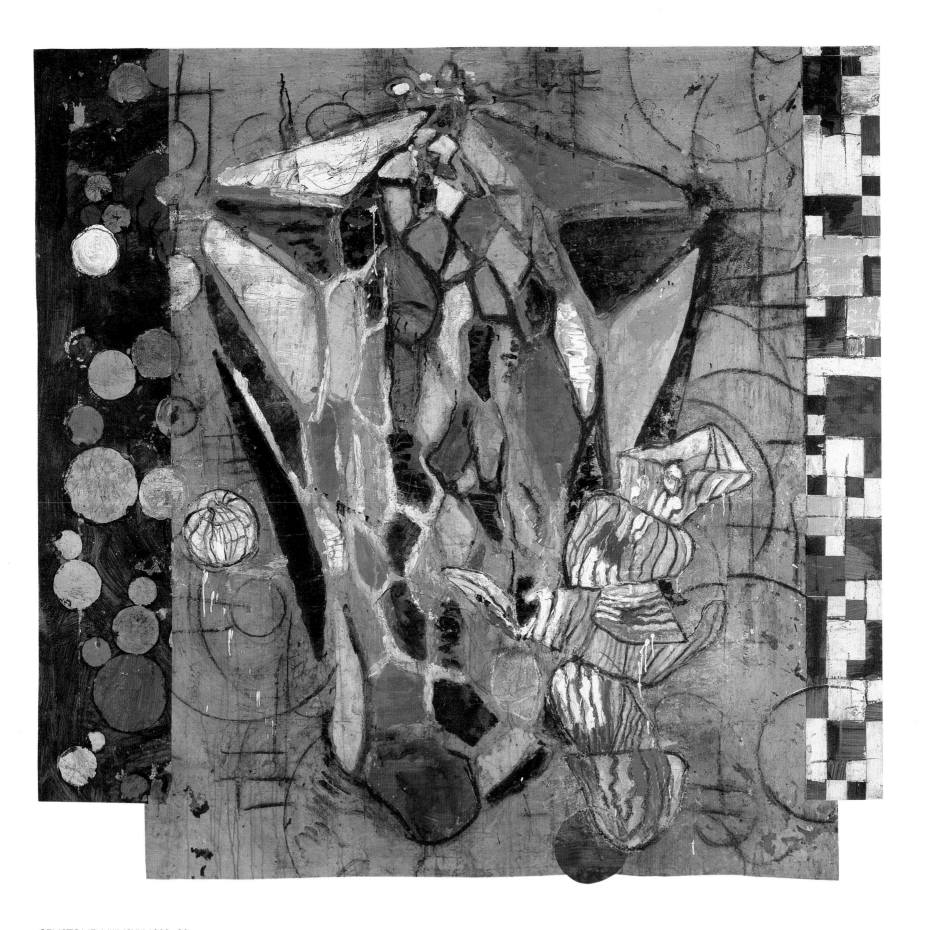

GEMSTONE: NIJINSKY, 1989–90

MIXED MEDIA ON CANVAS

83½ × 87 INCHES

PRIVATE COLLECTION, COURTESY ZOLLA/LIEBERMAN GALLERY, INC., CHICAGO

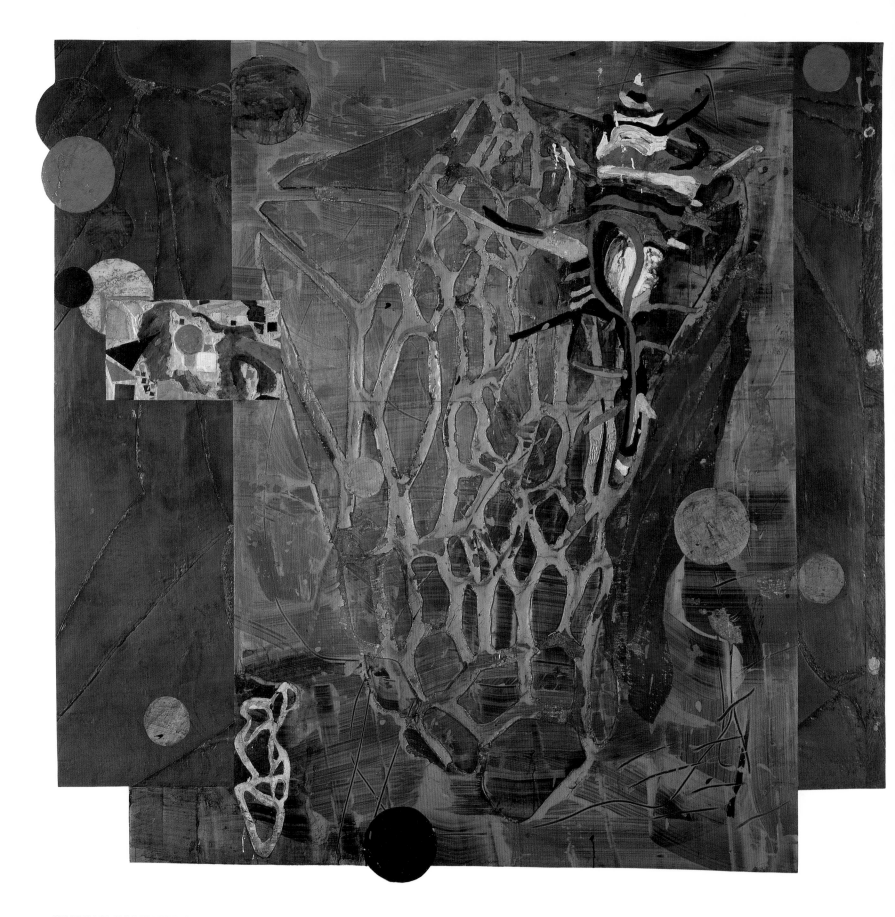

GEMSTONE: SUNKEN TREASURE, 1990

MIXED MEDIA ON CANVAS

84½ × 87½ INCHES

COURTESY ANDRE EMMERICH GALLERY, NEW YORK

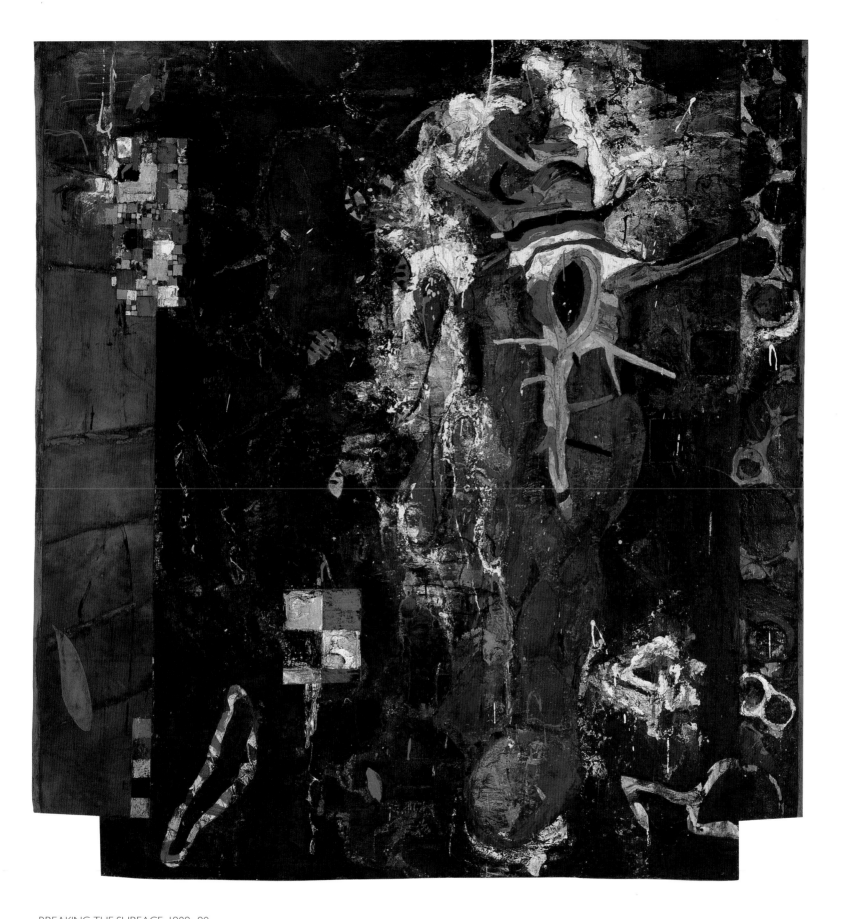

BREAKING THE SURFACE, 1989–90

MIXED MEDIA ON CANVAS

84¼ × 79¾ INCHES

COURTESY ZOLLA/LIEBERMAN GALLERY, INC., CHICAGO

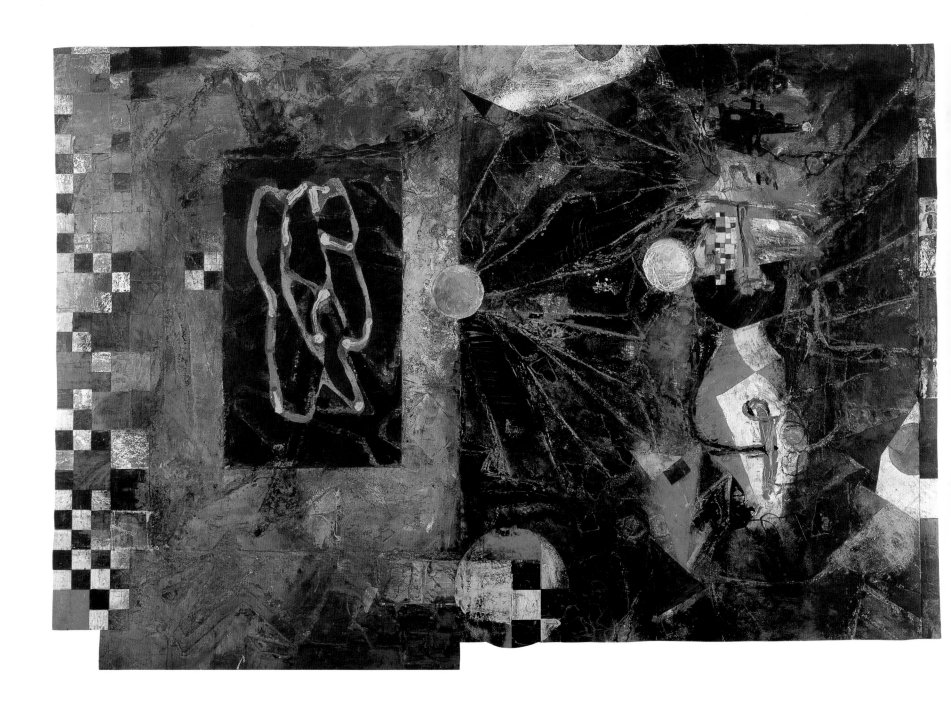

THE PORTRAIT GALLERY AT NIGHT, 1989–90

MIXED MEDIA ON CANVAS

62½ × 90½ INCHES

COURTESY ANDRE EMMERICH GALLERY, NEW YORK

NEPTUNE'S GATE, 1990
MIXED MEDIA ON CANVAS
56 × 62 INCHES
PRIVATE COLLECTION, BOSTON

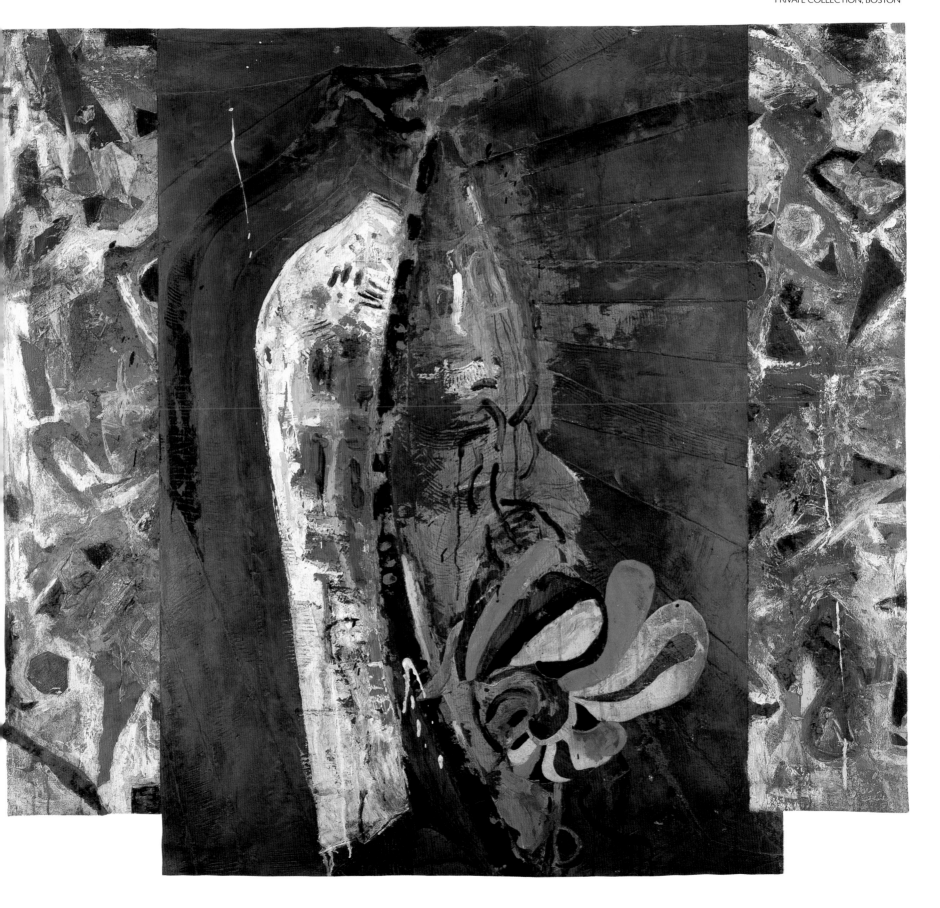

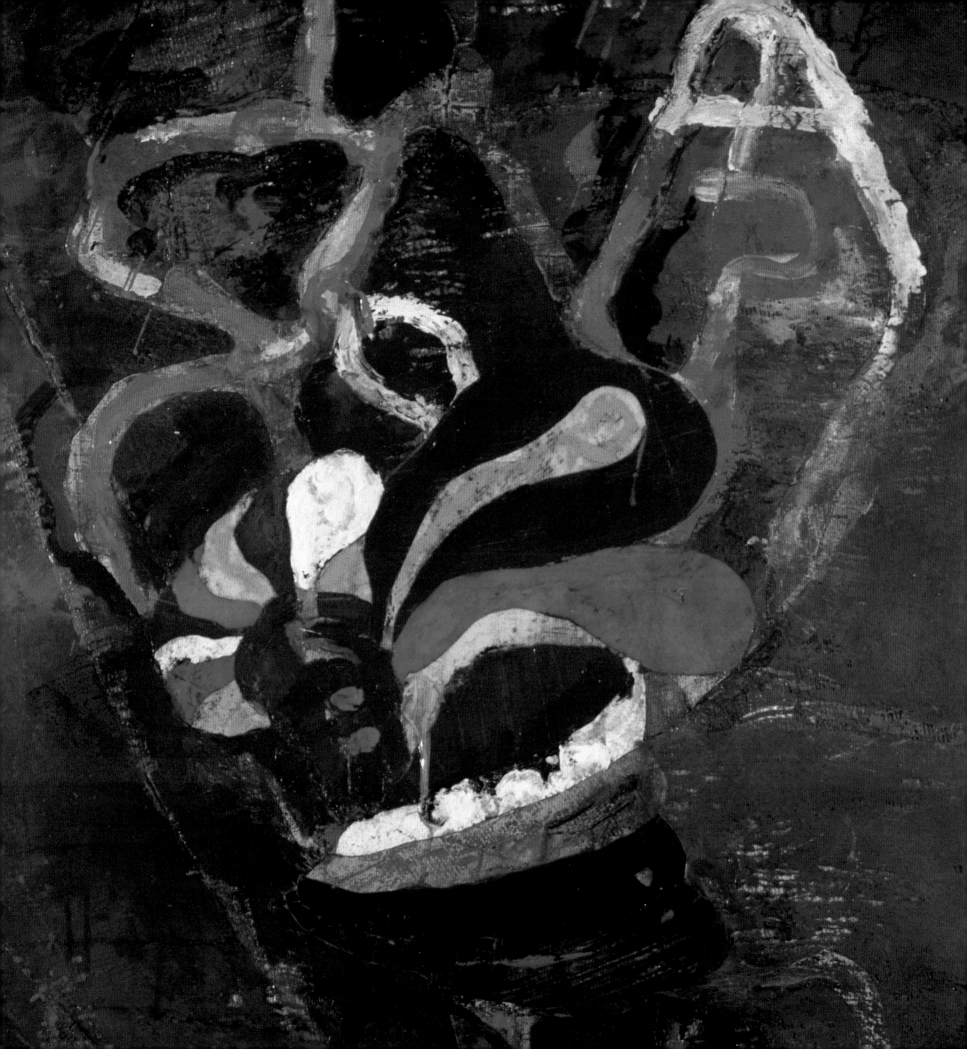

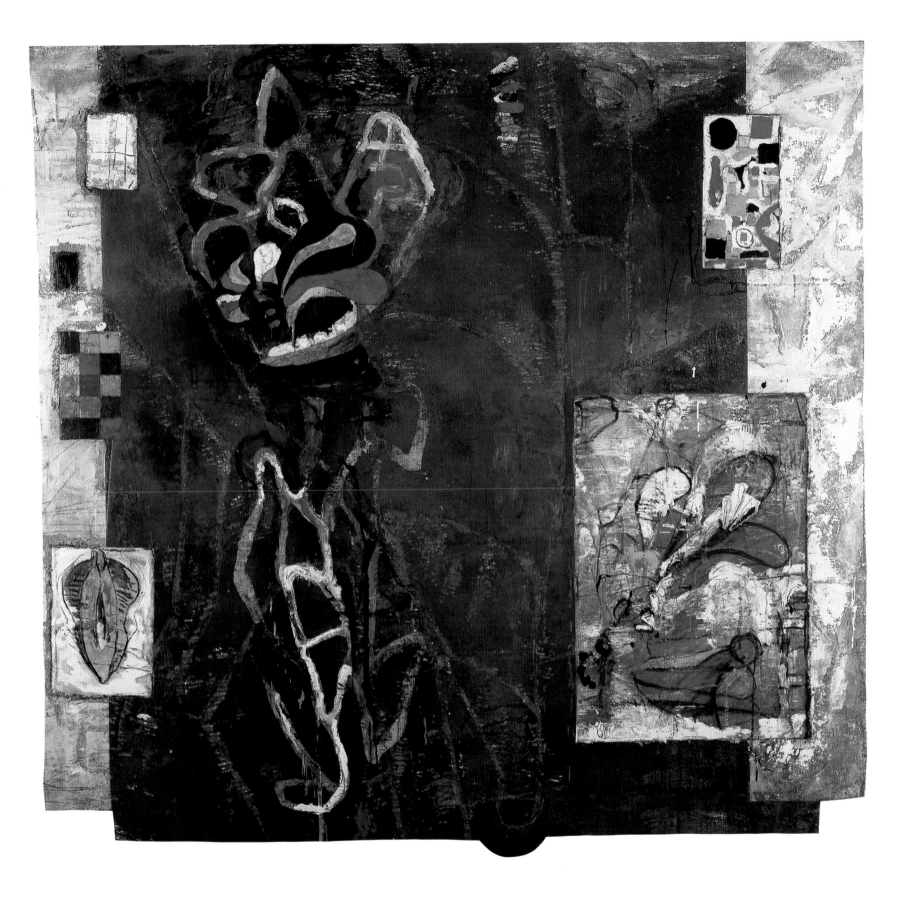

Detail of HOTEL DU LAC

HOTEL DU LAC, 1990
MIXED MEDIA ON CANVAS
76 × 79 INCHES
COURTESY ANDRE EMMERICH GALLERY, NEW YORK

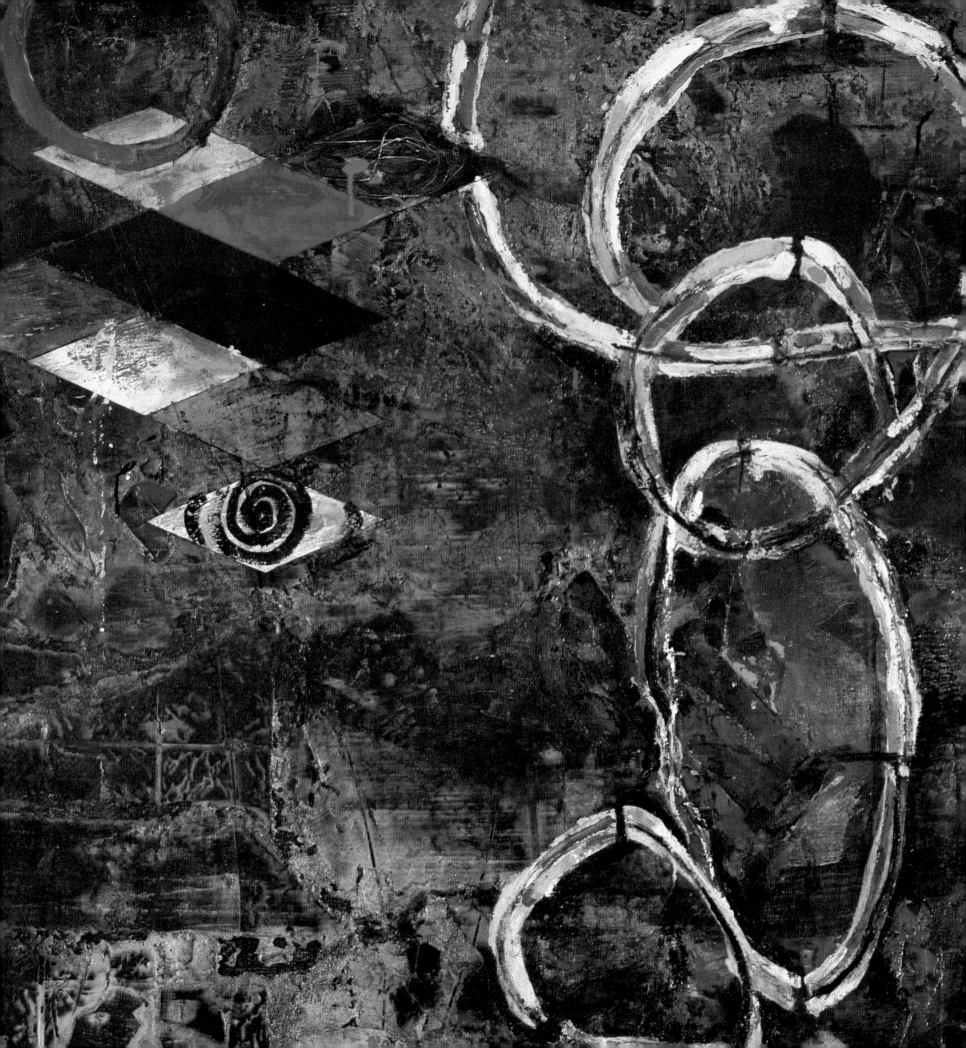

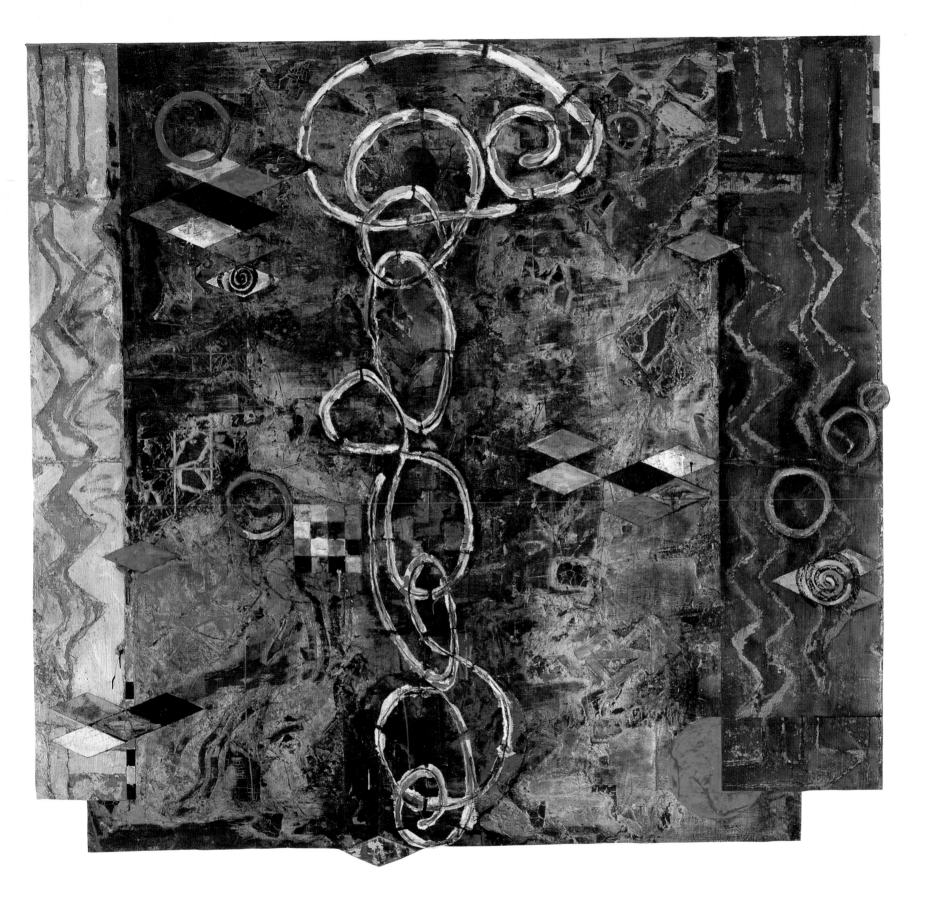

Detail of LIFE IN THE POND: SOME HOPE

LIFE IN THE POND: SOME HOPE, 1989–90
MIXED MEDIA ON CANVAS
94 × 100½ INCHES
COLLECTION DR. DOROTHEA KEESER, HAMBURG

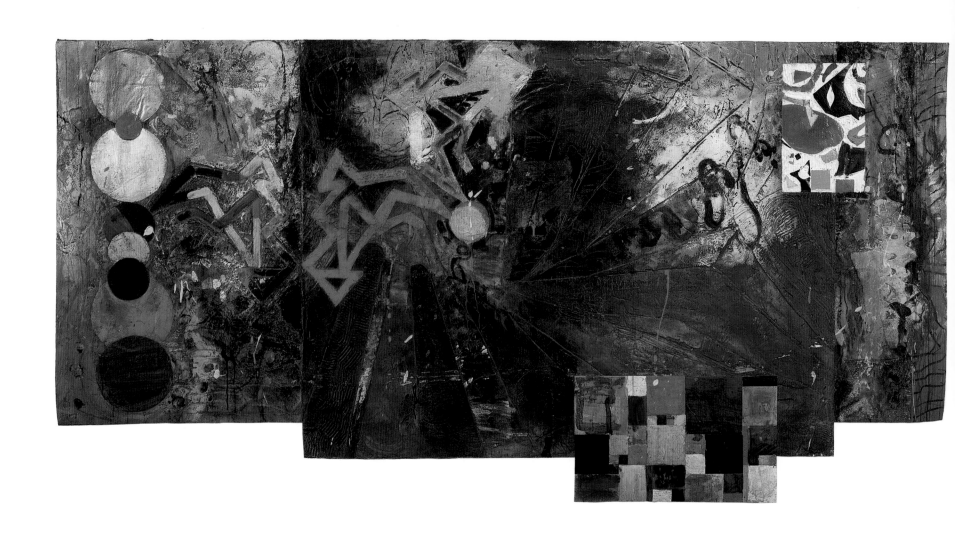

LOOKING INTO THE NIGHT, 1990–91

MIXED MEDIA ON CANVAS

47 × 93½ INCHES

COLLECTION PAUL AND SUZANNE JENKINS, NEW YORK

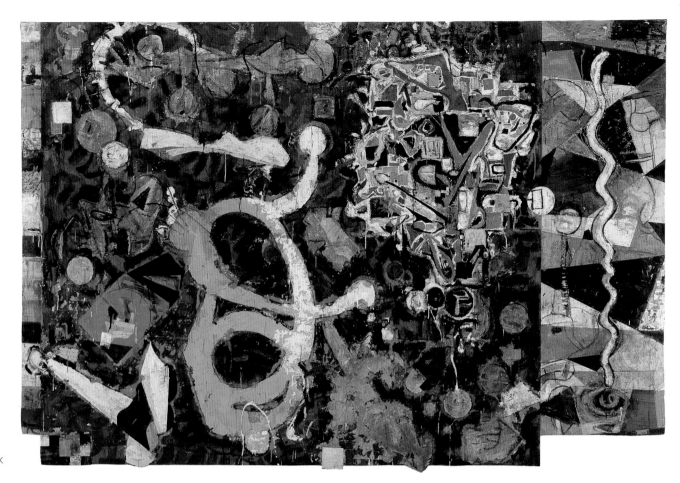

NIGHTTOWN, 1988–90
MIXED MEDIA ON CANVAS
83 × 124 INCHES
COURTESY ANDRE EMMERICH GALLERY, NEW YORK

HAITIAN ODALISQUE, 1990–91
MIXED MEDIA ON CANVAS
60 × 102 INCHES
COURTESY ANDRE EMMERICH GALLERY,
NEW YORK

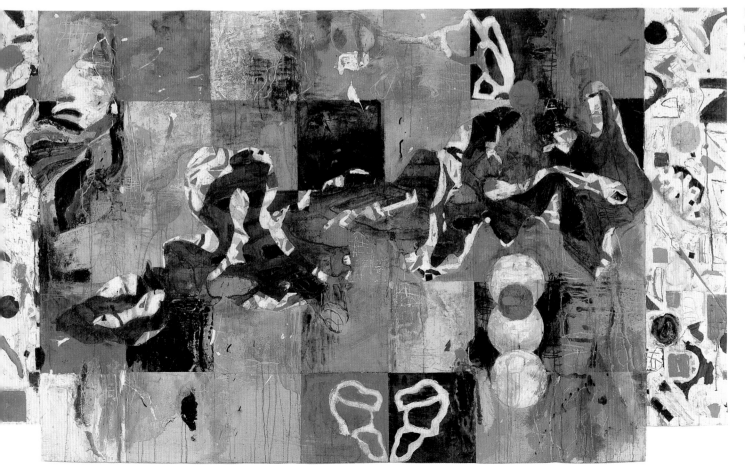

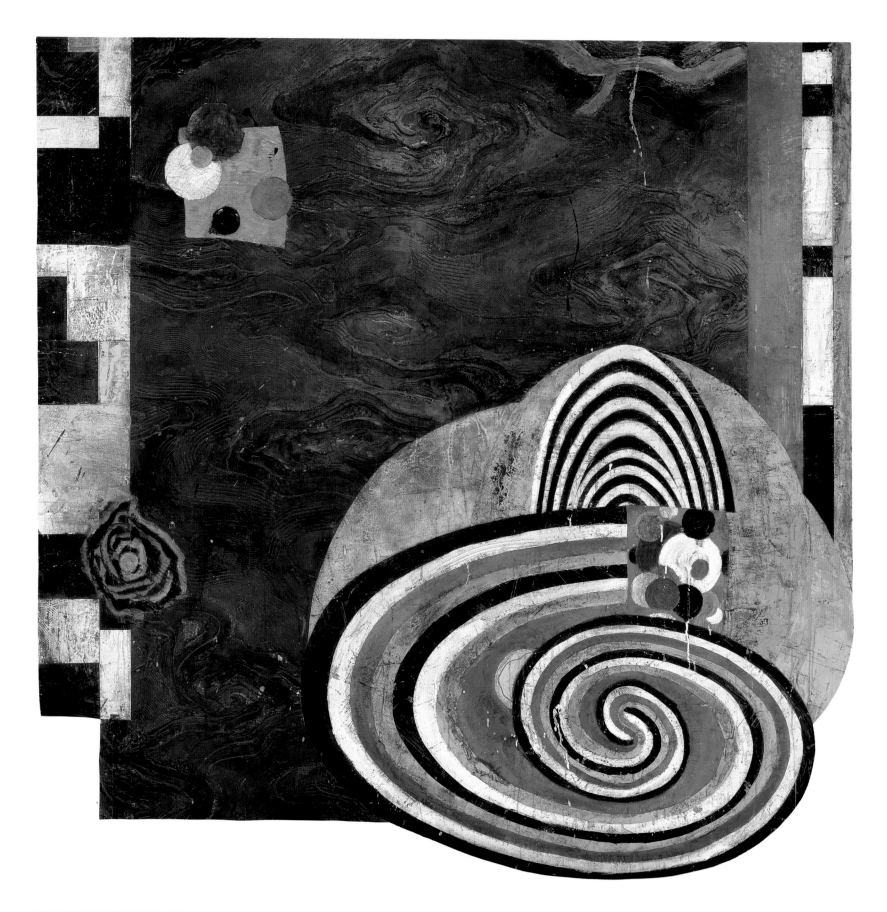

THE SMITHY OF THE SOUL, 1991
MIXED MEDIA ON CANVAS
75½ × 75½ INCHES
COURTESY ANDRE EMMERICH GALLERY, NEW YORK

A NOTE ON TERENCE LA NOUE'S STUDIO PROCESSES

Terence La Noue's work in the studio begins with a casting process. Low-relief molds that he has designed, built up, and modified over the years are placed flat on the studio floor. After they have been treated with a resist, several layers of colored acrylic are brushed onto them. When these first layers have dried somewhat, a layer of thin cotton netting, saturated with more colored acrylic, is applied. Following this the final layer, which consists of acrylic-saturated canvas, is laid on. This is left to dry overnight.

By the next day, all of these layers have bonded and can be pulled out of the mold as a single unit. The often translucent first layers become the front surface of the cast sheet, with the last, canvas layer at the back, and the netting layer in between these. Often, charcoal drawing, graphite, and metallic powders are integrated into the layers for various effects. Flat sheets of more pure color tones are also cast, using a similar method, directly from the scored studio floor.

These sheets of cast material are then cut up to form sections of the many panels and patterns that make up a finished work. They are glued together from the back with more panels of acrylic-saturated canvas. La Noue then completes the work with more drawing and painting directly on the front surface.

<div align="right">

ROBERT KUSZEK
Studio Manager

</div>

TERENCE LA NOUE

CHRONOLOGY

Terence La Noue was born in 1941 in Hammond, Indiana. He received a bachelor of fine arts degree from Ohio Wesleyan University, Delaware, Ohio, in 1964, and completed a master's degree in fine arts at Cornell University, Ithaca, New York, in 1967.

FELLOWSHIPS
1964–65 Fulbright Master Student fellowship, Hochschule für Bildende Künste, Berlin.
1972–73 National Endowment for the Arts.
1973 New York City Department of Cultural Affairs grant.
1982–83 John Simon Guggenheim Memorial Foundation fellowship.
1983–84 National Endowment for the Arts.

TEACHING EXPERIENCE
1963–64 Visiting Instructor of Sculpture, Denison University, Granville, Ohio.
1967–72 Assistant Professor of Art, Trinity College, Hartford, Connecticut.
1972–84 Associate Professor and Coordinator of Art, La Guardia Community College, City University of New York.

SELECTED EXHIBITIONS AND COLLECTIONS

SOLO EXHIBITIONS
1964 Denison University, Granville, Ohio.
1965 Galerie Springer, Berlin.
1967 Cornell University, Ithaca, New York.
1968 Trinity College, Hartford, Connecticut.
1969 Trinity College, Hartford, Connecticut.
1970 Trinity College, Hartford, Connecticut.
1971 Paley and Lowe, New York.
1972 Paley and Lowe, New York; University of Rochester, New York.
1973 Paley and Lowe, New York.
1974 Ohio Wesleyan University, Delaware, Ohio; Nancy Hoffman Gallery, New York.
1976 Nancy Hoffman Gallery, New York.
1977 Nancy Hoffman Gallery, New York; Galerie Farideh Cadot, Paris.
1978 Nancy Hoffman Gallery, New York; Zand Gallery, Teheran.
1979 Kingsborough Community College Gallery, Brooklyn, New York.
1980 Nancy Hoffman Gallery, New York; Tangeman Gallery, University of Cincinnati, Ohio; Florida International University, Miami; Suzanne Brown Gallery, Scottsdale, Arizona.
1981 Nancy Hoffman Gallery, New York; Nicola Jacobs Gallery, London.
1982 Fabian Carlson Gallery, Göteborg, Sweden.
1983 Gallery Ninety-Nine, Bay Harbor Islands, Florida; "Paintings and Works on Paper," Siegel Contemporary Art, New York. "Terence La Noue: Recent Paintings and Drawings," Arts Club of Chicago.
1984 "Paintings and Works on Paper," Zolla/Lieberman Gallery, Chicago; Tomasulo Gallery, Union County College, Cranford, New Jersey.
1985 Eve Mannes Gallery, Atlanta; Gallery Ninety-Nine, Bay Harbor Islands, Florida; Ruth Siegel Gallery, New York.
1986 Cirrus Gallery, Los Angeles; Davis/McClain Gallery, Houston; Experimental Workshop, International Contemporary Art Fair, Los Angeles; Zolla/Lieberman Gallery, Chicago.
1987 André Emmerich Gallery, New York; Dorothy Goldeen Gallery, Santa Monica, California; Eve Mannes Gallery, Atlanta; Gallery Ninety-Nine, Bay Harbor Islands, Florida; Tyler Graphics, Mount Kisco, New York.
1988 André Emmerich Gallery, New York; "Back to Berlin," Amerika-Haus and Galerie Springer, Berlin; Cologne Artfair; Davis/McClain Gallery, Houston; Gallery Ninety-Nine, Bay Harbor Islands, Florida; Zolla/Lieberman Gallery, Chicago.
1989 André Emmerich Gallery, New York; Davis/McClain Gallery, Houston; Dorothy Goldeen Gallery, Santa Monica, California; Gallery Ninety-Nine, Bay Harbor Islands, Florida; Heland Wetterling Gallery, Stockholm.
1990 André Emmerich Gallery, New York; Dorothy Goldeen Gallery, Santa Monica, California; Heland Wetterling Gallery, Stockholm; Hokin Gallery, Palm Beach, Florida.
1991 Davis/McClain Gallery, Houston; Galerie Charchut und Werth, Düsseldorf; Galerie Keeser-Bohbot, Hamburg; Zolla/Lieberman Gallery, Chicago.
1992 André Emmerich Gallery, New York (two exhibitions); Dorothy Goldeen Gallery, Santa Monica, California.

GROUP EXHIBITIONS
1962 Butler Institute of American Art, Youngstown, Ohio.
1963 Art Institute of Chicago; Ball State University, Muncie, Indiana; Dayton Art Institute, Ohio; Ohio Wesleyan University, Delaware, Ohio; Schumacher Gallery, Columbus, Ohio.
1966 Cornell University, Ithaca, New York; Los Feliz Gallery, Los Angeles; Munson-Williams-Proctor Institute, Utica, New York; New Britain Museum of Art, Connecticut; Silvermine Museum of Art, New Canaan, Connecticut.
1967 Wadsworth Atheneum, Hartford, Connecticut.
1970 Corcoran Gallery of Art, Washington, D.C.; O. K. Harris Works of Art, New York; Trinity College, Hartford, Connecticut.
1971 Colgate University, Hamilton, New York; Paley and Lowe, New York; Protech-Rivkin Gallery, Washington, D.C.
1972 Albright-Knox Art Gallery, Buffalo; Neuberger Museum, State University of New York, Purchase; Newark Museum, New Jersey; "Painting and Sculpture Today, 1972," Indianapolis Museum of Art; University of Rochester, New York.
1973 Aldrich Museum of Contemporary Art, Ridgefield, Connecticut.
1974 Delaware Art Museum, Wilmington; Hansen-Fuller Gallery, San Francisco; Henri Gallery, Washington, D.C.; "Vera List Selects," Greenwich Library, Connecticut; Whitney Museum of American Art Downtown, New York; Whitney Museum of American Art, New York.
1975 Albright-Knox Art Gallery, Buffalo; Fendrick Gallery, Washington, D.C.; "[Ninth] Paris Biennale," Musée d'Art Moderne de la Ville de Paris, Musée National d'Art Moderne, and Musée Galliera, Paris; "Thirty-fourth

Biennial of Contemporary American Painting," Corcoran Gallery of Art, Washington, D.C.

1976 "1976 Mid Year Show," Butler Institute of American Art, Youngstown, Ohio; State University of New York, Potsdam; "Selections from the [Ninth] Paris Biennale," Musée des Beaux-Arts, Strasbourg, and Musée des Beaux-Arts, Nice.

1977 "A Tube Show," Gallery 72, Omaha; "Group Show from the Nancy Hoffman Gallery," Miami University, Oxford, Ohio; "Sculpture Now," Cornell University, Ithaca, New York; "Spectrum '77—Painting and Sculpture," Kansas City Art Institute, Missouri; "The Material Dominant— Some Current Artists and Their Work," Museum of Art, Pennsylvania State University, College of Arts and Architecture, University Park; "Viewpoint '77: Options in Painting," Cranbrook Academy of Art, Bloomfield Hills, Michigan; "What's New in Soho," Morris A. Mechanic Theatre Art Gallery, Baltimore.

1978 Bard College, Annandale-on-Hudson, New York; Morris Gallery, Madison, New Jersey; "Nature," Iran American Society, Teheran; Philadelphia Museum of Art; Thomas Segal Gallery, Boston.

1979 Bronx Museum of the Arts, New York; Virginia Polytechnic Institute and State University, Blacksburg, traveling to James Madison University, Harrisonburg, Virginia, and Roanoke College, Salem, Virginia.

1980 "Eight from New York," Art Gallery, Fine Arts Center, State University of New York, Stony Brook; Institute of Contemporary Art, Virginia

Museum of Fine Arts, Richmond; Musée d'Art et d'Archéologie, Toulon, France; "Painting and Sculpture Today," Indianapolis Museum of Art; Simon Stern Gallery, New Orleans.

1981 "Collector's Choice," Mississippi Museum of Art, Jackson; "Director's Gallery Glimpse, 1981–82," Fine Arts Museum of Long Island, Hempstead, New York; Miami University, Oxford, Ohio; Nicola Jacobs Gallery, London; Root Art Center, Hamilton College, Clinton, New York; "Seventieth Annual Exhibition," Randolph-Macon Women's College, Lynchburg, Virginia; "Toronto/New York," Art Gallery of Ontario and Toronto Art Fair, Canada; Wake Forest University, Winston-Salem, North Carolina.

1982 "Carnegie International 1982–1983," Museum of Art, Carnegie Institute, Pittsburgh, traveling to Seattle Art Museum; "Major New Works: Tenth Anniversary Show," Nancy Hoffman Gallery, New York; "Post Minimalism," Aldrich Museum of Contemporary Art, Ridgefield, Connecticut; "Summer Group Show," Nancy Hoffman Gallery, New York.

1983 "Fulbright Alumni Exhibition," Pace University, New York; "Nocturne," Siegel Contemporary Art, New York; "Transpersonal Images," Eighth International Conference of the International Transpersonal Association, Davos, Switzerland.

1984 Fort Wayne Museum of Art, Indiana.

1985 "Abstract Painting Re-Defined," Louis Meisel Gallery, New York, 16 February–23 March, traveling to Munson-Williams-Proctor Institute, Utica, New York, 6 April–26 May; Danforth Museum, Framingham, Massachusetts, 14 July–8 September;

Bucknell University, Lewisberg, Pennsylvania, 1 October–15 November; Fine Arts Center Gallery, State University of New York, Stony Brook, 26 November–10 January 1986; "Harvest," Ruth Siegel Gallery, New York, 13 March–6 April.

1986 "Art from the City University of New York: Approaches to Abstraction," Shanghai; "Public and Private American Prints Today," Brooklyn Museum, New York, 7 February–5 May, traveling to Flint Institute of Arts, Michigan, 28 July–7 September; Rhode Island School of Design, Providence, 29 September–9 November; Museum of Art, Carnegie Institute, Pittsburgh, 1 December 1986–11 January 1987; Walker Art Center, Minneapolis, 1 February–22 March 1987.

1987 "A View of a Workshop: Selections from Tyler Graphics," Katonah Gallery, New York, 10 November 1987–3 January 1988; "Monotypes II," Allan Frumkin Gallery, New York, 24 November–31 December; "Thirty-ninth Annual Academy—Institute Purchase Exhibition, American Academy and Institute of Arts and Letters," New York, 16 November–13 December.

1988 "1988 Invitational," New Britain Museum of American Art, New Britain, Connecticut, 13 March–15 May; "Columnar," Hudson River Museum, Yonkers, New York, 17 July–16 October.

1989 "Projects and Portfolios: The Twenty-fifth National Print Exhibition," Brooklyn Museum, New York, 5 October–31 December.

WORKS IN PUBLIC COLLECTIONS

Albright-Knox Art Gallery, Buffalo

Aldrich Museum of Contemporary Art, Ridgefield, Connecticut

Brooklyn Museum, New York

Corcoran Gallery of Art, Washington, D.C.

Cranbrook Academy of Art Museum, Bloomfield Hills, Michigan

Delaware Art Museum, Wilmington

Indianapolis Museum of Art

Johnson Museum of Art, Cornell University, Ithaca, New York

Kansas City Art Institute, Missouri

Musée d'Art et d'Archéologie, Toulon, France

Musée des Beaux-Arts, Strasbourg

Carnegie Museum of Art, Pittsburgh

Museum of Contemporary Art, Teheran

Museum of Modern Art, New York

Neuberger Museum of Art, State University of New York, Purchase

Power Institute of Fine Arts, Sydney

Richmond Museum of Art, Virginia

Rose Art Museum, Brandeis University, Waltham, Massachusetts

Sheldon Museum of Art, University of Nebraska, Lincoln

Solomon R. Guggenheim Museum, New York

United States Embassy, Beijing

University of Hartford, Connecticut

University of Oklahoma, Norman

Wadsworth Atheneum, Hartford, Connecticut

Walker Art Center, Minneapolis

Whitney Museum of American Art, New York

WORKS IN SELECTED CORPORATE COLLECTIONS

Ahmanson Commercial Development, Oakland, California

Amerada Hess Corporation, Woodbridge, New Jersey

Atlantic Richfield Company, Los Angeles

Barnett Banks, Inc., Jacksonville, Florida

Chase Manhattan Bank, New York

Chemical Bank, New York

Coca-Cola Company, Atlanta

Exxon Corporation, New York

Merrill, Lynch, Pierce, Fenner, & Smith, Inc., New York

Owens Corning Fiberglass, Toledo, Ohio

Pepsico, Inc., Purchase, New York

Phillip Morris, Inc., New York

Pillsbury, Inc., Minneapolis

Prudential Insurance Company of America, Newark

Sohio, Inc., Cleveland

Southeast Banking Corporation, Miami

World Bank, Washington, D.C.

SELECTED BIBLIOGRAPHY

1965

"Der Mensch als Massenartikel." *Die Welt* (Hamburg), July.

I.K. "Aus Galerien und Ausstellungen." *Handelsblatt* (Berlin).

M.S. "Es Brodelt bei Springer." *Der Abend* (Berlin), July.

Ohf, Heinz. "Abstand vom Unterbewussten." *Der Tagesspiegel* (Berlin), 13 July.

Roters, Eberhard. Exh. cat., Berlin: Galerie Springer.

1969

Grohmann, Will. "Sachliches a la Pop." *Frankfurter Allgemeine Zeitung*, 19 July.

"Terence David La Noue," *Das Kunstwerk: The Work of Art* 22 (February–March): 28–32.

1971

Pincus-Witten, Robert. "New York." *Artforum* 9 (May): 77.

Wolmer, Bruce. "Reviews." *Art News* 70 (April): 18–19.

1972

Hyland, Drew. "Art and the Happening of Truth: Reflections on the End of Philosophy." *Journal of Aesthetics and Art Criticism* 30 (Winter): 177–87.

Kingsley, April. "Reviews." *Art News* 71 (April): 54.

Lubell, Ellen. "Reviews." *Arts Magazine* 46 (April): 68.

Pincus-Witten, Robert. "New York." *Artforum* (May).

1974

Gruen, John. *Soho Weekly News*, October.

Lubell, Ellen. *Arts Magazine* (December).

1975

Kozloff, Max. "Painters Reply— Terence La Noue." *Artforum* 14 (September): 28, 31.

Miana, Rene. "Paris." *Art International* 19 (November): 35.

Slade, Roy. *Thirty-fourth Biennial of Contemporary American Painting*. Exh. cat., Washington, D.C.: Corcoran Gallery of Art.

Zucker, Barbara. "New York Reviews." *Art News* (February): 118.

1976

Lubell, Ellen. "Literal Painting: The Art of Terence La Noue." *Arts Magazine* 50 (February): 78–80.

1977

Burnside, Madeline. "New York Reviews." *Art News* 76 (March): 139–40.

Lubell, Ellen. "Terence La Noue." *Arts Magazine* 51 (March): 39.

1978

Burnside, Madeline. "New York Reviews." *Art News* 77 (September): 181.

Lubell, Ellen. "Things Are Not What They Seem." *Soho Weekly News*, 18 May.

1979

"Terence La Noue—Des Cultures pénétrées par l'abstrait." *Art Presse* (March).

1980

Dobbs, Lillian. "La Noue Shows Exotic Influence of the Primitive." *Miami News*, 14 November, p. 8D.

Kohen, Helen L. "Material Matters." *Miami Herald*, 14 November.

Larson, Kay. "Terence La Noue." *Village Voice*, 10 March, p. 80.

Russell, John. *New York Times*, 7 March, sec. C, p. 19.

Stein, Donna. "The New Terence La Noue." *Arts Magazine* 54 (April): 190–92.

Tatransky, Valentin. "Terence La Noue." *Art International* 24 (November–December): 106–12.

Zimmer, William. "Terence La Noue." *Soho Weekly News*, 9 March.

1981

Adler, Nicholas. "Terence La Noue at Nicola Jacobs." *Artscribe*, no. 30.

Lavell, Steven. *Arts Review*, 5 June.

Schwindler, Gary. "Terence La Noue: The India Connection." *Arts Magazine* 56 (October): 157–60.

Wolff, Theodore. "Tapestries Bound for Art History Books." *Christian Science Monitor*, 26 October, p. 18.

1982

Baro, Gene. *Art International* 25 (March–April): 104–5.

Fry, Don. "Painter La Noue Feels Tradition Important in Contemporary Art." *Indianapolis Star*, 11 April, sec. C, p. 8.

Ratcliff, Carter. "Terence La Noue at Nancy Hoffman." *Art in America* 70 (March): 145, 147.

Terence La Noue: Recent Paintings and Drawings. Exh. cat., Chicago: Arts Club of Chicago.

Wolff, Theodore. "The Many Masks of Modern Art." *Christian Science Monitor*, 20 April, p. 20.

1983

Artner, Alan. "Terence La Noue." *Chicago Tribune*, 8 April, sec. C, p. 9.

Frackman, Noel. "Layers of Significance: Meaningful Transformation in the Work of Terence La Noue." *Arts Magazine* (November): 142–44.

Glueck, Grace. *New York Times*, 11 November, sec. C, p. 26.

Holg, Garrett. "Terence La Noue." *New Art Examiner* (June): 18.

Kendall, Sue Ann. "Artist Finds Niche in New York and Acclaim Everywhere." *Seattle Times*, 9 March, sec. G, p. 5.

Larson, Kay. *New York Magazine*, 21 November.

Levin, Kim. *Village Voice*, 8 November, p. 66.

Ratcliff, Carter. *Terence La Noue: Paintings and Works on Paper, 1981–1983*. Exh. cat., New York: Siegel Contemporary Art.

1984

Artner, Alan G. *Chicago Tribune*, 1 June.

Frank, Peter. *Indiana's Modern Legacy*. Exh. cat., New York: Independent Curators Inc. for Fort Wayne Art Museum, Indiana.

Haydon, Harold. "Galleries." *Chicago Sun-Times*, 11 May.

Klein, Ellen Lee. "Terence La Noue." *Arts Magazine* 58 (January): 51.

Lubell, Ellen. "Terence La Noue at Siegel." *Art in America* 72 (April): 184–85.

Wolff, Theodore F. "Frozen Music." *Christian Science Monitor*, 20 September, p. 38.

————. "Success in Art—an Elusive Goal." *Christian Science Monitor*, 3 December, p. 55.

1985

Ashton, Dore. "To Travel through the Paintings: The New Work of Terence La Noue." *Arts Magazine* 59 (April): 119–21.

Fox, Catherine. "La Noue Exhibit Offers Beauty, Color, Adventure." *Atlanta Journal and Constitution*, 22 November.

Glueck, Grace. "Art: Abstract Painters Regain Old Charisma." *New York Post*, 8 March.

Heartney, Eleanor. "Abstract Painting Redefined." *Art News* (March).

Lipson, Karin. "Big Abstracts from a Varied Lot." *Newsday* (New York), 27 December.

"Terence La Noue." *Art Papers* (September–October): 43.

Wolff, Theodore F. "Today's Art World Exciting, Innovating, but Needs to Nurture Depth, Wisdom and Maturity." *Houston Post*, 27 July.

1986

Artner, Alan G. "La Noue's Exotic Art Is Worthy of the Name." *Chicago Tribune*, 4 April, sec. 7, p. 48.

Jinker-Lloyd, Amy. "Terence La Noue." *Art Papers* (January–February): 65.

Klein, Ellen Lee. "Beneath the Surface: An Interview with Terence La Noue." *Arts Magazine* 60 (January): 34–37.

Ratcliff, Carter. "Recent Paintings by Terence La Noue." *Arts Magazine* 60 (March): 46–48.

1987

Heartney, Eleanor. "Terence La Noue at Emmerich." *Art in America* 75 (April): 219–20.

Kuspit, Donald. "Terence La Noue at André Emmerich Gallery." *Artforum* 25 (April): 126.

Wolff, Theodore. "Update on Three Promising Artists." *Christian Science Monitor*, 26 January, p. 23.

1988

Artner, Alan G. "La Noue Travels Deep into Human Culture." *Chicago Tribune*, 11 November, sec. 7, p. 60.

Ash, John. "Terence La Noue at Emmerich." *Art in America* 76 (May): 187, 188.

Galloway, David. "An Encounter with Terence La Noue." Exh. cat., Berlin: Amerika-Haus and Galerie Springer (March–April).

Gill, Susan. "Terence La Noue at André Emmerich." *Art News* 87 (May): 168.

Hunnenwell, Richard. "Marlborough, Emmerich, Miller, Midtown, Herstand." *Art/World* 12 (18 February–18 March): 6.

"Kosmisch und persisch: Sheila Isham und Terence La Noue im Amerika-Haus." *Der Tagesspiegel* (Berlin), 18 April.

1989

Geer, Suvan. "The Galleries: Santa Monica." *Los Angeles Times*, 19 May, sec. 6, p. 17.

Hammond, Pamela. "Terence La Noue at Dorothy Goldeen." *Art News* 88 (September): 190.

Stein, Donna. "Terence La Noue." *Art Scene* (May).

Terence La Noue: Paintings and Prints. Exh. cat., Stockholm: Heland Wetterling Gallery.

Woodard, Josef. "Merger of System and Sensuousness." *Artweek*, 3 June, p. 5.

1990

Ken Tyler: Twenty-five Glorious Years. Exh. cat., Stockholm: Heland Wetterling Gallery, p. 18.

Muchnik, Suzanne. "Modern Archaeology." *Los Angeles Times*, 20 July, sec. F, p. 19.

Walker, Barry. *Terence La Noue: New Work 1990*. Exh. cat., New York: André Emmerich Gallery.

1991

Galloway, David. *Terence La Noue and the Painterly Paradox*. Exh. cat., Düsseldorf: Galerie Charchut und Werth.

McCracken, David. "Terence La Noue at Zolla/Lieberman Gallery." *Chicago Tribune*, 19 April.

Werth, Wolfgang. *Der proteische Künstler—Die Bilderwelten des Terence La Noue*. Exh. cat., Hamburg: Galerie Keeser-Bohbot: English trans. pp. 22–24.

PHOTOGRAPH CREDITS

Bevan Davies: pages 30, 31, 99, 100 bottom, 101

J. Littkemann: pages 19, 20

Earl Ripling: pages 54, 56, 57, 59, 61, 62, 109, 110

Steven Sloman: pages 136–142; printed and published by Tyler Graphics Ltd., © Terence La Noue/Tyler Graphics Ltd., 1978, 1988, 1989, 1990, 1991

Zindman/Fremont: page 26

INDEX

Page numbers in *italics* refer to illustrations.